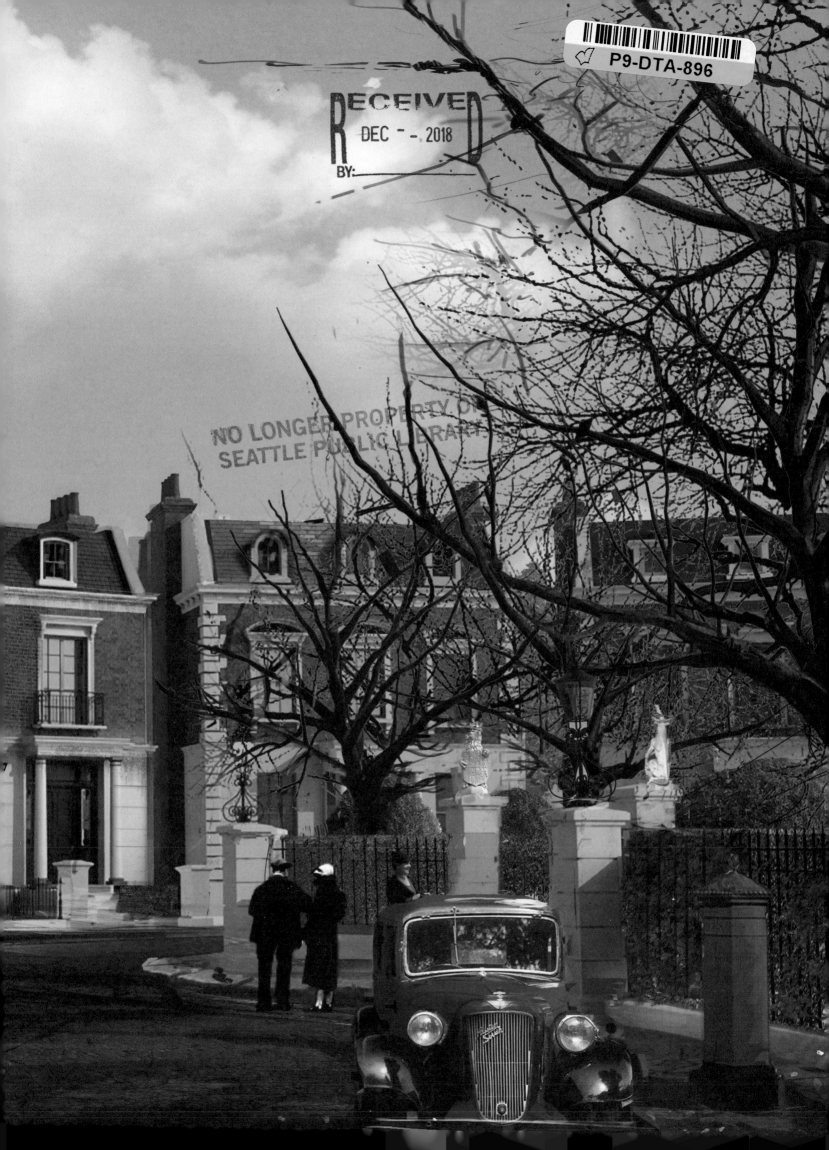

Mary Poppins was not invented by me. I don't do the controlling, and sometimes I'm surprised by what I've written. Again and again when I read over what I've put down I find myself saying 'Goodness, that's true. How did Mary think of that?' But then I realize that she is me. But is she?

—P. L. Travers

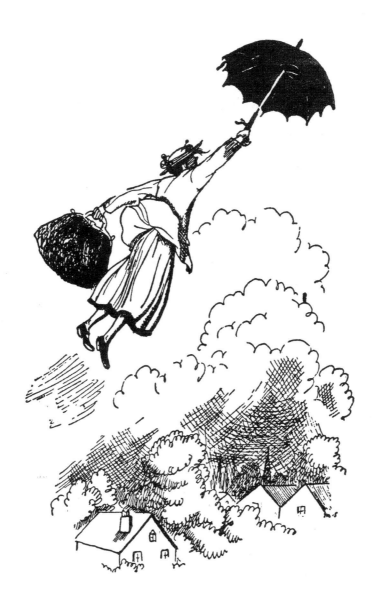

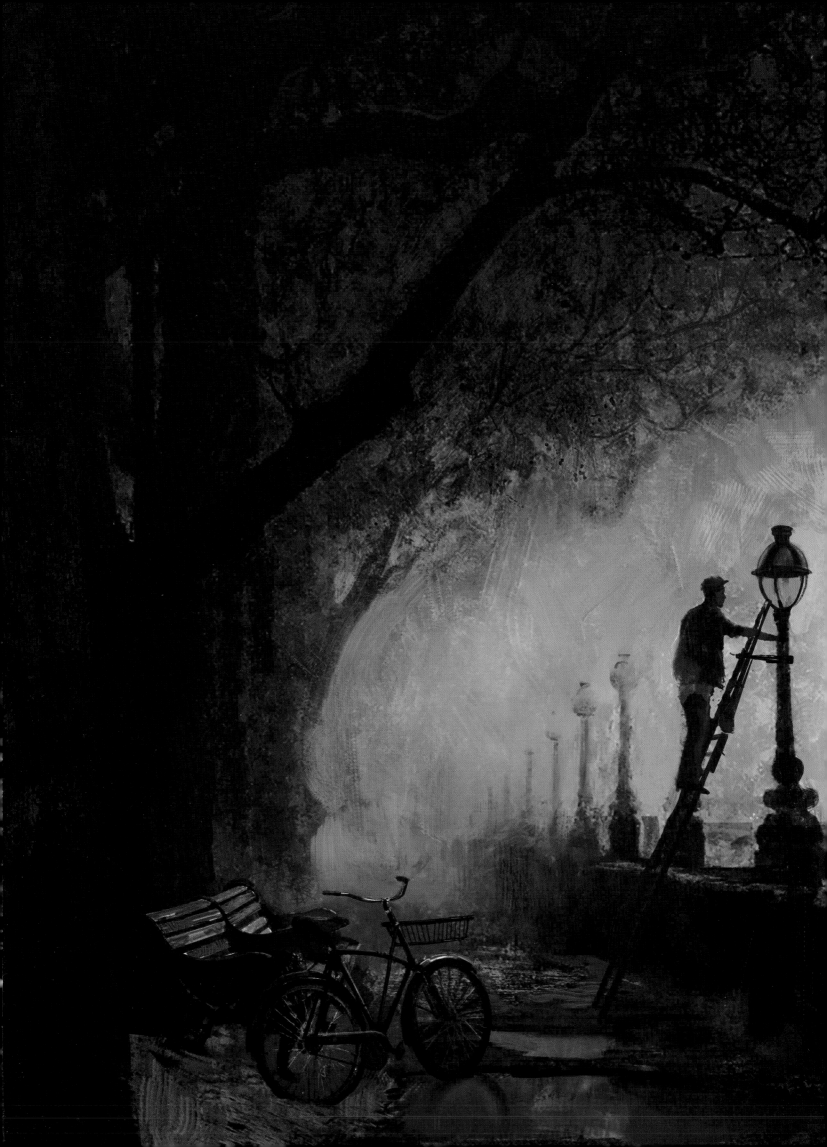

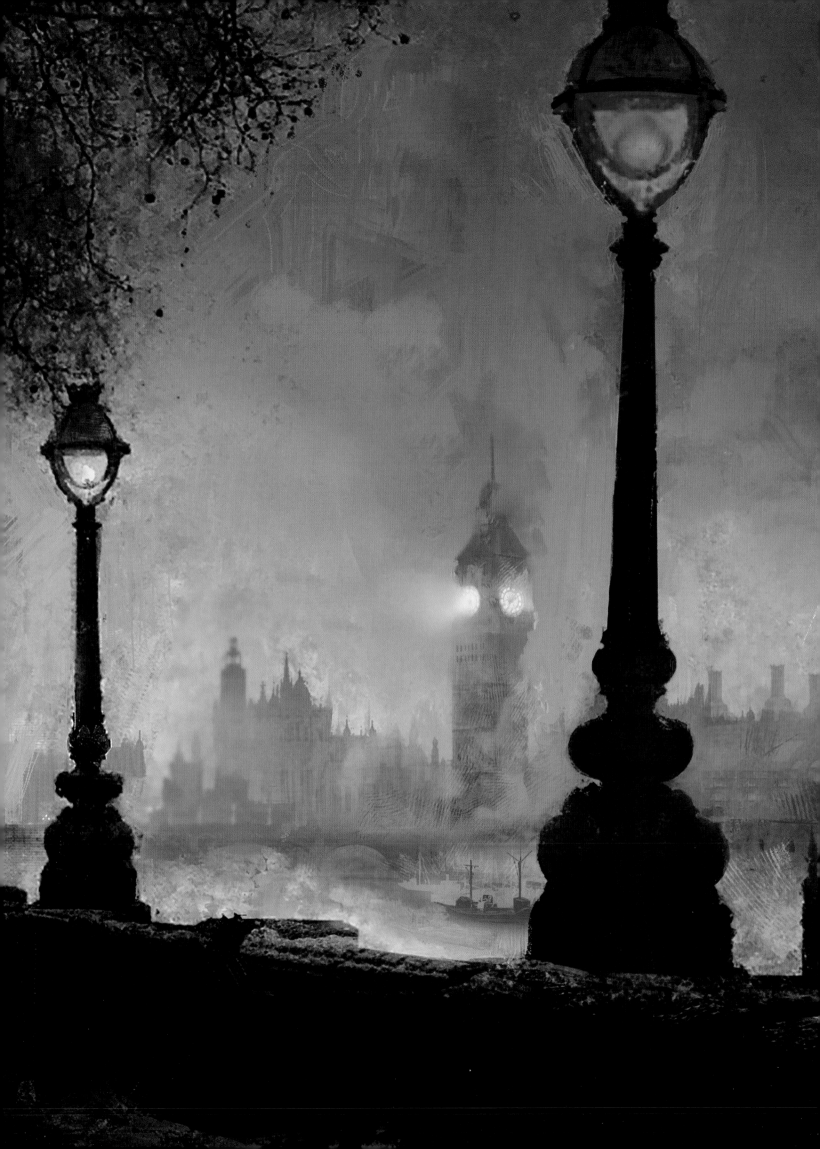

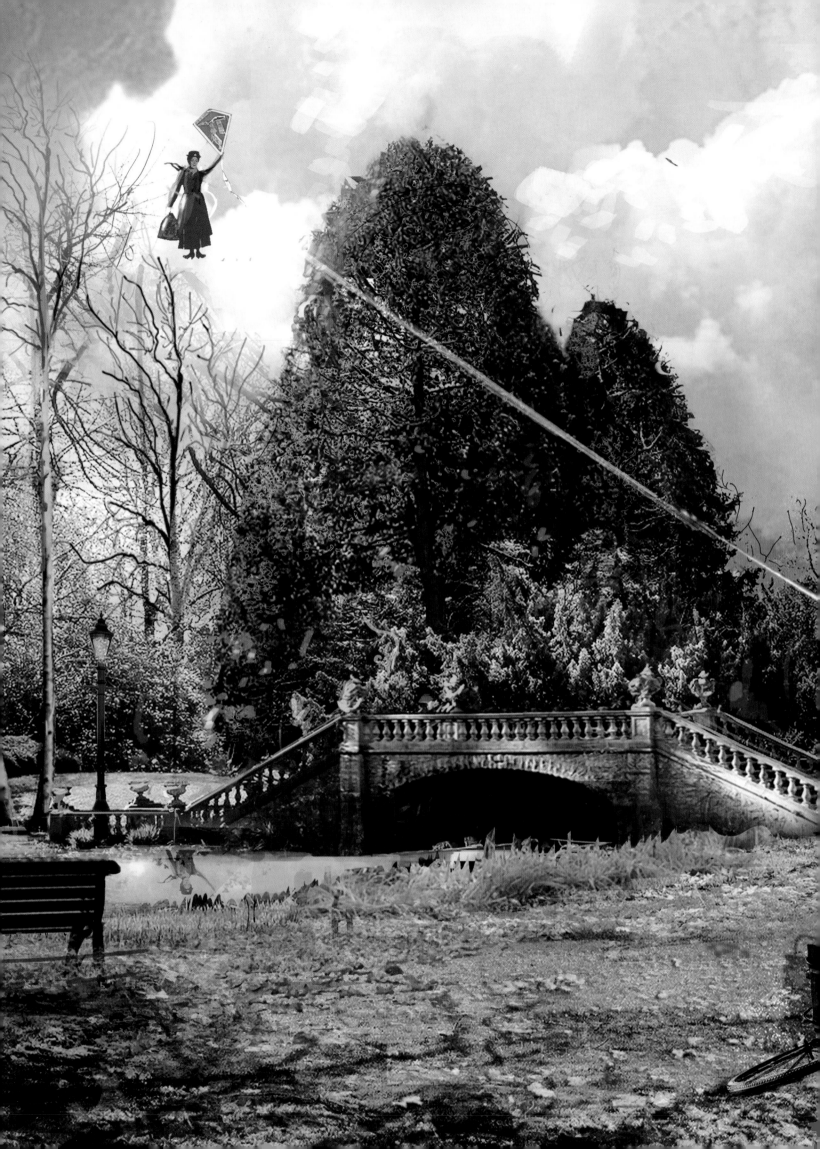

Practically POPPINS In Every Way

A Magical Carpetbag of Countless Wonders

Jeff Kurtti

Disney Editions

Los Angeles 🌂 New York

Editorial Director: Wendy Lefkon
Senior Editor: Jennifer Eastwood
Project Design Director: Winnie Ho

ISBN 978-1-368-02257-6
FAC-034274-18264

Printed in the United States of America
First Hardcover Edition, November 2018
Reinforced binding
10 9 8 7 6 5 4 3 2 1

Visit www.disneybooks.com

ABOVE: Sketch of Bert among the rooftop chimneys by Bob Crowley, designer of the Mary Poppins stage musical.

CONTENTS

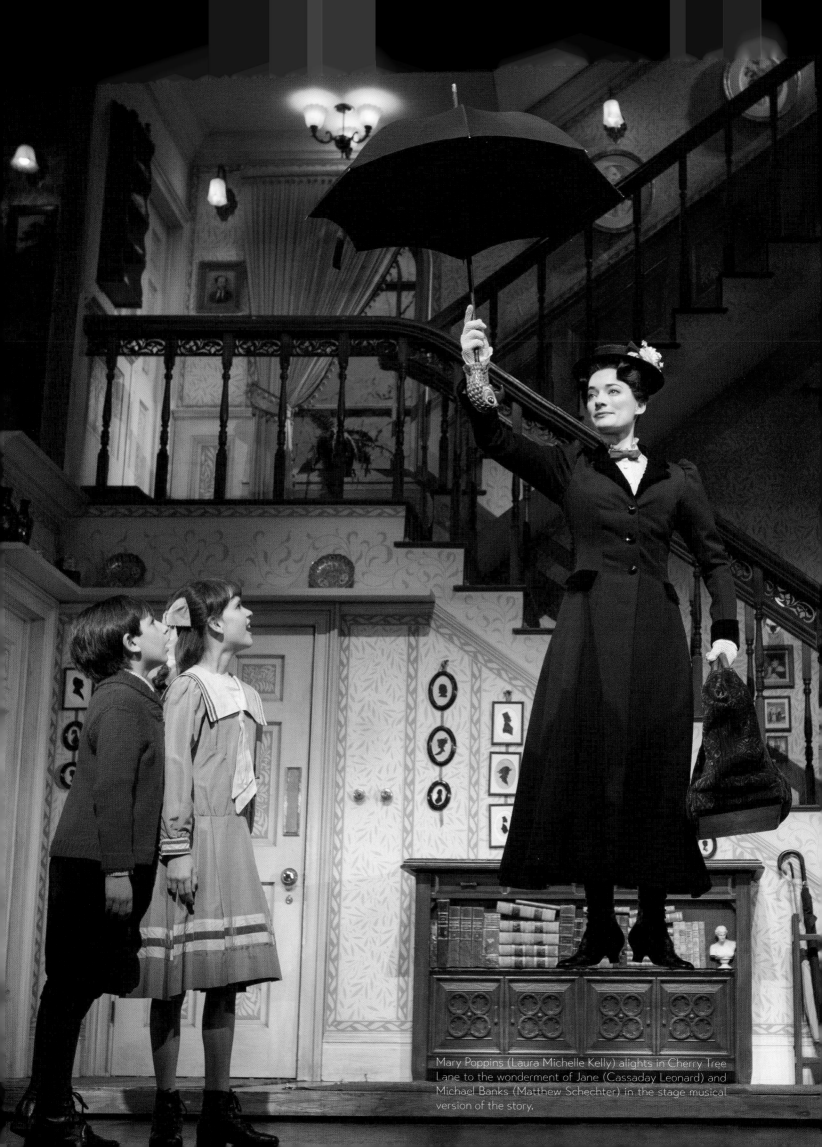

Mary Poppins (Laura Michelle Kelly) alights in Cherry Tree Lane to the wonderment of Jane (Cassaday Leonard) and Michael Banks (Matthew Schechter) in the stage musical version of the story.

Practically Perfect

A Nanny of Extraordinary Character

When Jeff Kurtti took me to meet Richard Sherman for the first time, we met in the lobby of the Beverly Hills Hotel. Richard lives nearby, and it seemed reasonable to start off at the legendary Polo Lounge.

We met in the lobby, shook hands, exchanged niceties, and headed into the restaurant. The pianist in the outer bar area saw Richard coming and immediately shifted his tune to "Chim Chim Cher-ee"—and I swooned.

You see, I had a love affair with *Mary Poppins* that had begun long before the author of this book introduced me to the Oscar-winning composer; almost forty years earlier, in fact. My family took an outing to Grauman's Chinese Theatre on Hollywood Boulevard to see Disney's latest, and perhaps most-praised triumph, *Mary Poppins*, in its premiere engagement.

I was swept up in the tale. I wanted to *live* in that film! This amazing woman, this force of nature (or the supernatural?) at the core of the film fascinated me—and has ever since then.

Everyone wants a Mary Poppins to arrive, to help us put our lives right. But of course, George Banks and his family don't see it that way at all. When Jane and Michael post a job for the "perfect nanny," they have no idea that what they need is a "healer"—or even an exorcist of sorts. Her idea of "playing games" is to *teach* all of them while they're unaware it's happening. They need some "tough love" that reveals a giant heart.

I'm also fascinated with how Mary Poppins is played by actors, and how she is interpreted by readers and audiences. Having met her as a child—and having worked with her image for the better part of two decades—I'm intrigued by how much variation there is.

She's contradictory, elusive, loving, tough, quirky, beautiful, stern, joyful—and always a mystery. "Let me make one thing perfectly clear," she says firmly. "I never explain anything." And she means it.

I've had the great joy of knowing a number of the ladies who brought Mary to life. Julie Andrews is typically the image that pops to one's mind immediately. I think she will always be our collective Mary Poppins. And like Mary, Dame Julie Andrews Edwards is remarkably generous of spirit, full of love and humor, and—trust me—you sit up straight when you are in her company. Because she makes you *want* to, just like Mary Poppins.

Our original West End and Broadway Marys, the exquisite Laura Michele Kelly and Ashley Brown, are both so special to me. They were the driving spirit of each of those massive original productions, and infused those shows with grace, charm, love, and extraordinary talent.

I even got to know television's Mary, the indomitable Mary Wickes. Her take on the material was far more what readers of the books (and Pamela Travers herself) might expect, rather than the one most Americans have become familiar with.

Emily Blunt steps logically and comfortably (and wittily and musically) into those sensible shoes, while making a Mary that's all her own. It's fitting in so many ways, because Mrs. Travers herself was unwilling to set boundaries for Mary. Ms. Blunt paints her very own fanciful images and conjures love in the hearts of children and adults as she sails across the screen and into Cherry Tree Lane.

She arrives airborne and unbidden, she works little miracles for people who aren't even aware they need them, and she is soon wafting away into the clouds again—but always with an implied promise to return; this is perhaps the most iconic image of Mary Poppins. She flies into our hearts, captures our imaginations—and leaves us all the better for it.

"Goodbye, Mary Poppins. And don't stay away too long."

Thomas Schumacher

is president and producer of Disney Theatrical Group, where he oversees the development, creation, and execution of all Disney live entertainment around the globe, including Broadway, touring, and licensed productions. His Broadway, West End, touring, and international production credits include Beauty and the Beast, The Lion King, The Hunchback of Notre Dame, *Elton John and Tim Rice's* Aida, Tarzan, Mary Poppins, The Little Mermaid, Newsies, Aladdin, *and* Frozen, *along with several new projects currently in development.*

Back to Cherry Tree Lane

A Return Visit for the Child Inside Us All

It's hard for me to remember one moment of my life without Walt Disney's film *Mary Poppins* being a part of it. It was the first film I ever saw as a child, and right then and there I was changed forever—for it opened the door to my love of music, fantasy, and magic in films. Of course, I, like millions of others, have revisited the movie many times since. And every time, there's a deep and warm feeling that I get that is hard to explain, except that when I see it, I am immediately transported to a place of pure wonder and joy.

So, imagine what I felt when I was approached by Disney to helm an all-new musical sequel . . . fifty-four years later! It had always been my dream to create an original musical specifically for film; and for *Mary Poppins Returns* to be the one felt like a miraculous adventure Mary Poppins herself would have dreamt up!

Of course, this all began when P. L. Travers first introduced the enigmatic nanny to the world in 1934, with the first of eight books that featured her whimsical adventures with the Banks family, who lived on Cherry Tree Lane. With the wealth of material from the additional books at hand, the challenge was how to find a new way in. . . . The decision was made to set the sequel in 1934 (the Depression-era London of Travers's books), twenty-four years later than the time period of the first film. So now the children, Michael and Jane Banks, are grown-ups (with Michael having three children of his own). And when the family suffers a personal loss, Mary Poppins returns to help a distraught Banks family find the joy and wonder missing in their lives.

As with all original musicals, it's *all* about collaboration; and I was lucky enough to assemble a stellar team. It included, first and foremost, my invaluable creative partner, John DeLuca, who shared every ounce of his passion and vision; our remarkable screenwriter, David Magee; our brilliant composers, Marc Shaiman and Scott Wittman; and our exceptional producing partner, Marc Platt. And that's just the start of it! The team extends to literally the finest artists, designers, musicians, animators, etc. in the world, crafting and bringing it all to glorious life.

And then there was the big question: Who plays the iconic role of Mary Poppins? Well, to be honest, that was the easiest decision of all. For there was only one actress in the world for me, and that was the "practically perfect in every way" Emily Blunt. And starring opposite her in the new role of the street lamplighter Jack is the insanely multitalented Lin-Manuel Miranda. Superlatives evade me when describing the rest of the dream cast that includes Ben Whishaw (Michael Banks), Emily Mortimer (Jane Banks), Colin Firth (Wilkins), Julie Walters (Ellen), Pixie Davies (Annabel), Nathanael Saleh (John), Joel Dawson (Georgie), and . . . Meryl Streep (Topsy)!

We were also honored to welcome two Disney Legends into the fold: the illustrious Angela Lansbury, as the magical Balloon Lady, and the ageless Dick Van Dyke, who plays Mr. Dawes, Jr., the son of the old banker he played in the original film!

Ultimately, my goal was to embrace the classic nature and beauty of the Mary Poppins books and film, while reimagining *Mary Poppins Returns* in a completely new way with an original story and score. And personally, it was important to me to emphasize Travers's recurring theme that as we become adults, we become disillusioned and cynical and forget how to look at life through a child's eyes.

There was a moment that I will never forget when Dick Van Dyke first walked onto our set. He turned to me and said, "I feel the exact same spirit here that I felt when we were doing the first film." Well, the little child in me couldn't have asked for anything more! For as Walt Disney himself said, "These films are not just for children, but for the child in all of us."

Rob Marshall
Director, Mary Poppins Returns

OPPOSITE: *Director Rob Marshall and Producer John DeLuca on the set of Mary Poppins Returns at Shepperton Studios in London, 2017.*

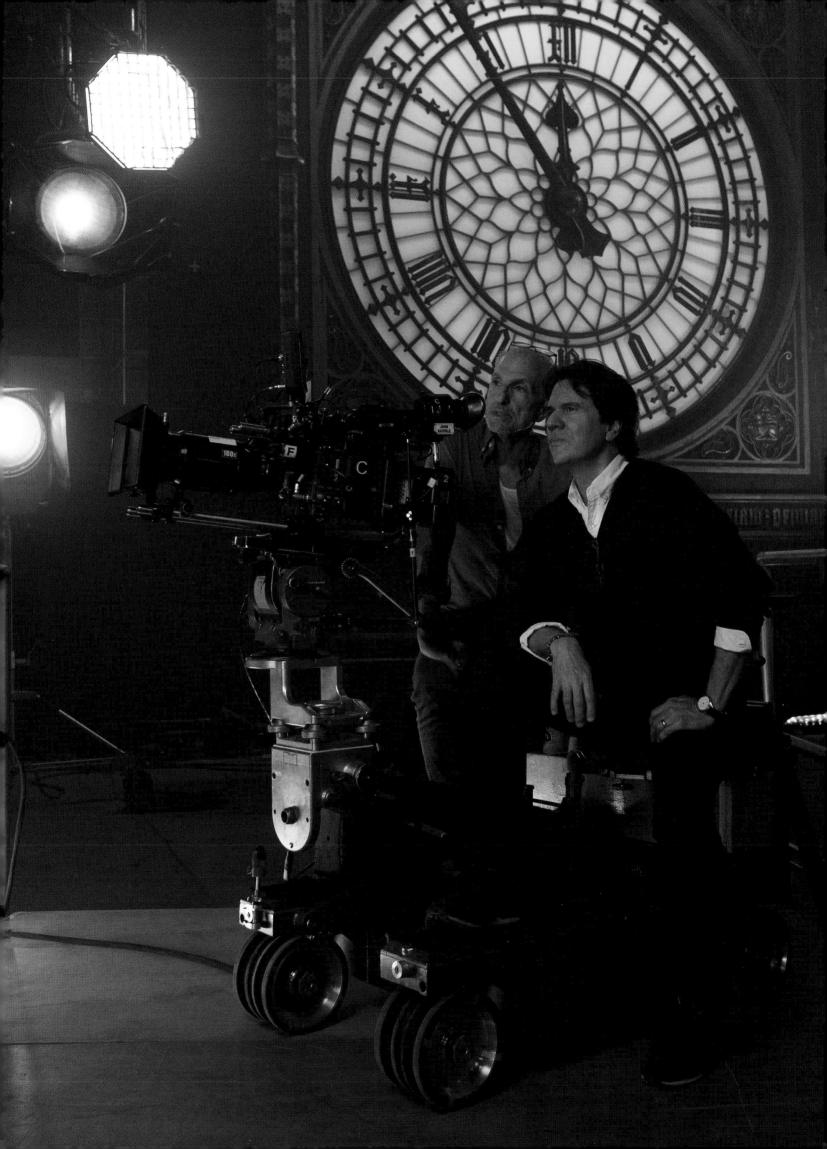

"I Shall Stay until the Wind Changes...."

The direction of the wind changes.

A locket chain breaks.

The door opens.

Aloft on an umbrella, grasping an airborne kite, or in a blaze of fireworks; over decades and in a variety of media, Mary Poppins arrives, creates an alchemy of mystery, confusion, consternation, and . . . perhaps a bit of magic?

When she feels the time is right (and only when she feels it to be so), she leaves again. But always, it seems, by saying "au revoir" and not "goodbye," or with a return ticket tucked in her remarkable carpetbag.

Over the past century, Mary Poppins stories have gone from being popular children's books to classics in the grand literary tradition, stories to be visited time and again for the joys—and the lessons—that they contain. The screen and stage adaptations have proven that Mary Poppins and her world occupy a revered space in the lexicon of entertainment—and the tradition of family culture and narrative all over the world.

"Mary Poppins brings a perspective of innocence into places where it's been lost," says Marc Platt, producer of *Mary Poppins Returns*. "When we grow up, we so often forget how to see the world through that lens of childhood. There's something joyous about this astonishing character who appears in the lives of a broken family and enables all their trouble to be seen through that lens again."

Mary Poppins Returns director Rob Marshall says, "There's something very deep and important about taking an ordinary life and transforming it into something special, an adventure. That's what Mary Poppins does, in the Travers books and on the screen."

"Mary Poppins is appealing and surprising, and in many ways has become eternal, like many other great literary characters," says *Mary Poppins* songwriter Richard M. Sherman. "In Mrs. Travers's books, she comes back again and again. She's a puzzling, peculiar, fascinating person—full of surprises. Telling *more* about her and her adventures, well, it's a storyteller's dream."

"The magic and mystery, the optimism and hope, a kind of all-knowing but utterly innocent view that Mary Poppins brings to the world . . . well, I think they're the same ingredients, the same qualities we're all looking for in our lives today," Platt says. "We want to be uplifted. We want not just to be entertained, but to be elevated and transported. Maybe it's always that way. Maybe that's why Mary Poppins is simply *timeless*."

OPPOSITE: Concept art for Mary Poppins, 1964. The British term for a sidewalk artist is "screever," a term said to date back to 1500. In 1890, it was estimated that more than five hundred people were making a full-time living as sidewalk artists in London alone.

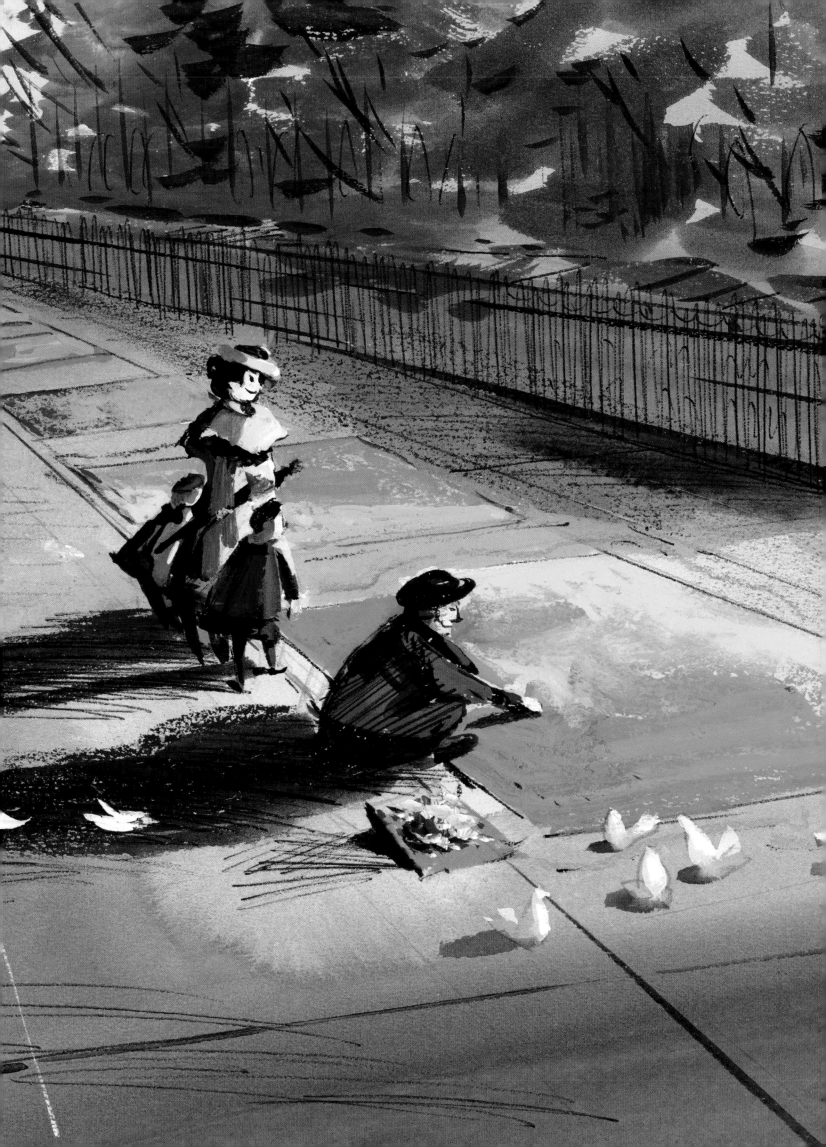

Living Legends

Disney Storytelling and the Power of Myth

The origins of a *Cinderella*-type story can be traced back to ancient Greece.

In 2016, researchers from Britain's Durham University found that iterations of *Beauty and the Beast* had roots in tales as far back as four thousand years ago, making it truly a "tale as old as time."

The Brothers Grimm popularized the fairy tale of Snow White in 1812. However, scholars have pointed to the origins of that story taking hold in historical lore a few hundred years earlier.

These stories have been passed through time, like a torch being handed from generation to generation. While themes and certain elements are carried through, a story seems to take on new life with each retelling. Sometimes changes are adapted to fit the culture in which they are shared. (For example, in early Asian Cinderella stories, the fairy godmother was a fish!) In others, these changes conform to the current time period.

When Walt Disney introduced his version of *Snow White and the Seven Dwarfs* to the world in 1937, it wasn't as though the moviegoing public was unfamiliar with the fairy tale. The title princess had made her way to the silver screen in silent form in 1916, and children had been hearing the tale in storybooks and bedtime stories long before that. But with Walt's telling, Snow White had a beautiful voice and whistled while she worked. The seven previously nameless dwarfs not only had names, but ones that matched their very distinct

personalities. The dwarfs went off to work singing "Heigh-Ho," a song that is now as synonymous with the tale as is the poisoned apple.

Many more retellings of classic folklore followed, and Walt's versions became the standard for these stories. Due to an almost mythical-unto-itself combination of Walt and his team's masterful storytelling, stunning animated characters and backdrops, and unforgettable music, these oft-told stories took on an originality of their own. Jiminy Cricket was Pinocchio's conscience, not an annoying bug dispatched early in the story as in Collodi's original. Princess Aurora was bestowed gifts by Flora, Fauna, and Merryweather, not the seven unnamed fairies of Perrault's telling. Peter Pan became a much more heroic figure compared to Barrie's literary antihero. Though taking root in the original stories, the "Disney versions" became originals of their own.

The same can be said of Walt Disney's film adaptation of P. L. Travers's *Mary Poppins*. After acquiring the film rights in 1961, Walt, along with Don DaGradi, Bill Walsh, and the Sherman brothers, formed a story based around the original book, making changes to the plot and time period. According to songwriter Richard Sherman, "First of all, there was no story line at all, so we took about six chapters that we thought were really the juicy ones— the ones with the most colorful stories and characters—and we wove a little tentative story, and we changed the period. It was written in the mid-thirties, a depressed time. We changed the period to 1910, which gave it a lot of color and sort of took away that veil of disbelief, so you could actually start believing that a nanny would fly in on a west wind."

In making these changes, along with the addition of original songs, Walt Disney's *Mary Poppins* took on a life of its own. "Supercalifragilisticexpialidocious" and spoonfuls of sugar became as associated with the titular nanny as the iconic umbrella and carpetbag that were introduced in the Travers novel.

Through theatrical reissues, books, merchandise tie-ins, and the advent of VHS and DVD for home viewing, the Disney versions of these tales became iconic. In many instances, they served as introductions to the origin stories, with parents passing the stories of their

youth to new generations. It's hard for many to speak of *Cinderella* without thinking "Bibbidi-Bobbidi-Boo," or of *The Jungle Book* without singing about the "Bare Necessities." They have become as much a part of the story lexicon as the original characters and themes created so many years prior.

These Disney stories were rich in storytelling, and familiar in character. Actually, they were so rich and familiar that when filmmakers began to envision new ways to tell these tales, they realized the necessity of telling them in a way that would honor both the origins and the Disney versions that so many had grown up knowing. When Kenneth Branagh set to directing a live-action version of *Cinderella*, for example, he was aware of a need to tell a new story that would relate to a fresh audience. "You can't live in nostalgia-land," Branagh stated. "It can't be just a life of looking backwards and being retro."

Yet Branagh also realized the familiarity filmgoers would expect from Walt's 1950 classic. "I could have given Gus-Gus another name," he mused in reference to the now-familiar mouse. "But you know what I was aware of was that I enjoyed the sound of Gus-Gus as a comedy rhythm. Gus-Gus connects across sixty-five years. It seems like a good name for a mouse, [and] that's also carrying a great big cultural wagon behind it of memory and affection and connection to the *Cinderella* experience, with the Disney experience, with families going to the movies together." The end result was another passing of the torch, with classic elements combining with a message of remaining true to oneself—truly a timeless story relatable to new audiences.

With *Mary Poppins Returns*, we see the torch being passed in a different way—with a continuation of the story so many have come to know and love. Jane and Michael Banks are no longer the children from the first film, but still need the magic of Mary Poppins in their lives. The Edwardian setting of the original film has now changed to Depression-era London

(the time period of the Travers books), yet the ever-familiar home at Number 17 Cherry Tree Lane still remains. With the opportunity to continue the *Mary Poppins* story, the filmmakers found themselves able to pull unused stories from the Travers books, pay respect to their new movie's 1964 predecessor, and still tell a fresh new story to moviegoers old and young.

Rob Marshall, director of *Mary Poppins Returns*, is very aware of the legacy of *Mary Poppins*, both in book and film. "The bar is so high for this," says Marshall. "But to be able to walk in the footsteps of this beautiful story about a woman who brings magic to this family that's looking for wonder and hope and joy in their lives . . . I feel a great responsibility and reverence every day. We all feel it. We're just lifting it up to get there with the right intentions behind it."

As time passes on, new stories are told and new memories are formed within these stories. Some will pass from generation to generation, each embellishing different parts of the story—perhaps with new characters or elements to fit the time period or audience to whom they are being told. Many stories that we recognize today as classics, such as *Cinderella*, *Beauty and the Beast*, and *Snow White and the Seven Dwarfs*, will still be shared in new and different forms (especially in our ever-changing world of technology and media), but original elements and themes will remain. From the folktales around a campfire to the newest Disney versions, these stories continue to breathe new life with each new telling.

At the end of 1964's *Mary Poppins*, Bert looks up to the sky and says, "Goodbye, Mary Poppins. Don't stay away too long." As long as there are people to tell the stories, she won't stay away too long at all.

Craig D. Barton

is a freelance writer, editor, and creative consultant. A lifelong Disney aficionado and advocate of performing arts, he is currently at work on a holiday-themed theatrical project, as well as a collection of arts-influenced essays. He lives in Avondale, Arizona with his wife and daughter.

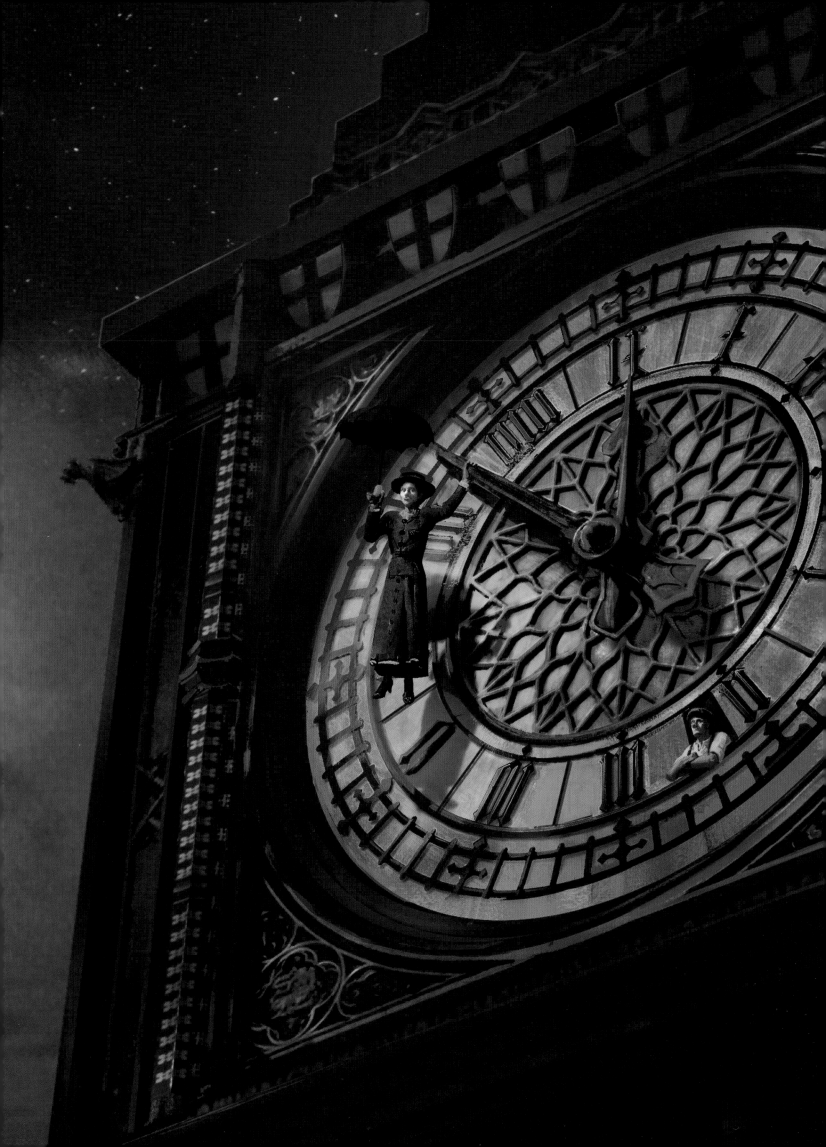

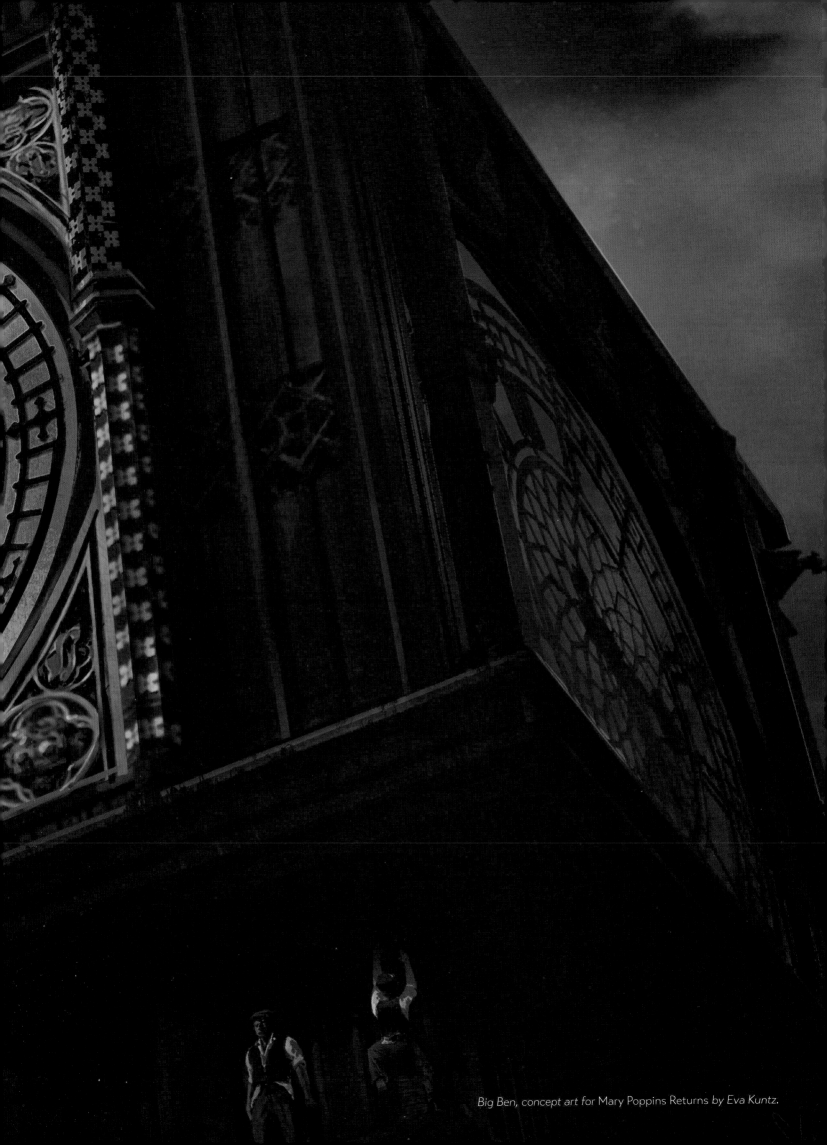

Big Ben, concept art for Mary Poppins Returns by Eva Kuntz.

East Wind

Magically and mysteriously, she arrives to meet a need—one that even those in need don't see.

"Demonic energies sometimes get loose, and they are very dangerous, but they are always brought back under control by the protecting figure of Mary Poppins, who is surrounded by the magic and excitement that she helps generate, but never really altered or affected by it," wrote Kenneth J. Reckford, professor of classics at the University of North Carolina. "She always guides the children home again, back to safe and known reality. The world has been transformed a little, and we with it."

This philosophy can be found at the heart of *Mary Poppins Returns*. "These stories have proven so resonant, so touching, so much a part of people's lives and culture for nearly a century," producer Marc Platt says, "it actually made us wonder if having Mary Poppins visit in another musical movie would be as outlandish as it might seem to be."

The 1964 screen adaptation of *Mary Poppins* is a revered classic, a beloved "rite of passage" film that is rightly regarded as Walt Disney's cinematic masterwork. To approach that esteemed material again seemed to invite negative comparisons and reflexive criticism.

Knowing this, the filmmakers instead struck a careful and conscious balance between respect and innovation—between that which is and that which is becoming. "Doing

a 'remake' never crossed our minds," director Rob Marshall says. "What would be the point of such a foolish exercise, trying to re-create Walt's greatest movie?"

Producer John DeLuca agrees. "At first, it was naturally somewhat daunting. Then, as a team, we looked at the characters and situations of all of the Mary Poppins works." They knew that erudition and understanding of the underlying works was key to creative success, but that to become too reverent would be crippling.

"We tried to understand the qualities within each that are appealing, that are timeless, that are engaging to readers and audiences," Platt observes. "We delved into the additional books written by P. L. Travers and found a treasure trove of characters and episodes, and more magic that opened up the world of Mary Poppins to us— and really gave us the confidence that together we could create something with respect for all of the preceding works, but that stands as a new interpretation, a reintroduction of Mary Poppins for a whole new generation of audiences."

Rob Marshall is a film and stage director, as well as a choreographer. His 2002 film adaptation of *Chicago* won the Academy Award for Best Picture, for which Marshall won a Directors Guild of America Award and nominations for the Oscar, BAFTA, and Golden Globe awards for Best Director.

"Rob and John DeLuca and I had just had a wonderful experience with

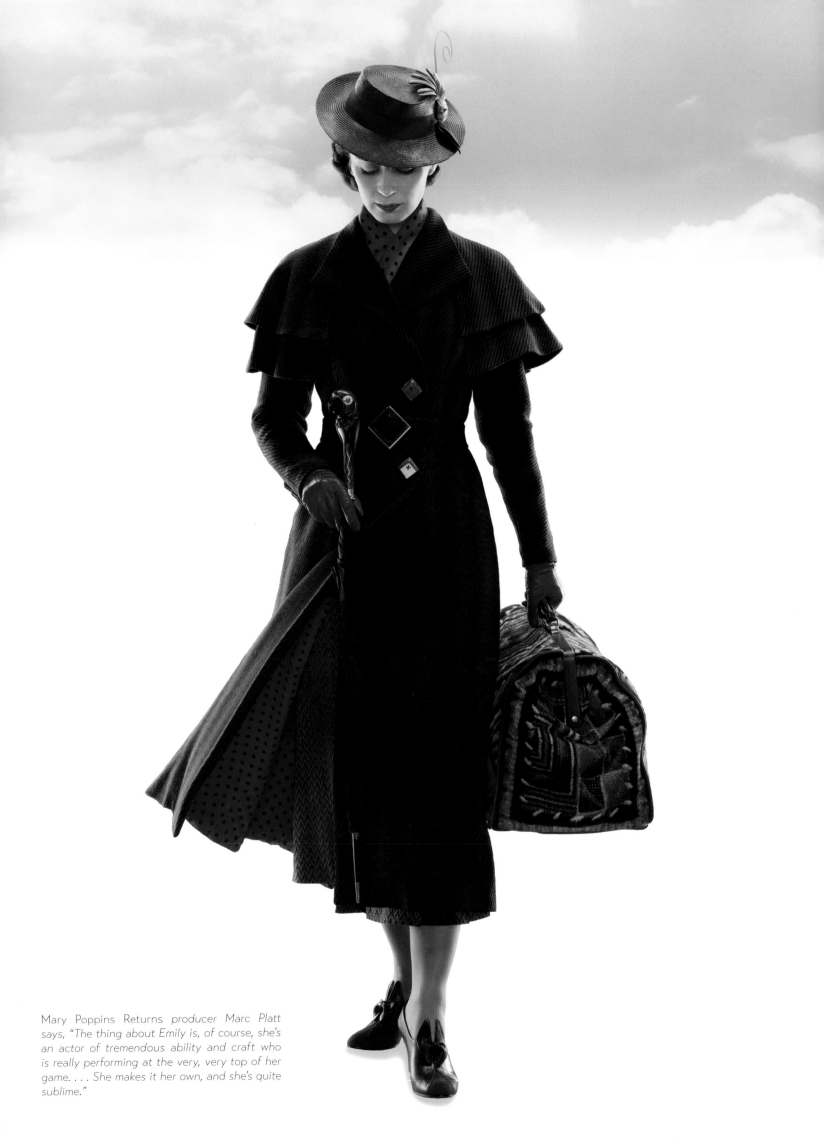

Mary Poppins Returns producer Marc Platt says, "The thing about Emily is, of course, she's an actor of tremendous ability and craft who is really performing at the very, very top of her game. . . . She makes it her own, and she's quite sublime."

Disney making the film version of *Into the Woods* (in 2014), and when that was completed we thought about what we might want to do next," says Platt.

A Baltimore native and longtime theater lover, Marc Platt was an executive at TriStar Pictures and then Universal before striking out on his own. He became a top independent producer thanks to such movie hits as the Legally Blonde franchise, *The Girl on the Train*, *Drive*, *Bridge of Spies*, and *La La Land*, plus such Broadway smashes as *Wicked*. The entertainment news source *Variety* lauded Platt for being "Well-known as a gentleman and a gentle soul in a cutthroat business."

"Rob [Marshall] always thought about a Mary Poppins film but was respectfully reticent because he has such affection for the original," Platt recalls. "And to step into those shoes was a big undertaking."

"Actually, I remember Rob and I talking about a Mary Poppins film as a sort of dream project for probably ten years," production designer John Myhre recalls.

Myhre is an Academy Award– and Emmy Award–winning production designer. He'd worked with Marshall on *Chicago*, *Memoirs of a Geisha*, and *Nine*. His "Disney fan" cred was sealed with his work on *The Haunted Mansion*, *Pirates of the Caribbean: On Stranger Tides*, and *X-Men: Days of Future Past*.

"As we continued to build our team," DeLuca remembers, "we brought on David Magee to create our screenplay; David is the Academy Award– and Golden Globe–nominated screenwriter of *Finding Neverland*, as well as *Miss Pettigrew Lives for a Day* and *Life of Pi*."

In *Mary Poppins Returns*, the writer found a project perfectly suited to his personal criteria. Magee says, "There

had to be something that when I first read the material, or when I first heard it, makes me say, 'Oh yes, I want that, I want to explore that idea'; or, 'I want to show that to my kids'; or, 'I've felt just like that'; or, 'That really moved me.'"

"We then worked really hard to figure out how to create a new musical voice for our project," Platt says. "A new score, new songs, and a musicality that would live in our new world of Mary Poppins and support our story, something that could stand on its own beside the immortal score by the Sherman brothers."

Marc Shaiman—a Grammy–, Emmy–, and Tony award–winning, and multi-Oscar–nominated composer and lyricist for films, television, and theater—also joined the *Mary Poppins Returns* team.

"Marc grew up being inspired by the Sherman brothers," Platt says. "So, there's a real emotional connection to the fantastic Sherman score and with some of that original story background, but which—like everything we do in this film—has a foothold in the original, but then builds on that and makes it our own."

Scott Wittman, who has cowritten the lyrics for *Mary Poppins Returns*, also cowrote (with Marc Shaiman) the lyrics for *Hairspray*, for which they received Tony and Grammy Awards.

"The combination of a literary origin in [P. L.] Travers and the rich storytelling words of the Sherman brothers' songs created some daunting challenges—but utterly thrilling and unique creative opportunities for a lyrical language of Mary Poppins," Wittman says. "The sly playfulness of the character herself was an additional inspiration."

Oscar-winning costume designer Sandy Powell was recruited to add her

unique creative vision to *Mary Poppins Returns*. She has won three Academy Awards for Best Costume Design for *Shakespeare in Love*, *The Aviator*, and *The Young Victoria*—and has been nominated twelve times for the Oscar!

"The most daunting task was really to create a new version of Mary Poppins," Powell says. "Not a *different* Mary Poppins, but a *new* version of the same character. The original Mary Poppins—everybody remembers what she looked like. I certainly remember what she looked like; it was the first film I ever saw, and I think it's just one of those iconic images that sticks in your head."

"Sandy Powell has a singular, imaginative, and fanciful design sensibility perfectly suited to this project," Platt says. "Her ability to create a character with color, texture, and silhouette is quite extraordinary."

A musical without choreography is a dull affair indeed. DeLuca states plainly, "It's a Rob Marshall film, so you can expect extraordinary dance sequences." To support the choreography of Marshall and DeLuca, the pair reunited with their *Chicago* colleague Joey Pizzi, who served as co-choreographer.

DeLuca has been a producer, second unit director, and, occasionally, a performer. He is a frequent collaborator of Rob Marshall's—he was choreography supervisor and second unit director for *Chicago*, a producer on *Pirates of the Caribbean: On Stranger Tides* and *Into the Woods* (on which DeLuca was also a second unit director).

"We found our creative team and started working," DeLuca states without hesitation. "The team members were all absolute giants in their respective fields, skillful and innovative—and every one of them carried a deep emotional connection to the story." DeLuca summarizes how each person on the team was "respectful, inspired, talented—erudite about the components of the storytelling that they would be challenged to create and support. And," he emphasizes, "a genuine team, a league of extraordinary collaborators all of whom brought a love of Mary Poppins to the work."

"Everything about our film is new, in that it is our shared personality," Platt says. "Audiences will feel immediately at ease that they're in a world with Mary Poppins, a place they're instantly familiar with. It moves with confidence, as good sequels do, into our own grammar, our own sensibility, and our own storytelling."

"I was truly humbled and honored to be asked by Disney to bring Travers's further adventures to the screen," says Marshall. "The iconic original film means so much to me personally, and creating an original movie musical that can bring Mary Poppins, and her message that childlike wonder can be found in even the most challenging of times, to a whole new generation—that's truly a once-in-a-lifetime opportunity."

Platt adds, "This will be the time to discover her magic, her humor, and her lessons as you experience the music, the unforgettable performances, and the extraordinary visual wonder that we bring to this film."

"The bar is so high for this," says Marshall. "But to be able to walk in the footsteps of this beautiful story about a woman who brings magic to this family that's looking for wonder and hope and joy in their lives . . . I feel a great responsibility and reverence every day. We all feel it. We're just lifting it up to get there, with the right intentions behind it."

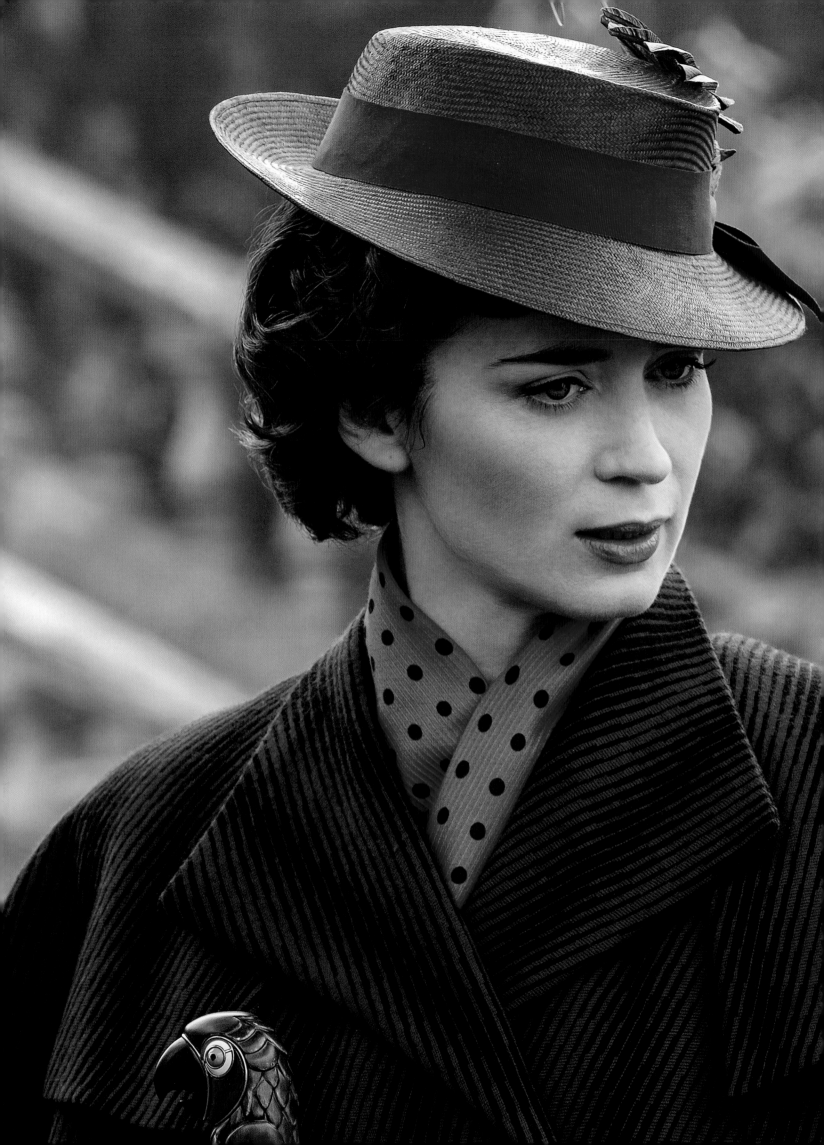

A Cover Is Not the Book

Literary Origins and Cinematic Inspirations

"If you want to find Cherry Tree Lane, all you have to do is ask the policeman at the crossroads. . . ."

So P. L. Travers wrote in the first of her eight books about the eccentric interloping child care professional. As the core filmmaking team came together, they began to mine the materials and meanings of Mary Poppins in seeking their own creative voice for *Mary Poppins Returns*.

Rob Marshall says, "We realized there was such a wealth of adventures that never materialized on-screen, and I thought, maybe there's a *reason* to do this film."

As their research continued, they were heartened to find that even the obstinate Mrs. Travers was amenable to the idea of a sequel. As they plumbed the literary assets of Mary Poppins, the team also realized that ignoring or fearing the classic Walt Disney film was foolhardy. "You can't *just* work from the books," Marshall says. "You have to embrace the fact that most of us know this story because of the film."

"So, we developed the project," Marc Platt says. "Our story takes place twenty-five years after the original film, in the mid-1930s in England—which is exactly the time period P. L. Travers published her first books, 1934 and 1935."

"You *feel* that era of the [Great] Depression in the novels," Marshall says. "When the decision was made by Walt to set his movie in a more idealistic time, in 1910, it was a brilliant idea to create an essence of warmth and theatricality. But I thought, *What can we bring to this besides a new story?* I felt we could be truer to the books themselves, which then led to the idea of it being twenty-five years later.

"Well, that means Jane and Michael have grown up," the director points out.

Drawing from the wealth of material in P. L. Travers's novels, the story follows a now-grown Jane and Michael Banks, who, along with Michael's three children, are visited by the

OPPOSITE: *The Banks family greets the returning Mary Poppins.*

enigmatic Mary Poppins. Through her unique personality and inexplicable skills, and with the aid of her friend Jack, a lamplighter, she helps the family rediscover the joy and wonder missing in their lives.

"The house on Cherry Tree Lane is inhabited by Michael Banks and his children," Platt says, "and there's been a loss in the family—so there's a *need* for Mary Poppins to come back into the world, and to make it bright again, make it magic. To make it sing. To bring innocence and love back into this family, and the world around them."

DeLuca adds, "Of course, Mary Poppins is the one character who hasn't aged—she *doesn't* age. Everybody else does in the world, but Mary lives *outside* of our world. She is as always, quite simply, Mary Poppins."

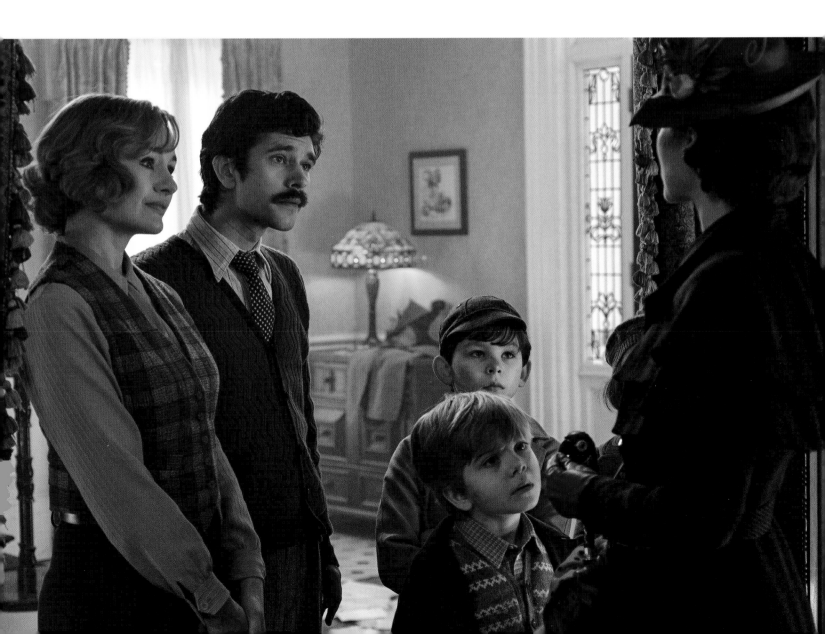

Can You Imagine That?

Developing a Screen Story

"I think there was more exploration and 'figuring out' early on with *Poppins* than there was with most other scripts I've written," screenwriter David Magee says.

Whether consciously or intuitively, the *Mary Poppins Returns* creative team actually followed the development pathway that Walt, the Sherman brothers, and Don DaGradi and Bill Walsh (cowriters of the original movie's script) had on *Mary Poppins* back in 1962: they created a collaborative storytelling work for the screen.

"I wrote *Poppins* essentially after collaborating on the outline with the director, the producer, the composer, and the lyricist for months," Magee recalls. "It was five of us in a room talking ideas, so the story evolved as a group. It's a really fun way to work, and by the time that we got to posting up notes, I already had a very strong idea of what the shape of the story was going to be."

Academy Award nominee David Magee headed into his screenwriting career after years performing as an actor and voice-over artist, and working as a writer, and a playwright. After high school, the Flint, Michigan, native left home to pursue an acting career. After attending Michigan State, he got an MFA at the University of Illinois. Along the way he began doing voice-overs for English-language books on tape, which led to an unusual career turn—crafting and editing abridgements of existing works.

"I've abridged more than eighty books—fiction, nonfiction, bestsellers, famous authors, obscure authors, romance novels, potboilers, bodice-ripping ridiculous stuff—everything!"

He also began developing his skills as a playwright. After a workshop performance of his first play, *Buying the Farm*, in New York City, he met a producer who had optioned the movie rights to a play but was having difficulty adapting it into a film. The producer asked Magee to take a crack at it, and the result was the Academy Award–nominated screenplay for the acclaimed 2004 feature *Finding Neverland*.

"From that very moment, I broke my acting habit," the screenwriter recalls.

Afterwards, he went on to write the 2008 film version of *Miss Pettigrew Lives for a Day* and was again Oscar-nominated, for his 2013 screenplay for *Life of Pi*.

Magee's work method in proceeding to a screenplay typically involves creating a large narrative map on whiteboards, which soon bloom with a colorful array of Post-it Notes, each with a key piece of action or dialogue (or in this case, song lyrics) jotted on it.

"The nice thing about the Post-it Notes is that you write as little as possible, and you don't get precious about your ideas. Then later, if it doesn't work, you don't feel bad about crumpling that note up and trying something else.

"I've been working very closely with the director and the producers, and I generally do so right up until the first few days of filming; and then my job is done for a while," Magee adds. "While they're shooting, I often go and visit the set because I want to see how it's all unfolding. But if I've done my job well enough, I'm not really needed there for the actual filming. Then once they're done filming and they assemble the edit of the film, that's when I might come back in a little bit and be an extra pair of eyes who hasn't watched it for a while— or to help clarify or adjust something."

In finding their new voice, the *Mary Poppins Returns* team members were continually reassured that their fundamental trust in the material was the right road. Indeed, the ideas and lessons of P. L. Travers have run through every aspect and adaptation of the Mary Poppins tales ever since the first one was published.

"There's a theme that runs through the books," Marshall says, "that as adults get older, they forget, and it's very easy to become cynical and jaded and not believe in things."

An example of this is found in the very first book. Jane and Michael's twin infant siblings, John and Barbara, freely and easily talk with Mary Poppins, a beam of sunlight, and a skylark that lands on the windowsill. The babies are puzzled that Jane and Michael can't (or don't) talk with the birds, the West Wind, and the sunbeams. Sadly, the skylark tells them, much too soon *they* will also forget.

"Huh!" said the Starling contemptuously. "Look at 'em! They think they're the World's Wonders. Little miracles—I don't think! Of course you'll forget—same as Jane and Michael."

"We won't," said the Twins, looking at the Starling as if they would like to murder him. The Starling jeered.

"I say you will," he insisted. "It isn't your fault, of course," he added more kindly. "You'll forget because you just can't help it. There never was a human being that remembered after the age of one—at the very latest—except, of course, Her." And he jerked his head over his shoulder at Mary Poppins.

"I think that's an important lesson for adults," Marshall says. "In this particular climate, I was so anxious to live in a place of optimism and joy, and this discovery of 'lost wonder.' I wanted to live in that world.

"I know what Mary Poppins brought me as a child," Marshall adds. "And Walt Disney always said, these movies are *not* 'for children.' They're for the child within all of us."

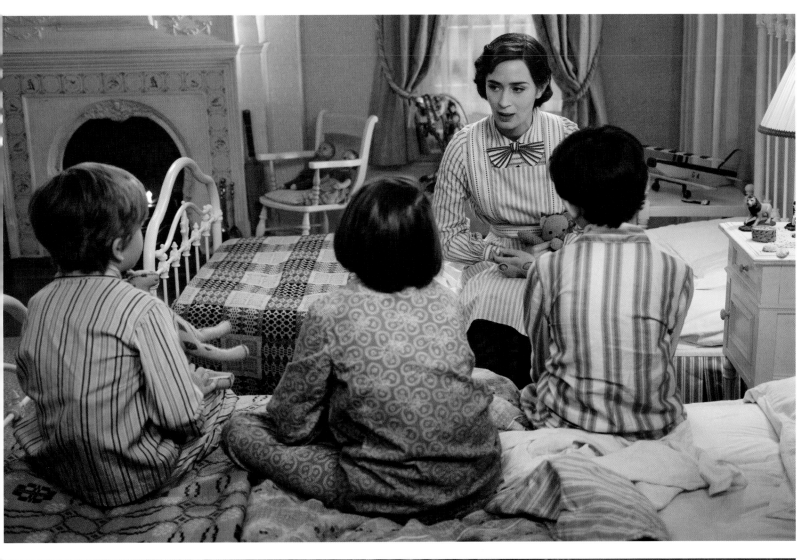

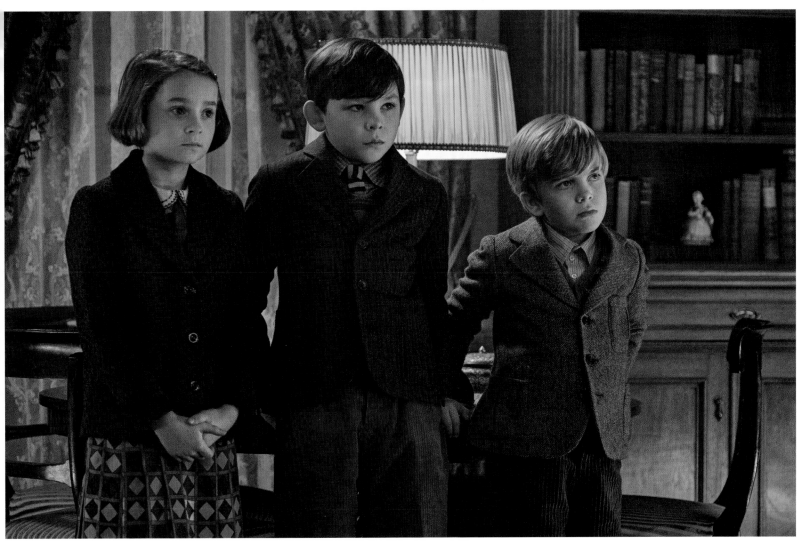

Underneath the Lovely London Sky

The Visual World of Mary Poppins Returns

"In my very first discussions with Rob Marshall about the *Mary Poppins Returns* project," production designer John Myhre says, "he said he wanted to make our film feel more tangible, more real—a little more gritty than Walt's.

"We talked about the original design, which we love and is so beautiful," continues Myhre. "You know, the combination of the theatrical design by Tony Walton and the beautiful glass matte paintings by Peter Ellenshaw—it gave the whole film a heightened sense of fantasy, a really painterly look. I love the opening of *Mary Poppins*, a series of moody, artful paintings of London, as opposed to some sort of actual, real 'flyover.' It immediately established a storybook feeling, a theatrical quality.

"I remember even as a kid not really knowing where the paintings stopped and the real sets started when the camera settled to Cherry Tree Lane," Myhre says. "All of that was clearly a design philosophy established by Walt's designers."

The filmmakers felt that the mood of the story evoked by their story line might benefit from a comparative/dualistic visual structure. Myhre explains, "It's set in 1934, during 'the Great Slump,' which was England's version of the Great Depression. Instead of just a beautiful storybook London, Rob wanted it to be a *real* London—with *real* problems and hardships. Then Mary Poppins comes in, bringing with her that wonder, the color, the fantasy and escape from those real-world issues.

"This approach also allowed us to look at using real London streets and locales," notes Myhre. "So, I got to go to London and scout locations, looking to see if there were streets that would be appropriate for our storytelling in London that we could convert back into the look of the 1930s."

"The locations are so rich, they almost became characters in themselves," John DeLuca says.

"One of the very first locations that we found is this lovely little serpentine street, King Charles Street, in an area called Queen Anne's Gate in Westminster," Myhre recounts. "It's got the most beautiful little pub you've ever seen set into it, and it looks so . . . London-y."

"The opening of the film is a charming musical number called 'Underneath the Lovely London Sky,' and it's really a kind of love letter to London," according to DeLuca. "That's what our design philosophy became, too. We start out on the embankment of the Thames, just as dawn is breaking; Big Ben and the Houses of Parliament are coming into view. Then we go down through the docks and riverfront, handsome shops and pubs, Tower Bridge, St. Paul's Cathedral, through a real park. The camera moves through all these real places, until we eventually end up on our lovely set for Number 17 Cherry Tree Lane."

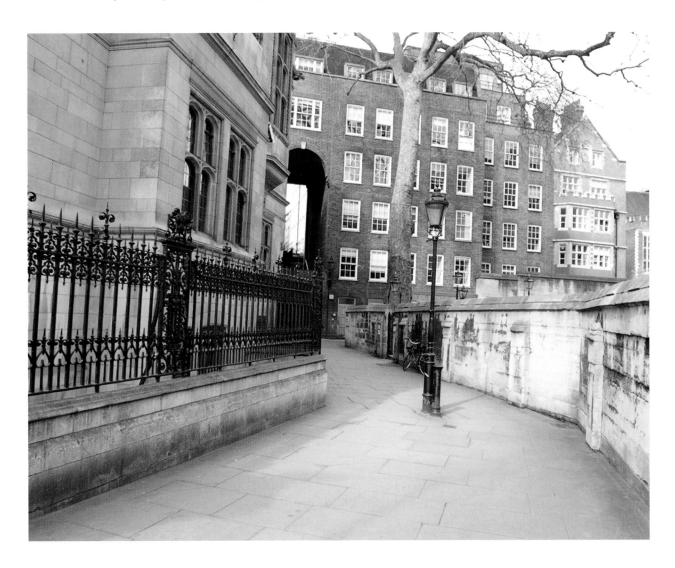

Cherry Tree Lane

" . . . right in the middle of Cherry-Tree Lane, where the houses run down one side and the Park runs down the other and the cherry-trees go dancing right down the middle."

One of Mrs. Travers's key complaints about Walt Disney's film was the opulence of the Banks house. The Tony Walton designs were certainly more theatrical, but were also meant to evoke a charm of fantasy and nostalgia.

"It ends up looking so upscale. Huge high ceilings, three-story houses, all beautifully and perfectly plastered, orderly, uniform. That feel just didn't set right with the second-generation Banks family of our story," John Myhre says.

"So, when we started doing drawings of the street, we tried to pull it down a little bit, so our houses are two-story houses. The ceiling heights don't disappear out of camera range; you catch a little bit of the ceiling, so you get a sense it's not quite as grand," points out Myhre. "And then we even decided not to plaster the whole house. In London at that time, the more expensive houses were skim-coated with beautiful white plaster. Less expensive houses were brick. We ended up plastering the bottom level and keeping the top of the houses on the street as exposed brick.

"Cherry Tree Lane was built on the biggest stage in Shepperton Studios, H Stage, and we took pains that the street had to look real—we had to make it *not* a perfect street. We had to have the broken curbs, and we needed to have all the sewer plates, and we needed to have worn potholes," Myhre explains.

What makes it so familiar as Cherry Tree Lane? The key to making it look like the street we all remember was the curve. "Something as simple as keeping the shape language makes it feel familiar," Myhre says. "Architecturally, the relationship of buildings to street to park is the same. Camera positons in several shots duplicated those of Walt's film. Staying in

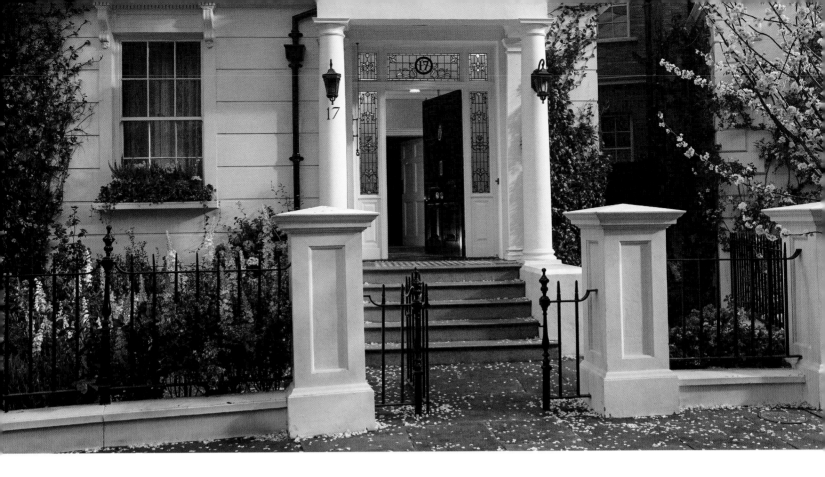

the shape and silhouette of things created a kind of living memory, a feeling of having been there before.

"Our goal was that when people see it they immediately feel that they're back on Cherry Tree Lane, "Myhre adds. "But it's a Cherry Tree Lane that's designed visually to tell the story that we're telling of 1934. That's the fun thing about what I get to do; being a production designer, you don't just draw up big, beautiful sets. You try to draw up sets that help to tell the story of the characters. We revisited the visuals of Cherry Tree Lane to better tell our story. That continued as we went inside."

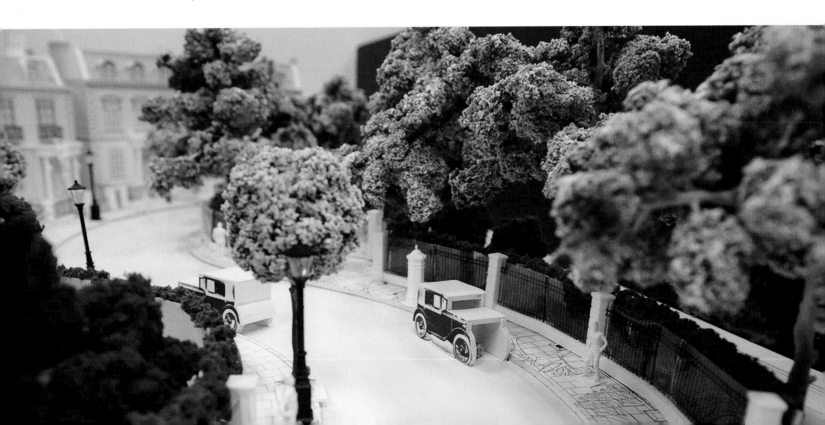

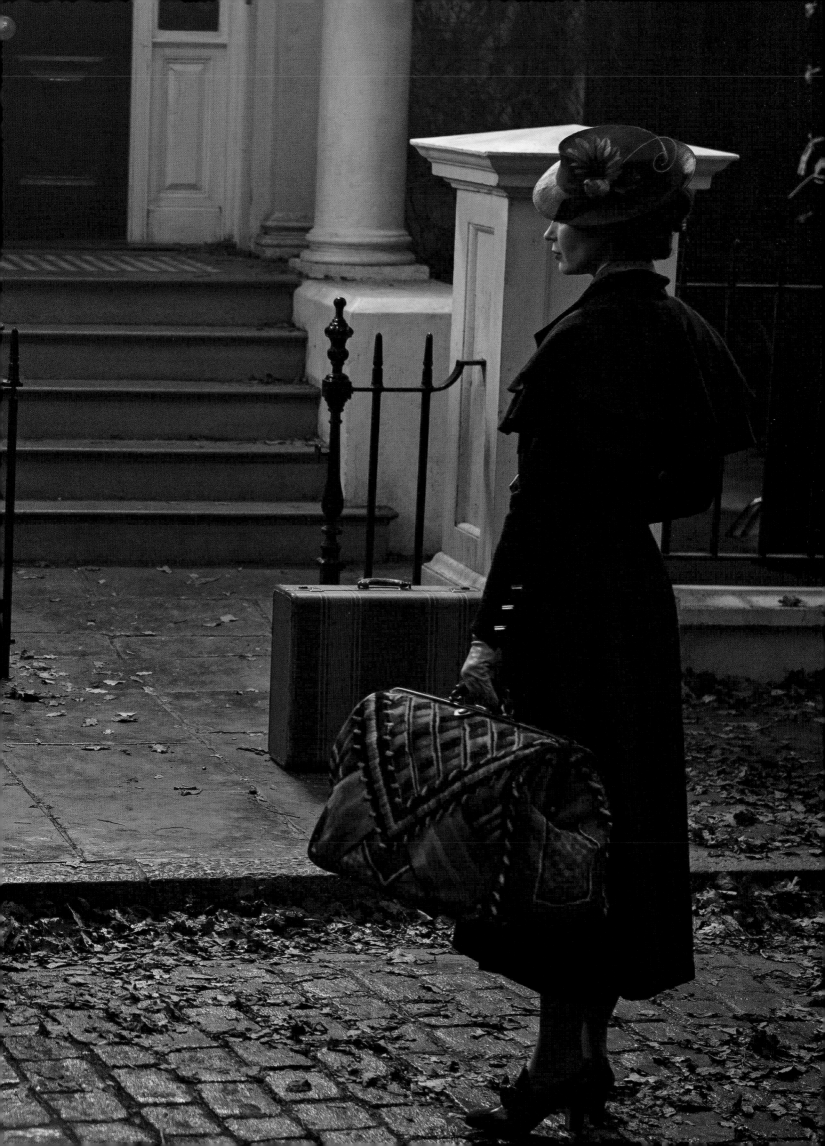

number 17

"To begin with, it is the smallest house in the Lane. And besides that, it is the only one that is rather dilapidated and needs a coat of paint. But Mr. Banks, who owns it, said to Mrs. Banks that she could have either a nice, clean, comfortable house or four children. But not both, for he couldn't afford it."

"The family stories, particularly the father's stories, are so different," says Myhre. "In *Mary Poppins*, George Banks is buttoned-down, authoritative, no-nonsense, and career-focused. It makes him come across as almost unloving or uncaring—not terribly connected to the children, emotionally absent.

"The design of the inside of the house reflects that, that everything is white, hard-surfaced, and feels sterile. When you look at the entry hallway, or the living room, or the dining room, you can't imagine the children ever being allowed in those spaces. The living room doesn't even have a sofa or comfortable place to sit," Myhre observes. "They are the places for the adults—and the children don't go there. But of course, that's there to serve the story, and that's the world that Mary Poppins comes into—and Tony Walton beautifully showed that story by creating that type of interior for his film.

"In our film, we meet Michael as an adult, the little boy who has grown up in the same house, he's been there his whole life," Myhre relates. George and Winifred have passed; Michael is an artist with three kids. He is deeply involved in the lives of his children. There is *no* room in the house the children *can't* go into, and there's evidence of children everywhere in our Number 17 Cherry Tree Lane, twenty-five years later.

"We wanted to make it comfortable and comforting, and we treated it almost like it's got a bit of a Bohemian flair to it," continues Myhre. In *Mary Poppins*, the parents were in charge of the house; in *Mary Poppins Returns*, the kids are in charge. So, we ended up putting in a lot more color, a lot more layers of time. It was never perfectly in order. It was always a little bit of, oh, a kids' book left here, or a toy left there. Maybe you'll notice their shoes tossed in a corner, kind of like it should be. So really, it's a place that the family enjoys living in *all* the rooms of the house. And that was expressed in the design of our film.

"Like the exterior, we used the same shapes, similar massing, and relationships of the rooms to each other, the same visual reminders that this *is* Number 17—but you'll feel something different that really adds textures and richness to the story."

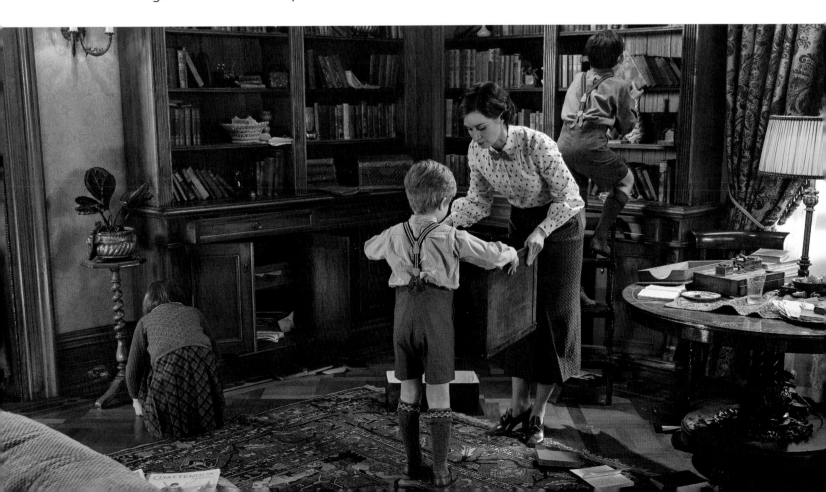

Trip a Little Light Fantastic

Motion, Music, Shapes, and Sets

"One of the most interesting things about working with Rob Marshall on a musical is that it's *all* about the music," production designer John Myhre says. "Whether he's talking to me as a production designer, or to costume designer Sandy Powell, or working directly with musicians or dancers, it's all about the music, the rhythm, the movement, and the *emotion*." Powell agrees, observing, "I think Rob thinks choreographically about every scene, even when there's *not* a dance number. That's what everything stems from."

Myhre continues, "One of the reasons I came onto the project so early was so that we could develop the major musical sets together, based on his vision for what would be happening on them musically. If you were to eavesdrop on an art department meeting with Rob and John, you'd almost think that he was talking to the choreographers and the composers as opposed to the visual creatives.

"Something we all agreed on early on was to avoid right angles, straight roads, and visual rigidity," Myhre emphasizes. "Except in the bank, where it really supports the story. Everything else we tried to keep kind of serpentine, with turns, forks in the roads. A visual movement.

"I've learned with Rob and John an idea of incorporating choreography into the architecture," Myhre points out. "This is kind of an obscure thing—even the leaded glass windows in the house are all curves and swirls, almost like dance moves. I tried to put in a lot of curves as architectural pieces, even down to the decorative elements of lampposts, and on signage—whenever we could get a sense of movement into the hard architecture we did. This notion goes along with the camera movements, and the way Sandy Powell's clothes move."

Making choreography come across on film can be very tricky. To capture the energy and motion of dance, the choice of moments where a camera observes, or a camera moves,

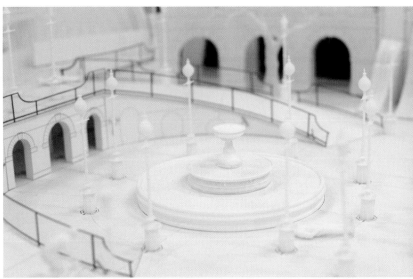

ABOVE: The Abandoned Park set was executed in a white foamcore model to bring dimensional understanding of the space for choreography and camera movement.

requires great thought and erudition. Moving performers *through* the field of vision rather than covering their dance in a static master shot—or cutting between both—requires attention to the music, the movement, the setting, and ultimately to the storytelling intent of all of these components.

"Jack, the lamplighter has a lot of time on a bicycle," Myhre points out. "With a lot of other filmmakers, you'd basically have Jack start at one end and just ride up the street. Maybe intercut a long shot from one end with a dolly shot following alongside. But with Rob, it's all about movement, interaction, character, and story enhancement through little subtleties. We put in a little food stall, let Jack roll around some apple bushels being off-loaded, cheekily test an apple, then toss it to someone standing in a food line. It wasn't just Jack riding down the street in a straight line, but rather moving in a *musical* way that's also telling a story, enhancing the richness of the setting, telling us more about the nature of the character."

Myhre further observes that Marshall "rehearses with his dancers before the actors come in, too. So, even some of the dramatic scenes, just physicality and movement, Rob's thought about already, so that when the actors come into rehearsals, he's got a really good sense of how he wants it to move. He brings in his cinematographer early, too—he's always watching to see how the actors are moving, or if the set suggests motion, or how the costumes are moving, or how or where the camera's moving. It's all a bit of a ballet. Literally and figuratively."

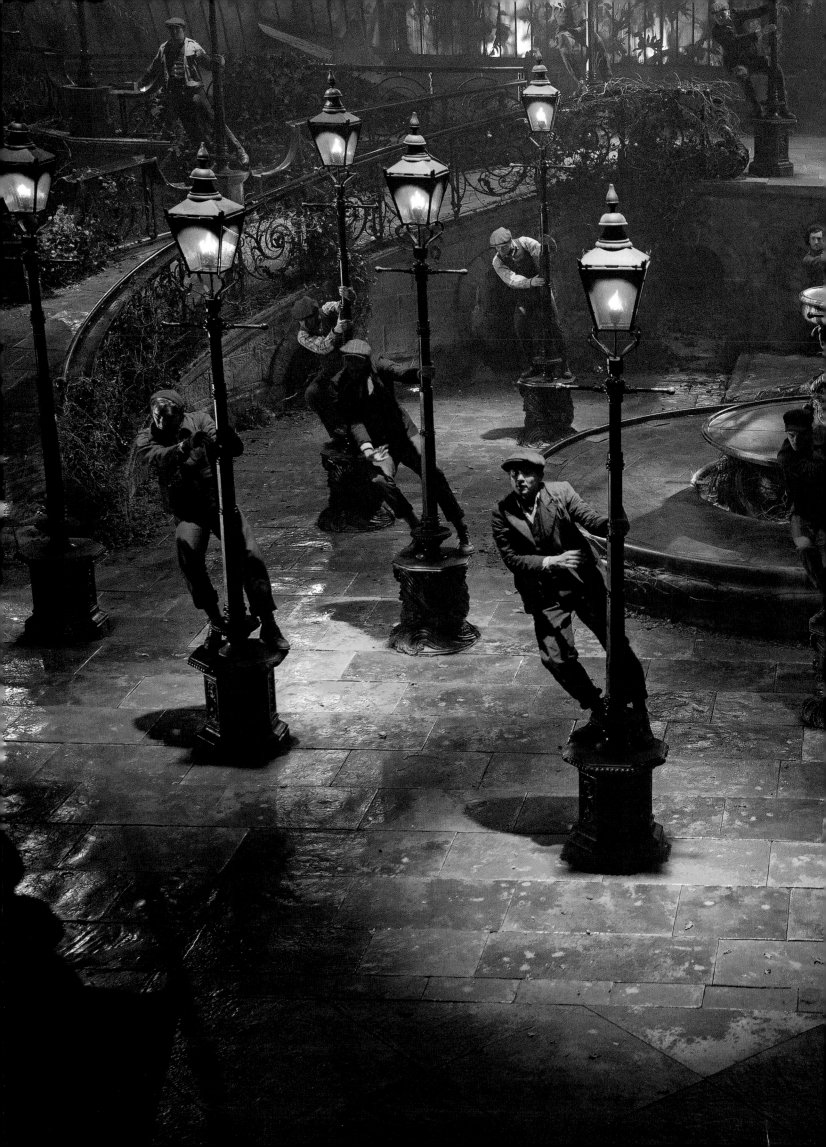

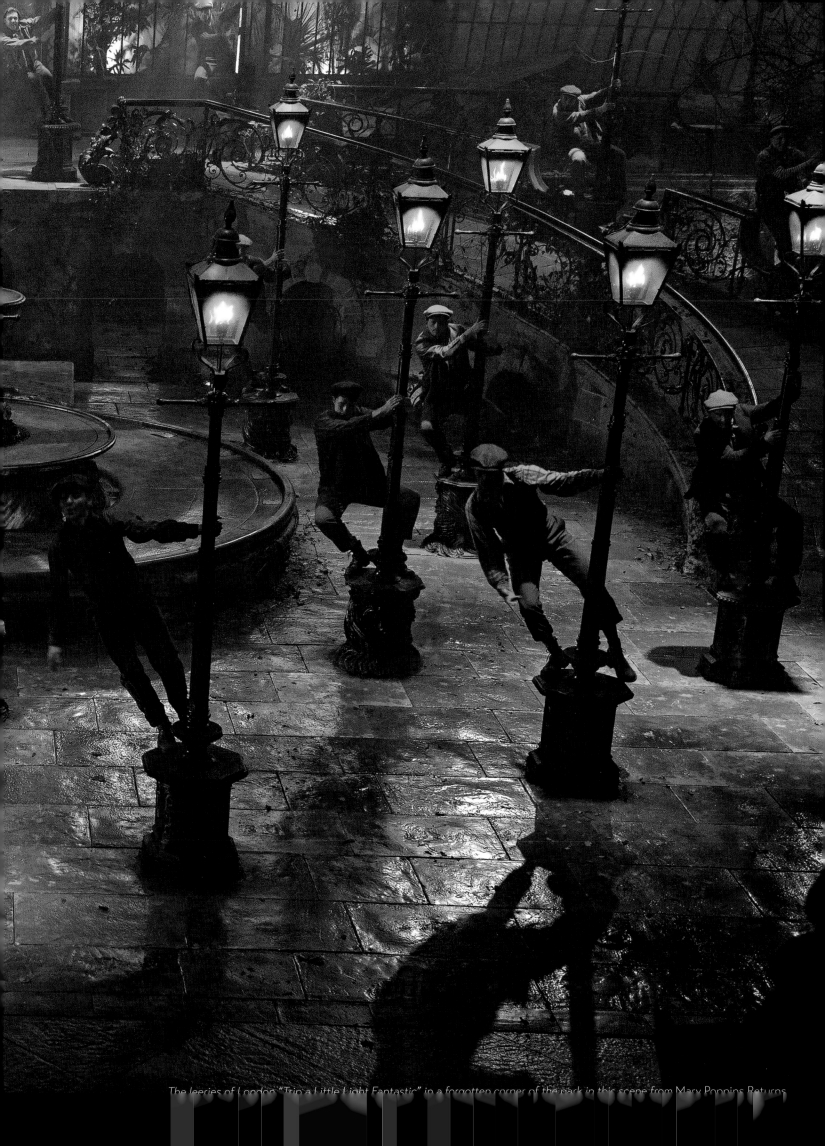

The leeries of London "Trip a Little Light Fantastic" in a forgotten corner of the park in this scene from Mary Poppins Returns.

Emily Blunt

as Mary Poppins

Emily Blunt, in a remarkably brief span of time, has become one of the most varied, prolific, and honored actors in the world. She had planned on a career as a live translator for the United Nations, but fate clearly had another path in mind.

After gaining attention in a student production at the 2000 Edinburgh Fringe Festival, she was cast in a London West End production of *The Royal Family*. Since then, Blunt has moved easily between stage, screen, and television work. She has appeared in TV productions such as *Foyle's War*, *Empire*, and a Golden Globe-winning role in *Gideon's Daughter*. Film projects have included *My Summer of Love*, her breakthrough popular role in *The Devil Wears Prada*, *The Jane Austen Book Club*, *Charlie Wilson's War*, *Sunshine Cleaning*, *The Young Victoria*, *Edge of Tomorrow*, *Into the Woods*, *Sicario*, *The Huntsman: Winter's War*, *The Girl on the Train*, and *A Quiet Place*.

"The only person we could think of to step into the shoes of Mary Poppins was and is Emily Blunt," Marc Platt says.

"Rob Marshall called me in the summer of 2015," Blunt recalls. "He pitched me the idea of doing Mary Poppins, and I was slightly blown away by the whole idea of it."

The actor was encouraged by her experience with Marshall and John DeLuca on *Into the Woods*—and by the trust being placed in them by Disney. "It's a great credit to Rob and John that Disney handed one of their most precious properties over to them," Blunt says. "He's approached it all with such elegance and finesse, and paid homage without it being derivative."

Blunt adds, "Rob has this incredible celebratory way of making you feel like you can do anything." Yet, she approached the role with a degree of caution. "I feel a little more trepidation . . . because she's so emblematic of people's nostalgia," Blunt says. "It's such an important character in people's childhood."

Towards that end, Blunt thoroughly assessed her approach to the famous nanny. "I looked into the books a lot more," she explains, "which is a different version of the character. There's a slightly sharp edge to her in the books. She's a bit mean. But my idea of her is that there's a comforting feeling in this magical way she flies in and sweeps everything up and she makes it right again. She takes no credit, she asks no reward. I remember taking great comfort in that as a child.

"But I love that stern part of her," the actor admits. "I think the idea of holding the children at arm's length to a certain extent benefits her, because she's not trying too hard. She is just thrilling for the children to be around, and that's enough. She's like a rare bird, they just can't help but follow her. They want to be around this light that has entered into their lives at a dark and fragile time."

Marc Platt says, "The thing about Emily is, of course, she's an actor of tremendous ability and craft who is really performing at the very, very top of her game. She sings beautifully, and she is decidedly authentic to this world, and to this character. There's no contrivance to it. It is completely organic. She makes it her own, and she's quite sublime."

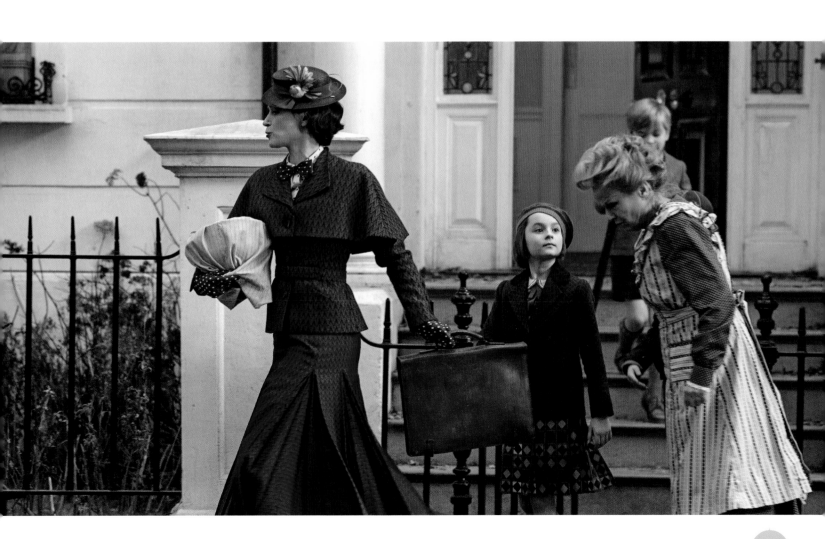

EAST WIND

Lin-Manuel Miranda

as Jack

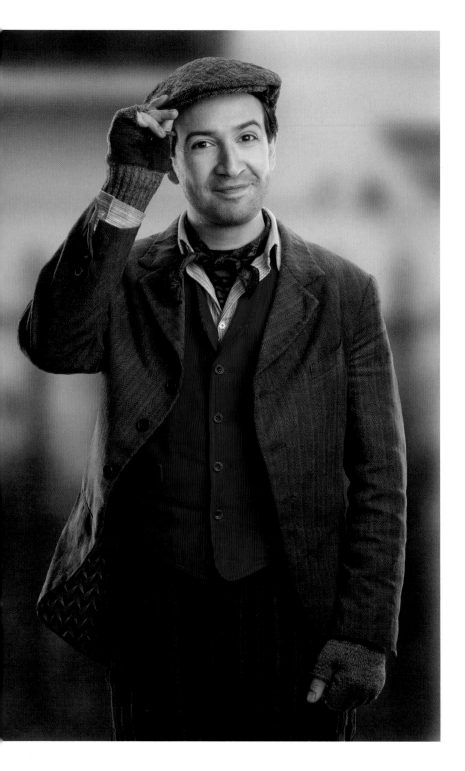

Lin-Manuel Miranda was doing a two-show day of his Broadway smash *Hamilton* when Rob Marshall and John DeLuca asked him if he could pop across the street between performances to talk about an idea they had.

"They said, 'Emily Blunt is Mary Poppins,' and I was basically in from that moment on," he confesses.

Award-winning composer, lyricist, and performer Lin-Manuel Miranda is probably most well-known for the blockbuster Broadway hit musical—with book, music, and lyrics all by Miranda (in addition to originating the title role). *Hamilton* was awarded the 2016 Pulitzer Prize for Drama and earned a record-breaking sixteen Tony nominations, winning eleven of the awards, including two for Miranda, for Book and Score of a Musical. He is also a 2015 MacArthur Foundation Award recipient. The Original Broadway cast recording of *Hamilton* won the Grammy for Best Musical Theater Album. Both Mr. Miranda and *Hamilton* won the 2016 Drama League Awards for Distinguished Performance and Outstanding Production of a Musical, respectively.

Miranda's first Broadway musical, *In the Heights*, won four Tony Awards (including Best Orchestrations, Best Choreography, and Best Musical), with Miranda receiving a Tony Award for Best Score, as well as a nomination for Best

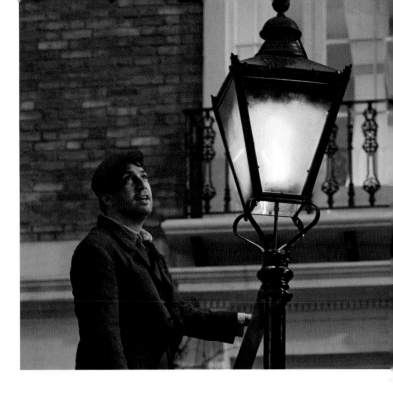

Leading Actor in a Musical. *In the Heights* also took home a Grammy Award for its original Broadway cast album and was recognized as a finalist for the Pulitzer Prize in Drama.

Miranda contributed music, lyrics, and vocals to several songs in Disney's feature film *Moana*, earning him an Oscar nomination and Grammy Award for the original song "How Far I'll Go."

He has appeared on TV in a range of projects from *The Electric Company* and *Sesame Street* to *The Sopranos, House, Modern Family, How I Met Your Mother,* and *Curb Your Enthusiasm.* Feature film work includes *The Odd Life of Timothy Green, 200 Cartas, Speech and Debate,* and *Moana.*

"In *Mary Poppins Returns*, I play Jack," Miranda says. "He's a lamplighter—a job that's not around anymore but was once one of those iconic London sights. These were the guys who took care of all the gaslights in London—they turned them on in the evening, and off again in the morning; but in their way, they became as much a part of the fabric of a neighborhood as the residents and their children and the bobby on the beat. There's something magical about the job, though, 'bringing light to London,' and I think that's something Jack does well. He goes on these incredible adventures with the Banks children and Mary Poppins, and he brings light to a dreary world.

"In the adventures of Mary Poppins," Miranda continues, "there are a few people she seems to know. Relatives usually, such as Uncle Albert or Cousin Topsy. But she knows Jack, they seem to have a familiarity that Mary doesn't share with others. Jack seems about the same age as Jane and Michael and seems a bit smitten with Jane. And we do learn briefly in the story that Jack apprenticed as a youth to an old friend of Mary's, a peculiar and beloved jack-of-all-trades named . . . Bert."

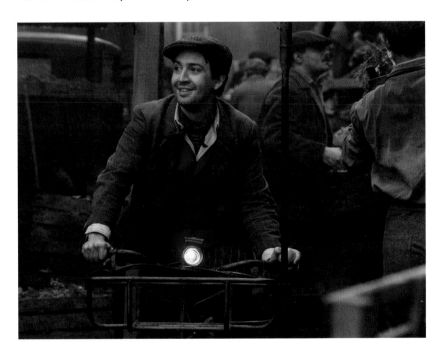

EAST WIND

Ben Whishaw
as Michael Banks

"Michael Banks is played by an actor by the name of Ben Whishaw," Marc Platt says. "He's well-known for the Bond movies, but his work goes way beyond that."

Whishaw is known on British television for *Nathan Barley*, *Criminal Justice*, *The Hour*, and *London Spy*; his varied film projects include *Perfume: The Story of a Murderer*, *I'm Not There*, *Bright Star*, *Brideshead Revisited*, *Cloud Atlas*, *The Lobster*, *Suffragette*, and *The Danish Girl*. He has played "Q" in the James Bond films *Skyfall* and *Spectre*, and has been the voice of Paddington Bear in *Paddington* and its sequel.

The actor is philosophical about playing the grown-up version of a character people know only as a child. "There's something lovely about revisiting these two people that an audience has seen as children, and rediscovering them as adults with all the problems and stuff that life inevitably throws at you.

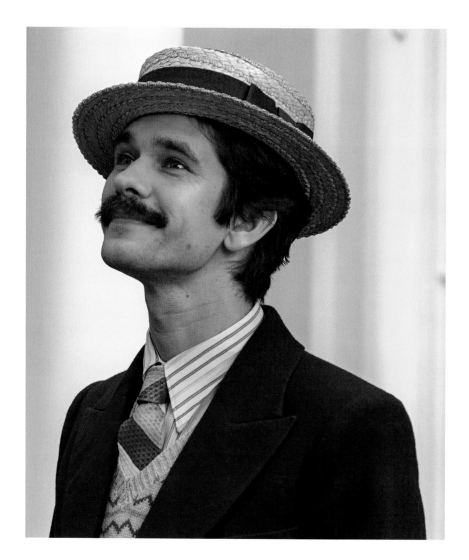

"He's struggling to cope with looking after three children on his own," Whishaw explains, "so he's trying to be very upright and English and not betray any stress or insecurity. But actually, everything is going completely wrong for him."

Marc Platt is enthused about Whishaw. "Ben is an extraordinary actor on his way to becoming a star."

Emily Mortimer

as Jane Banks

"She's inherited the mantle of her mom, and she's very socially conscious—and wears trousers, which is quite a big thing for a 1930s girl," says Emily Mortimer of her role as a grown-up Jane Banks.

Actor and screenwriter Emily Mortimer was in an Oxford University student production when spotted by a television producer who cast her in the 1995 adaptation of *The Glass Virgin*. She made her feature film debut in 1996 alongside Val Kilmer in *The Ghost and the Darkness*. She has worked continually since then, appearing in *Elizabeth*, *Notting Hill*, *Love's Labour's Lost*, *Match Point*, *The Pink Panther* and *The Pink Panther 2*, *Lars and the Real Girl*, *Shutter Island*, and *Hugo*, as well as the acclaimed HBO series *The Newsroom*. She has won two BAFTA Film Awards and four BAFTA TV Awards, plus received the BAFTA Fellowship in 2014.

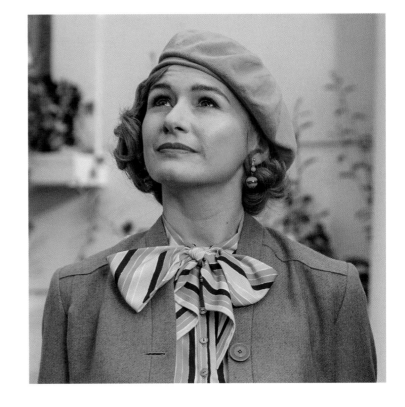

"She lives alone in a little flat, and she's given her life to the cause," Mortimer says of her Jane. "She's a looker-after of people, and so she's desperately trying to cheer Michael up and get him back on track. But she's kind of a child, too," adds Mortimer. "She's a little bit too ditzy and disorganized to be much help. She's a very loving soul who gives herself to other people but doesn't think too much about herself. They're both infantile in a way, like their parents, and in need of help themselves."

Mortimer is pleased to be adding to the Mary Poppins cinematic story. "We know who Jane and Michael's parents were, because they were living and breathing on celluloid before we were even born, just how it is in real life. And on the one hand, that might be daunting because they're all iconic characters; but on the other hand, you feel as if you've lived this life. I remember these people. I recognize them. I remember Jane's and Michael's childhoods almost as if they were my own. Because in some ways, they were."

Julie Walters

as Ellen, the Housekeeper

Julie Walters plays the role of Ellen, the longtime housemaid in the Bankses' home.

Dame Julie Walters, DBE, worked in regional theater, stand-up comedy, and cabaret before her breakthrough West End role in *Educating Rita*, which she reprised on film with Michael Caine. It earned her an Academy Award nomination for Best Actress and won her a BAFTA and a Golden Globe Award. She received a second Academy Award nomination, this time for Best Supporting Actress, for her role in the film *Billy Elliot*, which also won her a BAFTA. Her other film roles include *Personal Services*, *Prick Up Your Ears*, *Buster*, *Stepping Out*, *Calendar Girls*, *Mamma Mia!* and *Brave*. She also played Molly Weasley in seven of the eight Harry Potter films.

Onstage, she won an Olivier Award for Best Actress for the 2001 production of *All My Sons*.

"Ellen has been at Number 17 for a very long time," Walters says. "She was the housekeeper as Jane and Michael grew up, and now times are hard in the Banks household. They've got very little money, but she's trying to deal with everything and finding it a bit difficult. She's also a little bit forgetful, a little bit confused on occasion!

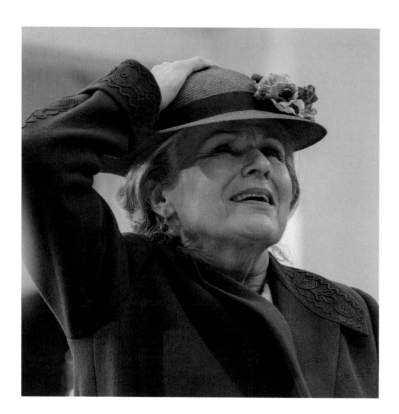

"It was perfect for me. I can't think why, me being so glamorous! But it was, and great fun. The fact that she's always crashing about in the kitchen, and the distant sound of breaking crockery, and all of that. I just loved it and she's also got the best lines in the script."

Walters feels refreshed with *Mary Poppins Returns*. "There is a spirit of the child in all of us. There definitely is. That's the essence of the film, really. There is a sense of that, and the fun of it, and the magic it will make—they stimulate the child in you."

Colin Firth

as William Weatherall Wilkins

"I remember feeling quite excited when I heard they were doing a Mary Poppins," Colin Firth says. "When the part came my way, I was thrilled . . . as soon as it worked out it felt like the right shape going in the right hole—it just had an almost inevitability about it."

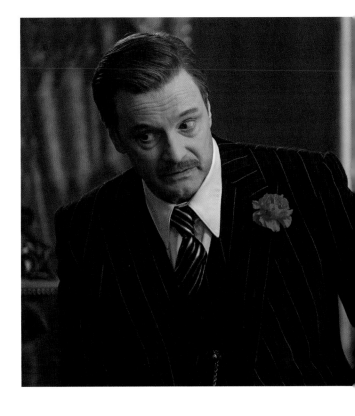

By the time he was fourteen, Colin Firth had already decided to be an actor, having attended drama workshops from the age of ten. He joined the National Youth Theatre at eighteen, later working in the wardrobe department at the National Theatre. He made his film debut in *Another Country* in 1984, then appeared in numerous television miniseries and movies, including *Shakespeare in Love*, *Bridget Jones's Diary*, *Love Actually*, and *A Single Man*. In 2010, Firth portrayed King George VI in Tom Hooper's acclaimed *The King's Speech*. Firth has received an Academy Award, a Golden Globe Award, two BAFTA Awards, and three Screen Actors Guild Awards.

In *Mary Poppins Returns*, Firth plays William Weatherall Wilkins, now head of the Fidelity Fiduciary Bank where George Banks was once a partner.

"Some scripts surprise you when you actually speak the lines, when you apply it," Firth says. "Sometimes it's disappointing. Sometimes you think it's wonderfully written, but once it's in action something doesn't just lift off the page as easily as you'd hoped. This was the opposite. It already looked good, but I was amazed at how much fun it was to actually speak these lines and interact with the other people."

Rob Marshall enthuses, "I've been wanting to work with Colin Firth for a long, long time, and he is so funny and so special. He is a consummate actor and an extraordinary gentleman—and was so enthusiastic about being a part of this film."

Firth, in turn, has been delighted to *be* part of it, too. "Rob Marshall projects a kind of atmosphere into the room which not only makes people feel comfortable, it creates a happy environment."

Meryl Streep

as Cousin Topsy

"The great Meryl Streep joined us," Marc Platt says, "playing a new character [who] originated from P. L. Travers's book, a distant cousin of Mary Poppins, who lives in an upside-down world."

Meryl Streep is simply a legend—her roles and achievements on stage, screen, and television are too numerous to recount, and she has been widely acknowledged as "the best actor of her generation." Nominated for a record twenty-one Academy Awards, she has won three; Streep has also received thirty-one Golden Globe nominations, winning eight—more nominations and competitive wins than any other performer in history.

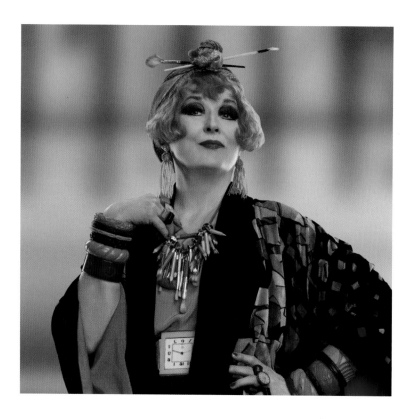

Streep was awarded the AFI Life Achievement Award in 2004, the Gala Tribute from the Film Society of Lincoln Center in 2008, and a Kennedy Center Honor in 2011 for her contribution to American culture through performing arts. President Barack Obama awarded her the 2010 National Medal of Arts and the Presidential Medal of Freedom in 2014. In 2003, the government of France made her a Commander of the Order of Arts and Letters. She was awarded the Golden Globe Cecil B. DeMille Award in 2017.

"This is my third film with Meryl Streep," Emily Blunt says. "She's just constantly reinventing herself; you can't wait to see what she's going to do next because it's always something completely unique, and singular, and thrilling, and 'out there.' This was no exception."

"Meryl Streep immediately said she wanted to be a part of this," Rob Marshall states. "She said, 'I want to send this out into the world.' She calls it a gift."

The Banks Children

"I suppose the film is about the way these children have become little adults and are really looking after Michael, although he doesn't realize that," says screen patriarch of the Banks household, actor Ben Whishaw.

Pixie Davies (Annabel Banks) has starred in many notable films and TV series, including *Roald Dahl's Esio Trot*, *The Secret of Crickley Hall*, *Out of the Dark*, *The White Queen*, *Humans*, and *Miss Peregrine's Home for Peculiar Children*. **Joel Dawson** (Georgie Banks) is making his screen debut in *Mary Poppins Returns*, and **Nathanael Saleh** (John Banks) started his acting career at age five as a member of a youth theater group in Warwick, England, in a staging of *O.U.T. Spells Out*. At age eight, he began to audition for film and television, leading to his appearance in *Game of Thrones* in 2016.

Whishaw positively glows with pride over his on-screen children. "The kids each bring their own beautiful, anarchic, sparkly personalities to their characters. Little Joel is a law unto himself, which is wonderful. And Nathanael and Pixie are very mature and have a wonderful, serious quality about them. They're completely, alarmingly on top of everything and know everyone's lines—which is very much the characters they're playing."

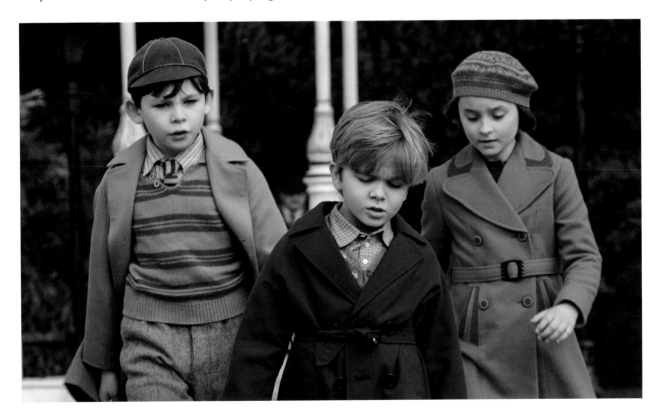

David Warner

as Admiral Boom

David Warner is perhaps best known for playing sinister characters and villains onstage and in, film, television, and even video games. In *Mary Poppins Returns*, Warner discards that wicked persona to assume command of Cherry Tree Lane as Admiral Boom, he of the shipshape house next door to Number 17.

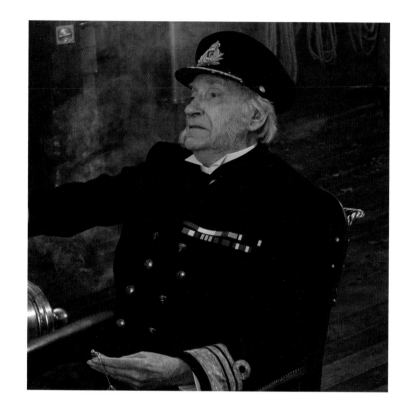

Warner is renowned for his work in such films as *Tom Jones*, *The Ballad of Cable Hogue*, *The Omen*, *Holocaust*, *Time After Time*, *Time Bandits*, *Tron*, and *Titanic*. He's well-known for his appearances in the Star Trek universe, including *Star Trek V: The Final Frontier*, *Star Trek VI: The Undiscovered Country*, and *Star Trek: The Next Generation*.

In 1981, Warner won an Emmy Award for Outstanding Supporting Actor in a Miniseries or Special for his portrayal of Pomponius Falco in the television miniseries *Masada*. And every holiday season, Warner sheds his more ominous screen identity, as audiences revisit his portrayal of Bob Cratchit in the 1984 adaptation of *A Christmas Carol* starring George C. Scott.

Jim Norton

as Mr. Binnacle

When asked what he would be if he were not an actor, Olivier– and Tony Award–winning performer Jim Norton smiles as he replies, "Desperately trying to be an actor."

Norton has been acting since he was ten years old, from radio plays as a child to guest roles on TV shows such as *Father Ted*, *Cheers*, and *Frasier*, to the feature films *Straw Dogs*, *The Boy in the Striped Pajamas*, and *Water for Elephants*, and award-winning Broadway plays such as *The Seafarer* and *Finian's Rainbow*. Having appeared in almost a hundred different films and television shows since 1965, and numerous plays before and since then, Norton is one of Ireland's best-known character actors.

In *Mary Poppins Returns*, Norton is on deck in the role of Admiral Boom's first mate and one-man crew, Mr. Binnacle.

After more than six decades as a performer, Norton remains grateful for his successes and

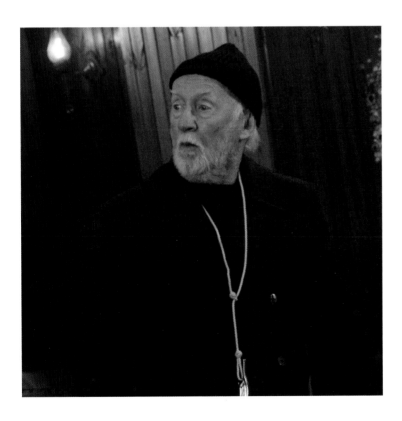

appreciative of his craft. "My grandmother, she used to say, 'It's all about what the fairies leave in the cradle,' which is a wonderful way of saying you either have it or you don't." He then adds, "She said, 'There's very little you can't do if you really want to do it and you're prepared to work hard.' I've always remembered that."

Angela Lansbury
as the Balloon Lady

In a career spanning seven decades, prolific, diverse, legendary, and iconic Angela Lansbury has appeared in theater, television, and film productions, as well as been a producer and singer. Her wide-ranging work has attracted international acclaim practically since she began performing.

Lansbury's achievements on stage, screen, and television are too numerous to recount, but she has received an Honorary Oscar, plus accrued five Tony Awards, six Golden Globes, and an Olivier Award. She has also been nominated for numerous other industry awards, including the Academy Award for Best Supporting Actress on three occasions, and various Primetime Emmy Awards on eighteen occasions. She is the recipient of the National Medal of Arts, the Kennedy Center Honors, and was named a Commander of the Order of the British Empire by Queen Elizabeth II in 1994 and a Disney Legend in 1995.

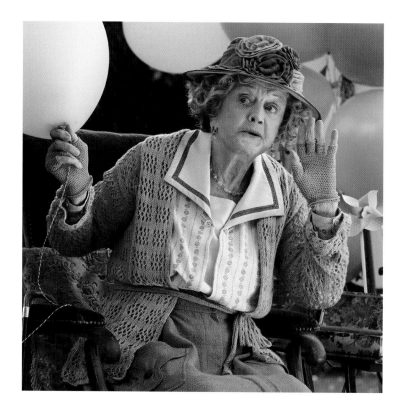

"I'm considered one of the Disney family because of *Bedknobs and Broomsticks* and *Beauty and the Beast*," the fabled star explains.

Lansbury appears in a cameo near the end of the film as a balloon vendor in the park. "There's a lot more to the Balloon Lady than just selling balloons," the renowned actor hints knowingly. "She's a sort of magical character. There's something a little bit mysterious and interesting about her, and that appealed to me. Mystery is my business, you know," the longtime star of *Murder, She Wrote* said with a wink.

"I was delighted to be included in *Mary Poppins Returns*, quite frankly," Lansbury states.

Dick Van Dyke

as Mr. Dawes, Jr.

Dick Van Dyke is a true American legend. His entertainment career has spanned seven decades and every medium. He first gained recognition on radio and Broadway; then he became a household name for the *The Dick Van Dyke Show*, which ran from 1961 to 1966. He starred and showed off his versatility in the musical films *Bye Bye Birdie, Mary Poppins*, and *Chitty Chitty Bang Bang*. Other important film roles include *The Comic, Dick Tracy, Curious George, Night at the Museum*, and *Night at the Museum: Secret of the Tomb*. In addition to *The Dick Van Dyke Show*, Van Dyke has also starred in other TV series including *The New Dick Van Dyke Show, Diagnosis: Murder*, and the Murder 101 film series for the Hallmark Channel.

Van Dyke has won five Primetime Emmys, a Tony, and a Grammy Award, and was inducted into the Television Academy Hall of Fame in 1995. He received the Screen Actors Guild's highest honor, the SAG Life Achievement Award, in 2013, has a star on the Hollywood Walk of Fame, and has been named a Disney Legend.

Van Dyke returns in a cameo appearance in *Mary Poppins Returns*, playing the son of the elderly bank executive he played in *Mary Poppins*.

"Dick Van Dyke said that the thing he remembers the most about doing the original film was the spirit," Rob Marshall says, "and he said, 'It's exactly the same spirit here.' He was right here on Cherry Tree Lane and he said, 'I feel like I'm home.'"

A Conversation...

with Sandy Powell Regarding the Costumes of Mary Poppins Returns

"I think Walt Disney's *Mary Poppins* is the first film I remember ever seeing in the cinema," Sandy Powell says. "I think because of that, when I got an e-mail from Rob Marshall saying straight on, 'I'm going to do a Mary Poppins film, and would you be interested in meeting about it?' the challenge of that was a most exciting prospect."

British costume designer Sandy Powell was a student at the Central School of Art and Design in London, but left before completing her degree, due to offers of work from noted designer Derek Jarman and others. The designer is often associated with Martin Scorsese, having designed six of his films (including *Gangs of New York*, *Hugo*, and *The Wolf of Wall Street*), and with Todd Haynes, for whom she designed four films, including *Far from Heaven* and *Wonderstruck*.

She has won three Academy Awards for Best Costume Design—for *Shakespeare in Love*, *The Aviator*, and *The Young Victoria*—and has been nominated twelve times for the Oscar. She has also received thirteen BAFTA Award nominations, winning for *Velvet Goldmine* and *The Young Victoria*. Powell was appointed Officer of the Order of the British Empire (OBE) in the 2011 New Year Honours list for services to the film industry.

Powell didn't just join a group of filmmakers; like her colleagues, she found herself in a league of remarkable *storytellers*, every craft and discipline committed to the Mary Poppins mythos, and engaged in their expertise to support the cinematic storytelling. Her first challenge was similar to John Myhre's: find both the beauty and the grit of a truthful 1930s London, and weave in the fantasy of Mary Poppins and her culture.

"Rob did want the real world to look fairly realistic, so I tried to achieve that. But then I do like to inject little bits of color, because I think it would be rather dull to look at if it really was completely monochromatic and gray, in the way that people sometimes imagine Depression-era films to look. I had to balance doing 'down-looking,' but with elements of boldness. In that way, we have a starting point when we get to the fantasy sequences, which really are an explosion of color.

"Our research involved looking at street photography of the 1930s—there's a lot of street photography in this period," Powell reflects. "We also have ready access to original clothing from the period. A lot of our extras in the street scene are wearing actual, original 1930s clothing, which we were able to find in vintages stores or hire from rental companies.

"Unfortunately, using original clothing means that it has been worn for years and years and years, therefore looking too old for what is supposed to be fairly new clothing at the time, so we have to be selective and only use things that will stand up to close scrutiny. There is also a department that I work with on every job, whatever the project is, who are textile artists. They dye a sort of movement of color into the fabrics, which can give depth and help make something look worn out naturally. They use various techniques of dyeing, painting, and spraying to get newly made costumes to look worn and old, greasy or dirty, or simply and subtly well-worn."

In the same vernacular as the Londoner she dressed, Powell needed to costume Jack and his leerie friends, yet create a special something *extra* for the sake of their character and story role.

"They're working men, they're working-class men," Powell explains, "when you

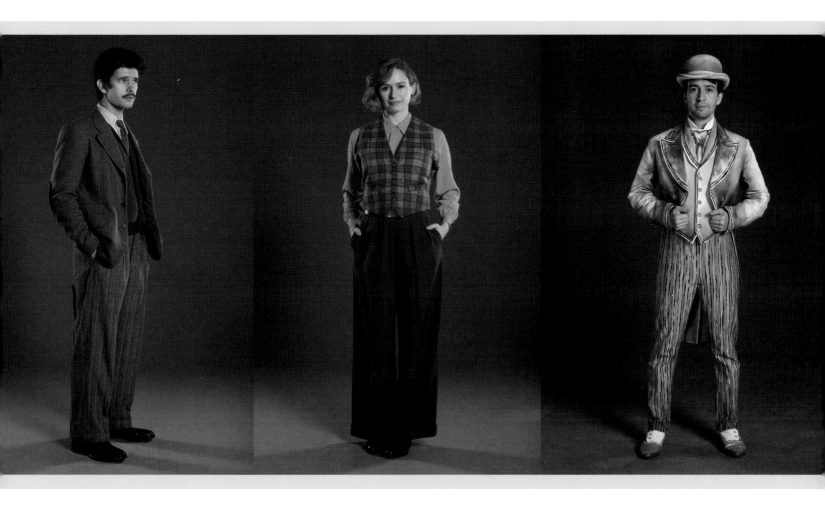

look at the reference pictures of all these guys, whether they are chimney sweeps or lamplighters, or road sweepers, they're quite often in what looked like old suit jackets which could have once belonged to their fathers' old suits and handed down; sometimes their look is a decade or more behind the style.

"The clothes for Jack and all of the leeries all had to be made from scratch, because they are all dancing, and they need multiples, and we then had to make everything look like it had been worn for years and years," Powell says. "I didn't actually want to put them in just gray suits, or brown or dark blue, which were the prevailing colors for menswear in 1934. I needed to inject a little bit of color since it is a musical after all!"

Powell revealed what was then done to get the authentic look: "Elements of color were infused into their suits—the waistcoats, or undershirts, or neckties and neck rags. I also had to bear in mind that although these clothes had to look authentically like working men's clothes, they had to work as dance costumes.

"For instance, we tested Lin-Manuel Miranda in a differently shaped jacket. It was a shorter jacket, and it really *looked* great, it really suited him," Powell related. "But when we did the camera test, Rob [Marshall] noticed that it didn't have much movement to it. So, we slightly backdated it to a slightly earlier period, with a cut called a swallowtail, so that when he moved, there was some movement in the back of the jacket as opposed to just being a straight cut."

For the fantasy sequences, Powell wanted to somehow resolve the problem of the live-action performers feeling removed from the animated characters, the sense live actors have of being placed on top of artwork.

Powell explains, "I wanted to help to make our live actors work more seamlessly with the animated characters. And I thought, *Why not try to make the costumes appear as if they'd been painted by the animation artists in the same style as the animation art?*

"I didn't really know what the animation was going to look like, so I contacted the team, who were at the early stages of designing the

animation, which is a very hand-drawn and hand-painted style for our film," Powell says. "I needed to see some examples of how they drew, the kind of lines that they used, the technique of background painting.

"I translated what I saw into a feel where you can see the white of the fabric coming through hand-painted colors, like the watercolor on top of paper. I started by experimenting on different textures of material, fabrics that you would normally paint on. After weeks and weeks of prototyping and experimenting with the same department who worked on all of the breaking down and the painting of the costumes for the leeries, I think we were able to bring the costumes a two-dimensional feel of having been painted into the scene in a way.

"The costumes came first, and then everything else—the backgrounds, design for the animated characters, the color palettes, and the style of their clothes followed the theme that had already been established with our wardrobe," continues Powell. "We were working in tandem with the animators, but building the costumes first. The whole color scheme for the animated part of the film came from the colors of the costumes after consultation with the production design team and animators. The color palette is much bolder and brighter and more 'summery,' I suppose, than any of the other colors in the rest of the film. It's a fantasy sequence, we *need* to dive into a world of color.

"Within that same sequence we have the music hall scene," Powell adds. "Mary Poppins and Jack perform a vaudeville number. For that, Rob had very specific ideas of what he wanted, based on the choreography, which was already in his head. The colors for this number needed to be bright and bold. I didn't want to do dark colors, and I'd already done all the pastel colors. It was Rob who actually suggested bright pink. I did the purple to go with that. It's not colors I would normally use in everyday life, but I think considering this is the theater moment, the musical moment, it worked incredibly well."

The iconic Mary Poppins costume was

probably not the hardest thing to do, Powell feels, but it was the most daunting task. "It came down to creating a new version of Mary Poppins," the designer says. "Not a *different* Mary Poppins, but a new version of the same character. Everybody knows what Mary Poppins looks like. I certainly remember what she looks like. It's just one of those images that sticks in your head and has been duplicated and drawn and parodied so often. Over a dark coat, a navy coat—which was traditional for nannies—belted. Long, just above the ankle. And there's the hat.

"What I wanted to do with the new Mary Poppins was pay homage to that, but do something different," Powell shares. "Fortunately, for the period that we're set in, the fashion for women at that time was a *longer* length, and not a million miles away from the shape that Julie Andrews wore as Mary Poppins. So, I had the silhouette, but I wanted to change it slightly and I came up with the idea of a cape. In fact, a double cape. I just had it in my head that that's what I wanted to do, I wanted to give Mary Poppins a cape. And what it actually does is provide a very strong silhouette from a distance, but it also creates movement.

"Then secondly, the color," Powell says. "Traditionally, a nanny wears blue, but I didn't want to go as dark as navy blue because it reads as black on camera, and I didn't want her to feel so severe. I needed to find a blue that would work, that would be dark enough from a distance and not be too frivolous, but up close we could actually see that it's a bright blue.

"The next thing that I had to figure out was Mary Poppins's hat. She had to have a hat because in the 1930s, all women wore them and a nanny should definitely wear one," Powell says. "Rob wanted something similar to the original and wanted to achieve the same effect of eccentricity with a little touch like the flowers that Mary Poppins had on her hat. I didn't want to do flowers. For some reason, flowers don't strike me as being appropriate for our Mary Poppins. I wanted *something*, but was thinking perhaps we could do a bird, because birds are traditionally used to

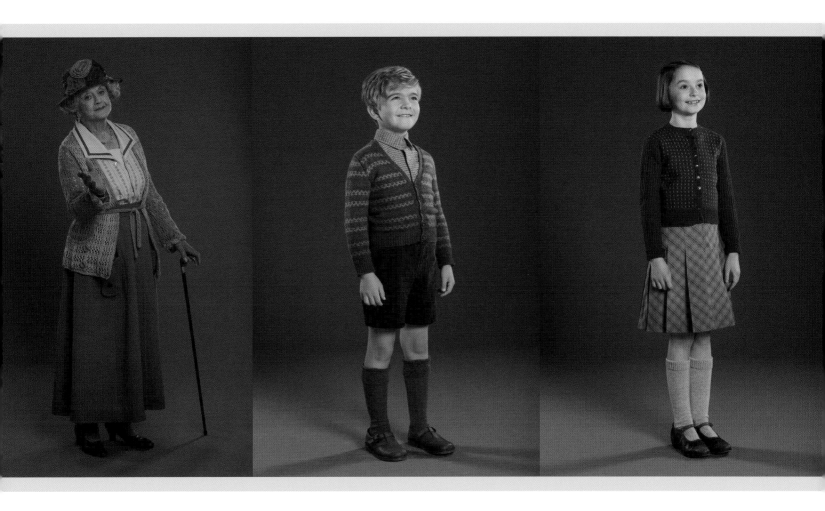

decorates millinery, particularly in the earlier periods. I thought using a stuffed real bird, which although historically accurate, would be wrong."

Powell focused on resolving the issue. "I played around with different versions of birds, and then came up with the idea of a robin, having remembered the robin from 'A Spoonful of Sugar' in Walt Disney's [*Mary Poppins*] film. The robin is actually on the end of a hatpin, so that when Mary Poppins takes her hat off, she takes the robin hatpin out. And then she can also use that same hatpin with the same robin on a hat in a different color that we see later in the film.

"It was also necessary to work with the props department over the design of the carpetbag, because obviously she carries it with her the whole time—and whatever the bag is, it has to work with the costume," Powell recounts. "It doesn't have to *match* the costume, but it has to not fight it. So, set decorator Gordon Sim and property master Ty Teiger came to me, and we all agreed that looking at art deco carpet from the period

would be an interesting way to go. I liked what they came up with, because I liked the 'boldness' and 'graphic-ness' of it. I liked the patterns that work well with the geometric patterns that I've used on Mary Poppins for most of her clothes.

"And finally, all of Mary Poppins's accessories are red. Really, that's stemmed from the hat, because when I first met Emily Blunt I tried various different shapes of hats on her to see what worked. One of them happened to be red. And at that point, I thought, *That works really well*. It's more interesting than black, and it actually really suited her. Having decided on the red hat, the accessories then had to be red—as did the shoes and the gloves and the scarf. There's also a little flash of red lining inside the coat.

"I don't know what it is about Mary Poppins," Powell says. "It's just that childhood thing. It really reminds you of that innocence, that wonder. That's really part of the charm that makes this film work."

Nowhere to Go but Up

The Musical Mastery of Mary Poppins Returns

Rob Marshall has loved musical theater and film throughout his life.

"I think Rob Marshall would be the first to tell you that he's kind of born into the wrong era," Lin-Manuel Miranda says. "If he'd been born in the MGM era, he'd have made fifty musicals by now."

"What I love about musicals," Marshall says simply, "when they work, is that words aren't enough, so you sing."

For *Mary Poppins Returns*, Marshall turned to the award-winning songwriting team of Marc Shaiman and Scott Wittman. Marshall says, "Marc and Scott have written this extraordinary score that has so much to it; there's emotion to it, there is such fun, and joyous numbers—and big dance numbers—and an elaborate animated sequence.

"There's a sweeping ballad, and small songs," adds Marshall. "Songs that are uplifting, fun, funny, catchy—rooted in the period of the 1930s. I think it's an extraordinary score. I'm really thrilled with the work."

Pianist, composer, lyricist, arranger, orchestrator, musical director, conductor, writer, producer, actor, and general all-round musician working in films, television, and musical theater, Marc Shaiman has contributed in some capacity to over eighty films and television shows, plus composed three full Broadway musicals and won several honors, including a Tony Award, two Drama Desk Awards, seven ASCAP Awards, and an Emmy (with eleven nominations), plus two Golden Globe nominations and five Oscar nominations.

Shaiman began his career as a pianist and musical director of cabaret. Working with Bette Midler as her arranger, he eventually became her regular musical director, co-produced many of her recordings ("The Wind Beneath My Wings," "From a Distance"), and helped to create material for her Emmy Award–winning performance on *The Tonight Show Starring Johnny Carson*. The close artistic relationship with Midler, and similar relationships with

Billy Crystal, Martin Short, Rob Reiner, and Trey Parker, is ongoing.

Shaiman first worked on Broadway as the arranger and musical director in the Peter Allen revue *Up in One* and for Midler's *Bette! Divine Madness*. But Shaiman, along with writing partner Scott Wittman, arrived in full force with the smash-hit musical *Hairspray*, which was adapted from John Waters's renowned and quirky film. The musical

was nominated for thirteen Tony Awards—and won eight! It ran for 2,642 performances. *Hairspray* also went on national tour of the United States, was produced around the world, and was made into a second hit motion picture. The London production of the musical won the Olivier Award for Best New Musical and was nominated in ten other categories. It also won them both a Tony Award and a Drama Desk Award.

Scott Wittman has created, written, and directed shows for Patti LuPone, Nathan Lane, Christine Ebersole, and Bette Midler. He cowrote *Charlie and the Chocolate Factory: The Musical*, which opened at the Lunt Fontanne Theater following a four-year run at London's Theatre Royal, Drury Lane.

Scott and Marc have teamed up on Broadway for *Martin Short: Fame Becomes Me*, which Scott also directed, and *Catch Me If You Can*. For their original songs for NBC's series *Smash*, they were nominated for two Emmy Awards, a Grammy, and a Golden Globe.

The composers are grateful for the creative environment provided to them by their director. Shaiman observes, "Rob Marshall is a real artist. He's a painter. He looks at and listens to every moment, as a good director should. Every moment is observed and considered, and he is very specific about what he likes—and yet he's very collaborative."

Wittman adds, "Movies are collaborative, but musicals are *especially* so. Everyone has to be working in tandem, and that atmosphere, the culture of the film—[well] Rob has created that."

"You have to *find* your way into a musical in order for it to translate to film," responds Marshall to the compliments. "Film is a living, breathing thing. It's very delicate, and you have to listen and watch for what it tells you. A musical needs to feel seamless, particularly as dialogue ramps up into a song. It needs to feel *earned* and organic. The key element for me is, why are they singing?"

"What's really exciting is to make an original live-action musical, which is very rare these days," Miranda adds.

"*Mary Poppins Returns* is a true musical," Shaiman says. "Rob Marshall and John DeLuca and David Magee and Scott and I sat together for nearly three months and chipped away at the musicality of the plot of the film. Where would the songs go; where does the story, or the pacing of the movie, call for a song?"

"We have very intense rehearsals, because this is music that's being *worked* on," Marshall says. "Marc and Scott have done multiple versions and variations on the songs. We tried this one, that one. Coming from Broadway, that is what you do in a workshop situation, or an out-of-town tryout. We're doing all of that here, now. We've been given an incredible amount of time to experiment and work, to try and then change numbers, to stage and choreograph things."

"We wrote a lot of other songs on the way to writing these songs," Shaiman says. "You write a song, everyone talks about it; you see what's good about it, what maybe could still happen in a song. And you go back to the drawing board." He then adds, "Robert Sherman

said, 'You have a great body of work—and a great *corpse* of work.' That's part of the process of finding the musical voice of a project like this."

"To work on a new score is one of the thrills of working on a new musical specifically for film," Marshall notes. "You're not taking something from the theater and *transferring* it to the screen and trying to make a jump."

"I've been a fan of Marc Shaiman and Scott Wittman for a really long time," Lin-Manuel Miranda emphasizes, "and I think they're uniquely suited to this project. Marc and Scott grew up with the Sherman brothers, and every note in this thing is a love letter to that style. They feel like classic Disney songs even though they're brand-new. Every day was a sort of joy in discovering and learning the music and getting to be a part of it."

"Rob is also a choreographer," Shaiman adds, "so one thing about the music is that it's very specific about the beats. We have even underscored the entire film in a musical way—accentuating the movements and actions of the actors with music makes it *all* seem even more choreographed."

"We did not want to stray too far from the sound of Walt Disney's movie," Wittman says. "We wanted it to feel as if we'd picked up where the first film ended. Our songs are certainly in the style of the Sherman brothers, and honor the style of their work. But as the time line of our film is twenty-five years later, we worked to evolve our musical vernacular in the same way."

"The musical element of this film has been an utter joy," Emily Blunt says. "I've been very much a part of the process from the moment they began to conceive the songs. They would bring me in the studio, let me have a go at them. They sort of catered the songs to me and what I am able to do, so that was awesome."

"It's been so wonderful to see the songs take shape, to learn the music, to feel the echoes of the original in Marc and Scott's incredible work," Miranda says. "As someone who's been a part of the process of making new musicals, it's really exciting to be there as an actor and be part of it all."

"I feel very excited to be embracing this new musical in ways that, perhaps, it was done many, many years ago during that golden age of MGM musicals," Marshall adds.

"It's been deeply collaborative, and Rob is so very attentive to your needs as an actor and your vision for the part," Blunt says. "It's wonderful to be on a set like this, with that music just blasting out of the playback speakers. I think on those long days, where we've all been shooting for a long time, it's the reminder to everyone—the crew, the actors, everyone— that we're making something that is . . . well, rather incredible, actually."

"If you're lucky enough to work on a great project," Shaiman says, "you work on it to

CHAPTER ONE

the point that you forget you worked on it. You forget about the day-to-day—and the fights, and the challenges. You forget you were part of the machinery and just get lost in the whole story.

"I think I've been touched by the spirit of Mary Poppins all my life," professes Shaiman. "Truly. All my life. Everything I've written has grown in a garden that Walt Disney's *Mary Poppins* created, and I sprouted from it. Songwriting, music writing, lyric writing, orchestration, storytelling. I learned it all from *Mary Poppins*."

EAST WIND

An Animated Adventure

A Lively Voyage in a Porcelain Vessel

"Other nannies take children to the park" Bert said in *Mary Poppins*. "When you're with Mary Poppins, suddenly you're in places you've never dreamed of, and quick as you can say, 'Bob's your uncle,' the most unusual things begin to happen."

That's true of *Mary Poppins Returns*, where the Banks children find themselves whisked away into an animated world contained in the colorful illustrations that grace an antique Royal Doulton bowl on the nursery mantelpiece.

"We're using a big variety of different animation techniques," Marc Platt says. "We're evoking the look of classic hand-drawn animation, but then we're also doing more complicated, very modern computer-generated backgrounds that allow us to move the camera through it, to create a much more dimensional feeling."

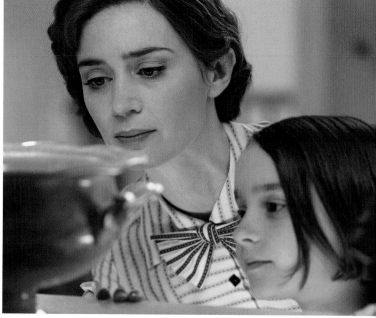

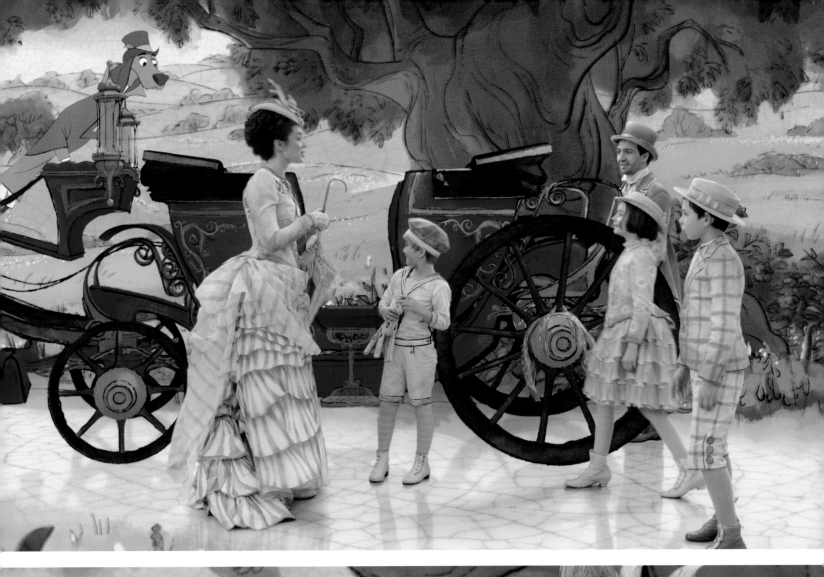

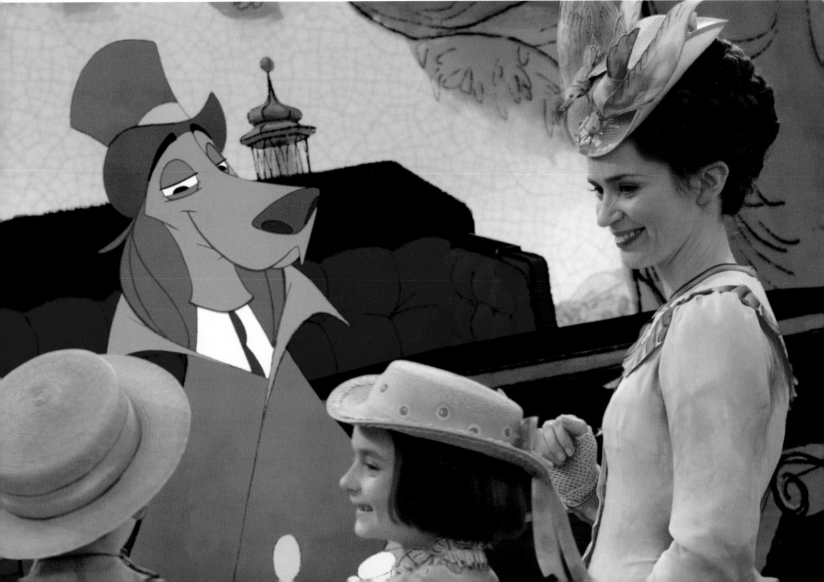

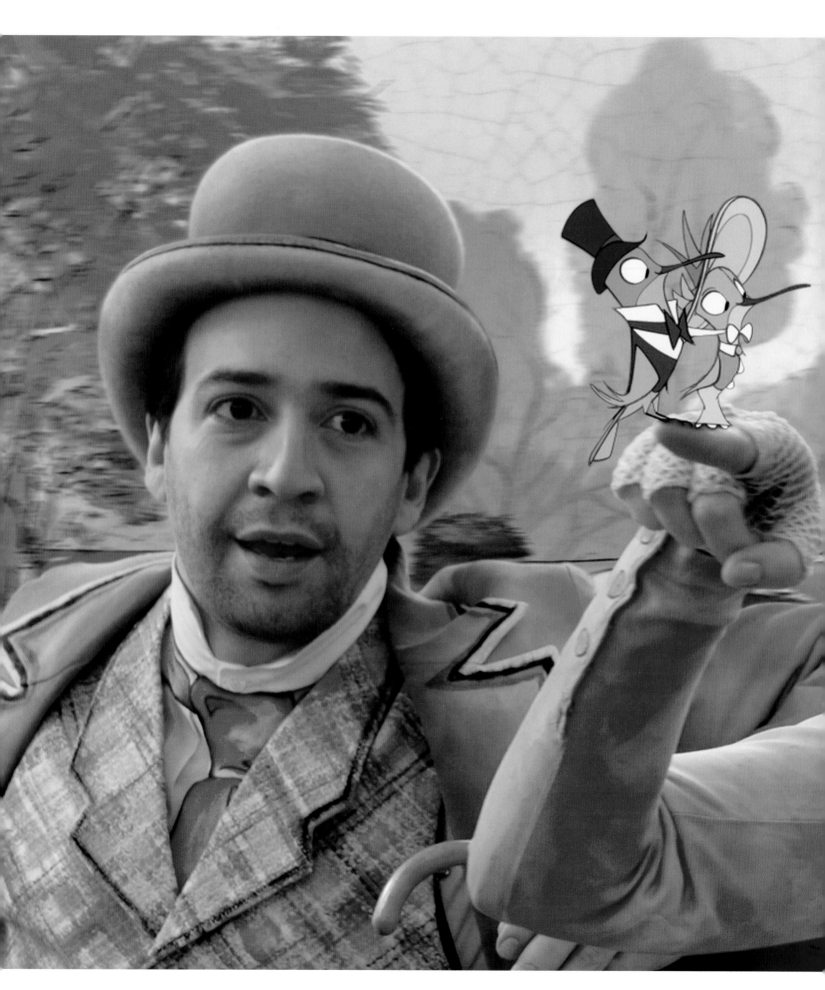

EAST WIND

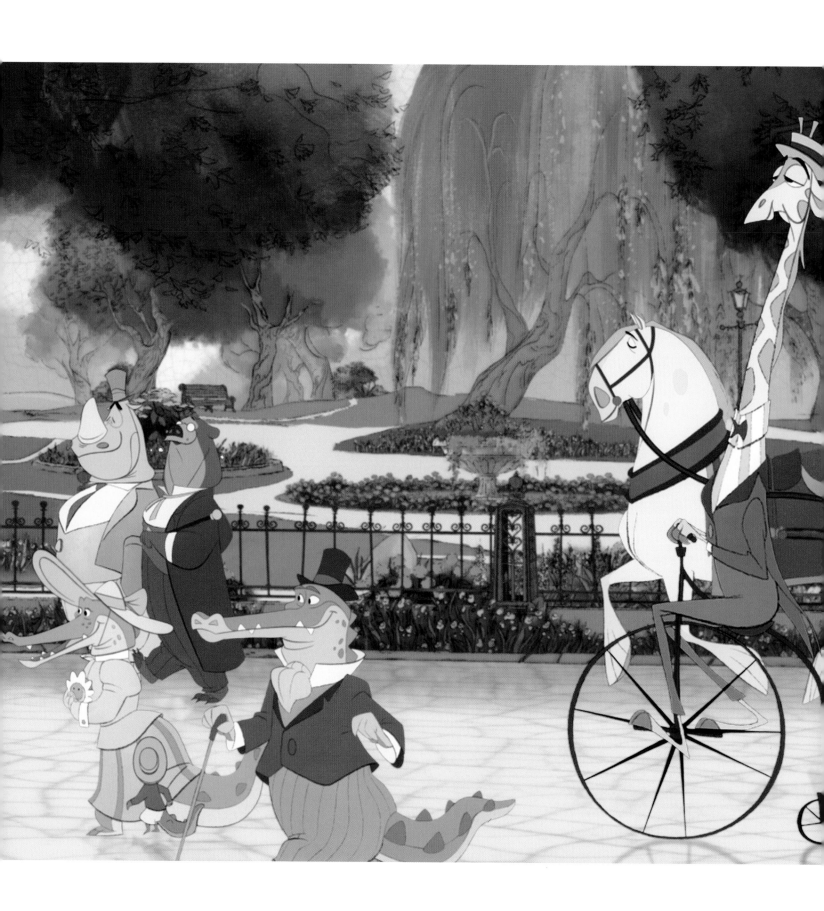

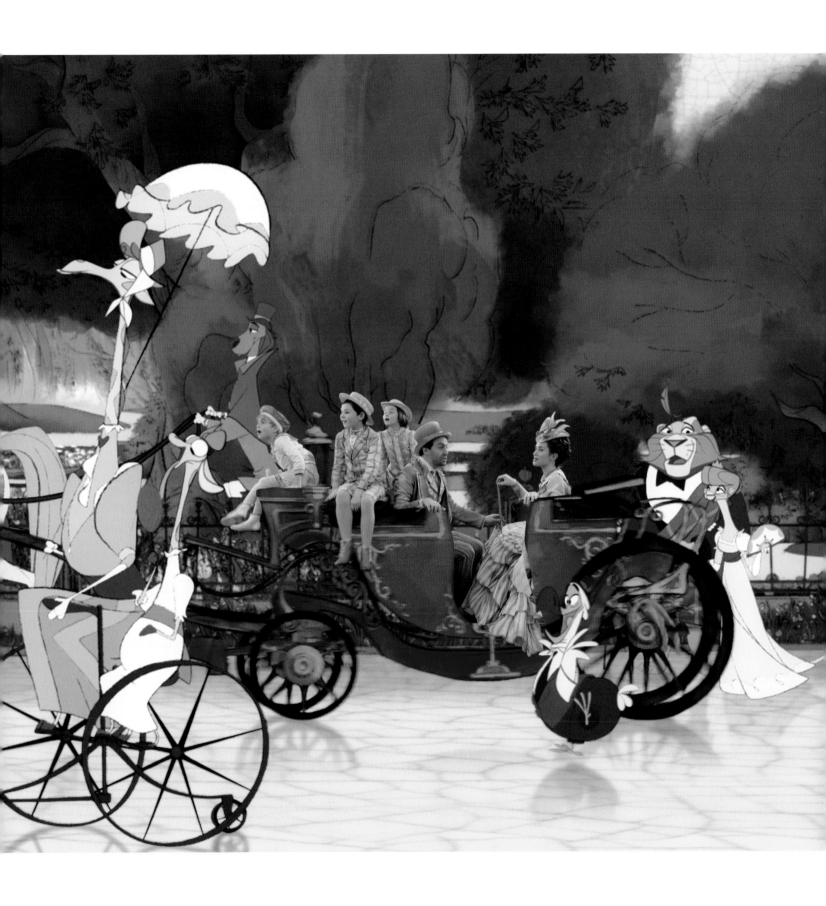

Mrs. Travers in Cherry Tree Lane

The story of Mary Poppins and her arrival in the world has been steeped in legend, fiction, romance, and nostalgia for nearly a century. P. L. Travers herself, the author of the eight Mary Poppins books, was responsible for much of the mystery, and her own personal biography was for decades as much a cipher as the "creation story" she placed on her beloved character. (She was born Helen Lyndon Goff, for instance, and was presumed to be English, a notion she never refuted, even though she was a native of Australia.)

Even as a revelatory and definitive biography of Mrs. Travers, *Mary Poppins, She Wrote: The Life of P. L. Travers*, appeared in 1999, her personal tale and that of Mary Poppins were again romanticized and fictionalized in the 2013 feature film *Saving Mr. Banks*. It seems as if Travers's actual life and career will ever be entwined in fantasies and fictions—and perhaps that's just the way she would like it.

It further appears as well that the story of Mary Poppins's origin is the story of a creator and her creation as a method of seeking to examine and understand the story of her own life, or to bring sense and harmony to a chaotic past; there's a deep wish, it seems, to purge a lifelong guilt over her inability to either help or redeem her loving father. Travers herself, perhaps, needed to bring Mary Poppins to her house for the presence of a decorous and dignified adult who might bring order to disarray, even if it could only be in conscience, memory, and nostalgia.

Emma Thompson, who portrayed Travers in *Saving Mr. Banks*, after extensive research and study, says, "She was writing something that came from some subatomic part of her that she wasn't willing to let go at all, because she relied on it emotionally."

Thompson also sees Travers as rather cleverly realigning the classic mythic form of the Western as a means of asserting feminine authority in a masculine world. "This is my theory," Thompson says, "but because women have traditionally been locked out of the superstructures or the power structures that we all live in . . . P. L. Travers felt the same way about Mary Poppins. There's a very real connection [with Westerns], in the sense that the outsider comes into the place where there is difficulty, solves the problem using unorthodox methods, and then must leave. That's a Western. And because women don't have that kind of power, the Western form, which is an essential myth, emerges in the female world in the nursery."

Fortunately, and again as is often the case, the trials and turmoil of an artist resulted in a masterful expression of her persona and a triumph over her subjugation (real or imagined); her creation further coalesced these elements, resulting in an enduring work of art, a generous gift to the world at large—one that continues to reward, even decades later.

OPPOSITE: P. L. Travers's often-conflicted relationship with and perception of the Disney adaptation is on display in this 1964 publicity photo; she cradles a promotional recording of the film's music while gazing thoughtfully at the camera.

Someone Rather like Mary Poppins

P. L. Travers and Her Creation

"Answers, answers, answers!" P. L. Travers fixed me with forget-me-not blue eyes that, though belonging to someone who was in her eighties, could still flash with steely fire. "All you ever expect from me is *answers!*"

In response, I dared to suggest that the character of Mary Poppins is a source of many questions. *Who is she? Where does she come from? Where does she go?* I should have known better. After all, the author had once written that for Mary Poppins, mundane, obvious questions like, "Where and How and When and Why" were totally beside the point because "as far as she was concerned those questions had no answers."

"When will you realize," said Pamela Travers when I again pressed for an answer to some question, "[that] I am not an *answerer?*" The subject was closed.

Pamela Lyndon Travers applied the same principle to matters concerning the Where, How, When, and Why of her own life as she did to her famous heroine. An intensely private person, she wove a gossamer web of mystery around her personal life, sometimes to embroider, sometimes to conceal.

When she died, few people realized that she was ninety-six. It was hardly surprising; for many years, she had been creatively adjusting her date of birth—even within the authoritative pages of *Who's Who*. "Oh, I can't remember," she once replied when I asked the year of some event. "I am not very good at anything to do with figures."

In truth, she was born on August 9, 1899, in Maryborough, Queensland, Australia, and named Helen Lyndon Goff, though it was by her Gaelic second name that she was always known within the family. Her mother came from Scottish stock; her father was born in south London, but had sufficient Irish ancestry for her to romantically describe him as "an Irishman," allegedly born in that ancient land of myth and poetry. His occupation, she would say, was a sugar planter, as indeed he had once been, although by the time of her birth, he was actually

ABOVE: *The Mary Poppins House in Allora, Queensland, Australia, the home of Travers Goff and his family from 1905–1907.*

employed—like the children's father in the stories—in a bank.

Over a period of just a few years, Lyndon's father was moved to a number of different branches of the Australian Joint Stock Bank in various capacities, from manager to, following some indiscretion, lowly clerk. His position was later restored when he became manager of a branch in Allora, in southern Queensland.

The eldest of three daughters, the young Lyndon fell under the spell of the great storytellers, beginning with the tales collected by the Brothers Grimm. "I was in love with those stories," she recalled, "and I got the idea that any story was a 'grimm.' I used to ask everyone to 'tell me a grimm,' and they *did!* We had a washerwoman called Matilda who was *full* of grimms! And sometimes the postman, who rode by two or three times a week on his horse with his saddle bag and his great blue cloak, would stop and tell us a grimm, as we children sat on the slip rails."

Throughout her life, the stories—often thousands of years old—from the oral storytelling tradition remained her first true love. "Of all stories," she said, "they are most precious."

Nevertheless, the young Lyndon was soon devouring any and every book she could find: the mystical tales spun by Hans Christian Andersen, the nonsense realms of Lewis Carroll and Edward Lear, as well as the captivating world of dressed animals, created by one of the writers she most admired, Beatrix Potter. She then graduated to the plays of Shakespeare at a very early age—not, she told me, out of any childhood precocity, but because it was a book and because Shakespeare "might know a grimm or two!"

Lyndon was soon inventing little tales and verses of her own, and spending more time than most youngsters her age just *thinking*.

In an anecdote that she shared with me in later life, the three-year-old Lyndon went to a children's party, but while the other youngsters were busily engaged in the usual party games, she was spotted sitting by herself to one side. An adult bustled over and asked, condescendingly, what she was doing "all alone," to which she replied: "Oh, I'm not alone—I'm thinking."

The sudden death of her adored father, when she was seven, affected Lyndon deeply and, despite serious weaknesses in his character, she would later give him sentimental immortality in the person of George Banks, the one character in her books, after Mary Poppins, about whom she was most opinionated and most defensive.

A few years later, Lyndon's mother, inconsolable over her husband's death, abandoned her children one night and rushed from the house, in a fit of grief, threatening to drown herself. As the Goff children waited to see whether or not their mother would return, it was Lyndon, the eldest, who comforted her two sisters by telling them a story about a magic horse who came galloping with "sparks of light flashing from his hooves . . . to a place that has no name."

The magical horse could do anything: dive to the bottom of sea, fly without wings—and he could carry the three children away to a shining land in a cloud of light. The mother—who did not commit suicide—returned to her family but, on that stressful night, Lyndon discovered her destiny as a storyteller.

The Goff family moved to Bowral in New South Wales and, in 1907, Lyndon went to live in Sydney with her aunt Ellie, who was given to indicating her views on things with a snort-like sniff—a trait that would later be given to Mary Poppins.

Lyndon attended a private high school for girls in Sydney and, by the time she was sixteen, was having the first of her poems published in the *Sydney Morning Herald*. She was also discovering within herself the beginnings of a lifelong spiritual quest for what she would later call the "connectedness" of things—past and present, seen and unseen; that is something to which Mary Poppins opens the eyes of the children and adults with whom she comes in contact.

Reading of Shakespeare, combined with taking part in school musicals, led to a passion for the theater and a longing to act. Her aunt and mother initially resisted this ambition but, in her twenties (after a spell as a secretary with the Australian Gas Light Company), Lyndon joined a traveling theater group, taking a stage name by which she would be known for the rest of her life.

She chose Pamela because she thought it was pretty and actressy—and combined it with her own name, Lyndon (with its Irish associations). For a surname, however, the actress took her late father's first name: Travers.

While touring with the theater company in Australia and New Zealand, Pamela was also contributing poems, articles, and stories to various papers and journals, and her blossoming career in journalism eventually led her out of the theater. However, her love of drama and dance never left her and fired her desire to, one day, see the story of Mary Poppins enacted on the stage.

It was as a journalist that Pamela traveled to London in 1926, leaving Australia forever—physically and emotionally. Cameron Mackintosh recalls asking her about her life in Australia: "She didn't really want to talk about it. It was like, 'Oh,' she said, 'that was a long time ago,' and shut off."

Although something of the mysterious dreamtime of her native land remained

P. L. Travers in the 1920s, in the role of Titania in A Midsummer Night's Dream.

forever discernible in her writings, she would become increasingly reluctant to acknowledge her antipodean roots, preferring to identify with what she saw as her spiritual home beyond the Irish Sea.

During the first of many pilgrimages to Ireland, she became a friend and protégé of George William Russell, editor of the *Irish Statesman*, and was admitted into the coterie of Irish poets and writers led by W. B. Yeats.

One of several father figures in Pamela's life, Russell introduced her to the Russian thinker Gurdjieff, whose philosophy became a significant influence. Later gurus and teachers who intensified her innate search for spiritual understanding included Krishnamurti and Laurens van der Post, as well as the writers of Zen Buddhism and the storytellers of the Navajo tribe of North America, with whom she lived for a while.

It was in 1934, while living in Pound Cottage in England's Mayfield, Sussex, that she wrote the book that was to make her famous. She was recovering from an illness and somewhere—in that strange state between being ill and getting better—the idea of a person like Mary Poppins had blown into her imagination—rather as she blows into the lives of the Banks family.

CHAPTER TWO

Plain-looking and plain-speaking, Mary Poppins permits neither disorder nor disharmony in her nursery; but she is also a magician, whisking the children into a world of fantasy and misrule presided over by her mysterious friends and relations.

Pamela always resisted the suggestion that she had "created" Mary Poppins. "I don't like that word 'created,'" she once told me. "I think people use it far too casually. I feel very much with C. S. Lewis when he said that there is only one creator and we merely mix the elements that are given."

That is why there was no point in asking where Mary Poppins went or what she did when she wasn't at Number 17 Cherry Tree Lane, let alone where she came from. "I don't *want* to know where she comes from," she insisted. "It isn't as though I secretly know and wouldn't tell anyone. I *don't* know. And I feel visited by her; I don't feel for a moment that I invented her."

When, in 1960, she wrote a film treatment for the Disney studio, she included the following exchange between Jane and the newly arrived Mary Poppins:

"We were just saying, Mary Poppins, that you're not a bit like what we invented."

"Invented!" Mary Poppins is affronted. "And who were you inventing, pray? You're not going to tell me, I suppose that you invented me?"

As she would later tell Cameron Mackintosh, when he, too, sought answers to questions about her enigmatic heroine: "She just came to me . . ."

Despite Pamela's reticence about Mary Poppins's origins, she admitted to Cameron, in the same conversation, "With everyone who writes, obviously, part of what they've experienced in life is somewhere in what they write—even if they don't realize it."

Years earlier, she had told a journalist, "If you are looking for autobiographical facts, *Mary Poppins* is the story of my life." It's an unlikely claim, perhaps, when you recall some of Mary Poppins's extraordinary exploits. Yet several characters in the books were, indeed, inspired by and named after people recalled from her Australian childhood, such as the local storekeeper in Bowral, immortalized as the curious Mrs. Corry, who is as old as history

and counts Alfred the Great, William the Conqueror, and Christopher Columbus among her acquaintances.

The book, with illustrations by Mary Shepard (daughter of the man who drew Winnie the Pooh) was an immediate success, and was followed, in 1935, by a sequel, *Mary Poppins Comes Back*. Then, after a nine-year gap, the third book in the series, *Mary Poppins Opens the Door*, appeared.

It *wasn't* goodbye to Mary Poppins, however, as it turned out. Eight years later, *Mary Poppins in the Park* was published, and the practically perfect nanny reappeared again and again in various spin-offs, including an alphabet book, *Mary Poppins from A to Z* (which, for some reason, was subsequently translated into Latin), and a book of stories and recipes entitled *Mary Poppins in the Kitchen*.

As a result of the popularity of these books, the author received many letters from young readers. Pamela recalled one particular correspondent: "A young boy wrote to me and asked, 'Will you marry me when you grow up?' I wrote back, 'Well, let's wait a little while until *you're* grown up and then we'll consider it again.'"

There were also surprising letters from grown-ups: "One woman wrote to me that she was knee-deep in children and if Mary Poppins had left the Banks family, perhaps I could pass on her address, because she could really do with her!"

Late in life, Pamela wrote two more slim volumes: *Mary Poppins in Cherry Tree Lane* in 1982 and, finally in 1988, *Mary Poppins and the House Next Door*.

On becoming a writer, Pamela had retained her early stage name, using only the initials, P. L. Travers to hide her gender and avoid being dismissed as the archetypal female author of children's books.

She was known by various forms of intimacy to her friends and admirers, each of whom saw a different aspect of her persona and scarcely knew of one another's existence until after her death.

From early in our friendship I was invited to call her Pamela, but other friends simply

called her P. L. or P. L. T., while her many correspondents from America—knowing that she had an honorary doctorate from Chatham College, Pittsburgh—addressed her as Dr. Travers, a form of address that appealed to a Poppins-like streak of vanity in her personality. To Walt Disney, as well as various agents and publishers, she answered to Mrs. Travers for, although unmarried, she had adopted a child, Camillus, from an Irish family in 1939 and raised him as her own.

During the war, Pamela worked in America for the Office of War Information at a time when Hollywood, and Walt Disney in particular, was beginning to show an interest in filming *Mary Poppins*, although it would be another twenty years before it reached the screen and became a much-loved, Oscar-winning classic of fantasy cinema.

Pamela Travers's other books included *The Fox at the Manger*, a fable in which the newborn Christ-child receives, from a canine visitor to the stable, the gift of cunning; *Friend Monkey*, a novel (her best, she always thought) inspired by the character of Hanuman, the monkey god of Hindu mythology; and *About the Sleeping Beauty*, in honor of her favorite fairy tale and the one in which, as a pantomime, she had made her professional debut as a dancer, a lifetime and a half a world away.

Her motivation for writing was always the same: she didn't write for a particular audience, child or adult, nor did she write simply to please herself. "I have written the books I have written," she said, "because *they were there to be written.*"

Awarded the Order of the British Empire in 1977, Pamela became a prolific contributor to *Parabola, The Magazine of Myth and Tradition* (later collected in a volume entitled *What the Bee Knows*). She was a teacher and mentor to many, although, like Mary Poppins, she never "explained," always expecting questioners to arrive at answers by a process of self-discovery. She told me once, when I was in an irritatingly questioning mood, of a Chinese ideogram called "Pai," which had two meanings: one was "to explain"; the other, "in vain." That was the lesson she taught: "To explain is vain. . . ."

In that, she was like Mary Poppins. As Jane and Michael Banks knew all too well, Mary

Poppins might know the answers to the questions they were burning to ask, but she would never, ever tell. In addition, like Mary Poppins, Pamela Travers could be vain and coquettish—and surprisingly fearsome if you unwittingly trespassed into territories to which you had not been given access. But, again like the character she gave to the world, she earned and received from her friends great loyalty and much love.

Although Pamela Travers died on April 23, 1996, she lives on through her spit-spot, no-nonsense, practically perfect heroine on the page, on film, and onstage, working strange magic and dispensing, in equal measure, wisdom and love.

"Did you ever know anyone who was like Mary Poppins?" I once asked Pamela Travers. Even as the words left my lips, I knew that it was a fruitless question. A moment's pause and she answered, as indeed her heroine might have done, with *another* question: "Did *you* ever know anyone like Mary Poppins? Did *you* ever know anyone who could slide *up* the banisters?" I replied that I hadn't, but that I rather wished I had. "Well," she said with a conclusive finality, "there you are then."

What, of course, I *should* have said was, "Yes, I *have* met someone rather like Mary Poppins—and she is *you*. . . ."

Brian Sibley

is the author of more than a hundred hours of radio drama and has written and presented hundreds of radio documentaries, features, and weekly programs. He is widely known as the author of many movie 'making of' books, including those for the Harry Potter *series and* The Lord of the Rings *and* The Hobbit *trilogies;* The Disney Studio Story *and* Snow White and the Seven Dwarfs: The Making of the Movie Classic (with Richard Holliss); and* Mary Poppins: Anything Can Happen if You Let It *(with Michael Lassell).*

OPPOSITE: Mary Poppins statue by sculptor Tanya Bartlett in the Australian town of Bowral, where Travers lived as a child and teenager.

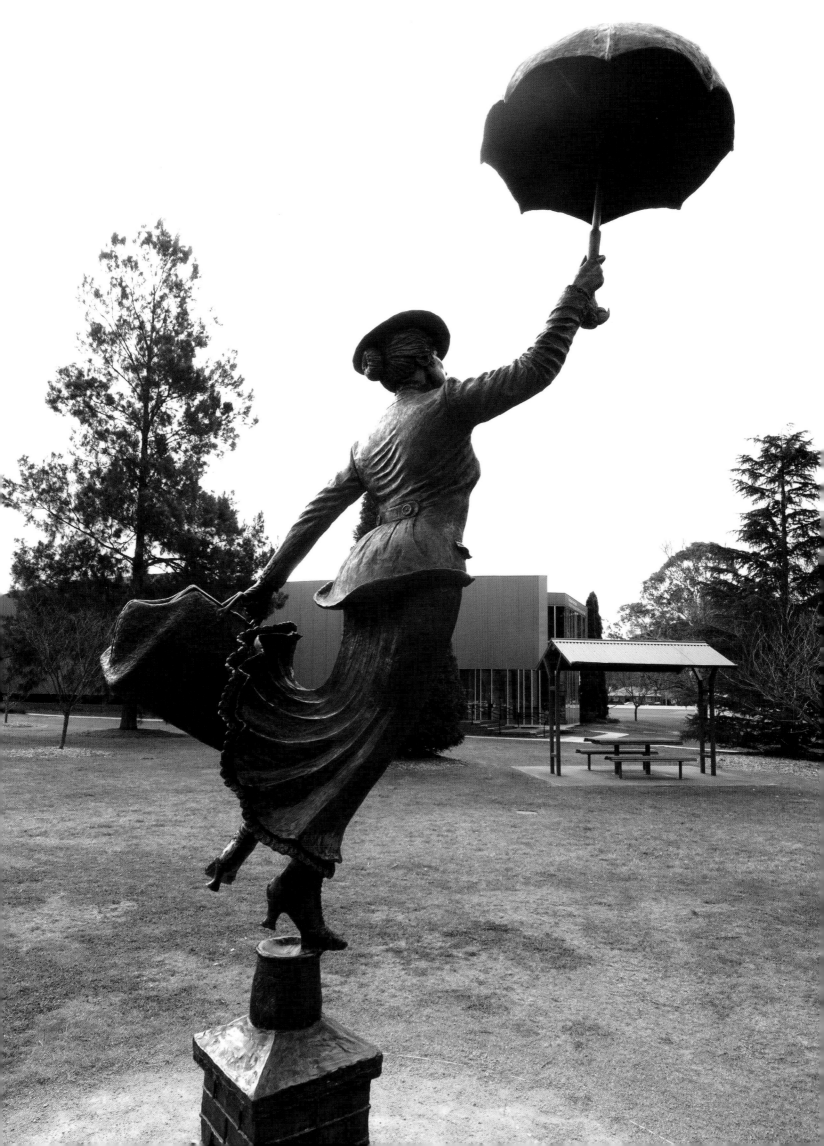

The Literary Mary

The Nuances of Character Between Page and Screen

One of the peeves of P. L. Travers was that the Disney film adaptation simply got her character wrong. Critics of Julie Andrews's casting frequently use the words "sugary" or "saccharine" to dismiss her Oscar-winning performance—neither of which characteristic is evinced in her playing of the part. She may have moments of greater warmth, or where she is rather more obviously aware of her own demeanor than the Poppins of the page, but Andrews's Mary is simply a variation on a theme established by the author. "Well," Travers told Andrews in a phone call, "you're too pretty; but you've got the nose for it, that's for sure." She later admitted that Andrews had "integrity and a true sense of comedy." But it's probable that no actor or adaptation would have satisfied the fussy author. "The real Mary Poppins, inevitably, as it seems to me," she wrote in a letter to Walt Disney, "must remain within the covers of books."

London, July 1989. My husband and I emerged from the Underground at Sloane Square Station in Chelsea and turned along King's Road. Outwardly, I was calm and (I hoped) poised, but inside I was all aflutter. Author and broadcaster Brian Sibley, who I'd met when he visited the Walt Disney Archives to research his first of many Disney books and projects, had arranged for us to take tea with P. L. Travers, author—but *not*, as she has adamantly asserted, the *creator*—of the world's most famous (not to mention "practically perfect") nanny.

We turned onto Shawfield Street, and there it was: Pamela Travers's signature pink door of Number 29. We rang the bell, and there she was: at nearly ninety, a diminutive, bright-eyed woman. She sized us up with a sharp glance. *Oh dear*, I thought as I heard in my mind Julie Andrews as Mary Poppins noting, *Not as well turned out as I'd like. Still, there's time. There's time.* She welcomed us into her parlor, a true author's nest with books and papers everywhere. In her tiny kitchen, she and I prepared tea, with toast and jam.

Brian had been working with Mrs. Travers on a screenplay for a *Mary Poppins* sequel that she hoped The Walt Disney Company would produce, and recommended me to her as a Disney archivist who had begun as a children's librarian and who loved her original Mary

Poppins books. I think she was hoping I would bring her good news about the Company's reaction to her screenplay—in which she hoped to "fix" some of the things she didn't like about the 1964 film, but very quickly our conversation turned to the books themselves and their continued popularity with children of all ages. She admitted that she had come around to some sort of reconciliation with Walt's version, agreeing that while there are differences between her Mary and Walt's adaptation, each is its own creature, and neither diminishes the other, but rather is a means of approaching the story and the character. If someone is thrilled by Walt's Mary Poppins, and wants to spend more time with her, it very well could be a pathway to Mary Poppins on the page.

We also spoke at length about the importance of myth and legend, and the mythic qualities of the Mary Poppins character: we do not know where she comes from when she arrives at Number 17 Cherry Tree Lane, and we know not where she goes when the wind changes. (We do know, however, that she has been there before, and she won't stay away too long.)

Born in Australia as Helen Goff, the young girl who would become P. L. Travers developed a connection to legend, myth, and magic, and believed there are worlds beyond our own

MRS. TRAVERS IN CHERRY TREE LANE

that we can sense, and perhaps even experience. Myths were ways in which man began to figure out his place in the universe, seeking the answers to the most basic questions: "Why are we here? What is our purpose?"

Throughout her life, Travers remained open to those other worlds. "The very first things I think children should read are myths, fairy tales, and folklore. I feel it's absolutely imperative to get rooted in your own ancestral material."

Mary Poppins first appeared on November 13, 1926, in a short story by Pamela Travers, published in the *Sun,* a local paper in Christchurch, New Zealand. "Mary Poppins and the Match-Man" tells "The Day Out" adventure of the seventeen-year-old "underneath" nurse of Jane, Michael, John, and Barbara Banks (called "underneath" because "being only 17— she wasn't old enough to be anything else"). Dressed in her best frock and with her parrot head–handled umbrella, Mary Poppins meets up with the Match-Man, Bert:

"Mary!" he cried, and you could see by the way he cried it that he loved her.

Mary Poppins smoothed out her dress and looked hard at her shoes and smiled at the Match-Man all at once, and you knew by that that she loved him, too.

Eight years later, P. L. Travers wrote her first Mary Poppins book, in which Mary Poppins was no longer seventeen, and had "shiny black hair—'Rather like a wooden Dutch doll,' whispered Jane." Mary Poppins was "thin, with large feet and hands, and small, rather peering blue eyes." Travers revised "The Day Out" adventure so that when Bert called out, "Mary!"

. . . You could tell by the way he cried it that Mary Poppins was a very important person in his life.

Mary Poppins looked down at her feet and rubbed the toe of one shoe along the pavement two or three times. Then she smiled at the shoe in such a way that the shoe knew quite well that the smile wasn't meant for it.

This version of Mary Poppins does not express her feelings, something that Travers demanded when Walt and his creative team adapted "The Day Out" chapter into the "Jolly

Holiday" sequence. There must be no hint of a romance between Mary Poppins and Bert, she declared—deliberately dismissing their relationship in her original story. This was not the only change between the literary Mary and her film counterpart.

In the film, Mary Poppins accomplishes the jump into Bert's chalk landscape. But in both the original story and the published chapter it is Bert who draws them into the countryside he created. Travers populated the Mary Poppins books with characters who, like Mary, have a connection to worlds beyond ours.

They include Uncle Albert, filled with laughing gas, holding a tea party up in the air; the Bird Woman, who communes with the creatures of the sky; storybook princes and a unicorn who leap out of their pages; the marble boy Neleus and his dolphin, who jump from their statue to play with Jane and Michael; Mrs. Corry, whose gilt paper gingerbread stars become stars in the night sky; the constellations themselves, that come

ABOVE: "Holding her hat on with one hand and carrying a bag in the other" by Mary Shepard, from the original edition of Mary Poppins, *1934.*

down to dance in the park on Midsummer's Eve; and twin babies, John and Barbara, who converse with the Starling and understand the language of the trees and the wind and the sunlight and the stars—but will lose that ability (just like all humans) once they've passed their first birthday. There is only one who remembers: "the Great Exception."

Walt and his creative team, headed by Bill Walsh, Don DaGradi, and Richard and Robert Sherman, wisely condensed the story to focus on "the Great Exception." The film's Mary Poppins is the conduit through whom Jane and Michael—and we, along with them—experience the beauty, joy, and magic of the world in which we live, and the Banks family

To Walt Disney —
 Not another "Mickey"
but I think you should like
our Mary.
 P. L. Travers

is made whole. The literary Mary Poppins opens windows and doors into wonders of the universe.

As a visiting lecturer at Smith College in 1966, Travers explained that writers do not create characters, but "summon" them. Again and again she asserted that Mary Poppins herself came to her one night, fully formed, through her bedroom window when she was ill and resting in bed. "Mary Poppins was not invented by me. I don't do the controlling, and sometimes I'm surprised by what I've written. Again and again when I read over what I've put down I find myself saying 'Goodness, that's true. How did Mary think of that?' But then I realize that she is me. But is she?"

In 1976 Travers began serving as a consulting editor and writer for *Parabola* magazine, a role she continued through the 1980s. In one essay she recalled, "As a child, the stars seemed so close. I used to think I could hear them laughing. I never told anyone, they would have laughed. . . . Would you accept a carpetbag coming from the stars? . . . When Mary Poppins arrived, the children looked into her carpetbag and . . . found it empty. And yet out of it came all her mundane daily possessions, including a camp bed! Did all that come from the stars? We do not know. Emptiness is fullness."

Presenting me with a copy of her collected essays, published in book form in 1989 as *What the Bee Knows: Reflections on Myth, Symbol, and Story*, she called them a "sampling of the philosophy of Mary Poppins." P. L. Travers was the vessel through which the unseen but not unfelt world of myth and fairy stories—as personified by Mary Poppins—connects with our world.

Paula Sigman Lowery

is an internationally recognized author and expert on Walt Disney and the history of The Walt Disney Company. A former archivist for the Walt Disney Archives, she was one of the lead creative consultants in the design and development of the Walt Disney Family Museum, for which she continues to serve as consulting historian. She has written scripts for Disney storytelling records and books, articles for Disney Magazine and the Walt Disney Family Museum, was a contributing author for Marc Davis: Walt Disney's Renaissance Man, and authored liner notes for Walt Disney Records Legacy Collection releases of the Sleeping Beauty, Cinderella, and Robin Hood soundtracks.

OPPOSITE: *Walt Disney reads to his young daughters Sharon (left) and Diane in this 1939 publicity photo.*

Walt Disney's personal copy of Mary Poppins was inscribed by publisher Eugene Reynal.

Mary Poppins in Studio One

A Forgotten Debut from the Golden Age of TV

There is a Mary Poppins that even devotees of the books by P. L. Travers and aficionados of Walt Disney's film frequently don't know about. I certainly didn't. As a Disney-obsessed child (who would become a Disney-obsessed adult), I shared my enthusiasm for *Mary Poppins* with my grandmother. This kind and loving woman told me that she recalled seeing a television version of the Poppins stories. Assuming she must be thinking of another unrelated production, I set her straight, informing her that there never had been a TV version of *Mary Poppins*, and assured her that the only screen version ever produced was Walt Disney's theatrical film.

Being the wise person she was, my grandmother simply accepted my point. But I discovered a few years back that my grandmother was in actuality correct—as she usually was. In 1949, "Mary Poppins" was telecast as a one-hour dramatization on CBS. And, ever since discovering this early non-Disney version of P. L. Travers's literary creation, I've felt guilty for mistakenly "correcting" my grandmother.

This all-but-forgotten production was part of the prestigious dramatic TV series *Studio One* that had premiered on CBS television in 1948. This weekly program, broadcast live, was one of the most popular and acclaimed anthology series of television's "Golden Age." Offering a myriad of televised dramatizations, either adaptions or originals created especially for the new medium, *Studio One* received Emmy nominations every year from 1950 to 1958.

The series staged some extraordinary teleplays among its nearly five hundred episodes, including "Twelve Angry Men" in 1954. *Studio One* had been on the air for just over a year when "Mary Poppins" was telecast on December 19, 1949. As in the original book, the mysterious nursemaid is blown by the East Wind against the door of the Banks family house at Number 17 Cherry Tree Lane. From then on, Mary Poppins makes magic, enhancing the lives of Jane and Michael Banks until the West Wind carries her away, open umbrella held aloft.

Produced as a TV Christmas treat—indeed, the climax of the story is set at Yuletide—"Mary Poppins" added the element of fantasy to the program's mix of drama and comedy, suspense and literary classics.

It presumably took some doing to convince P. L. Travers to relinquish the rights to her literary heroine. But in reality, though the author was famously resistant to Walt Disney's attempts to obtain screen rights to her stories, she was less reticent when it came to the overtures of others. In May 1947, Hollywood columnist Hedda Hopper reported that director Vincente Minnelli was developing a Mary Poppins movie script, and in October 1950, producer Samuel Goldwyn bought the rights to the first three books. Obviously, these efforts came to naught—and within a year Goldwyn's option had lapsed. Walt then launched into another eight years of making approaches (and being rebuffed)—though in the midst of all this activity, Mary Poppins became a television star, thanks to the one-hour teleplay adapted from the Poppins stories by *Studio One*

producer Worthington H. "Tony" Miner, an early television visionary.

Miner's *Studio One* adaptation is faithful to the Travers books in spirit and in many other specific ways. While including Mary Poppins's penchant for sliding up the banister and her bottomless carpetbag, the teleplay also includes a number of adventures from Travers's original works not seen in the 1964 film, such as pasting stars in the sky with Mrs. Corry and Mary Poppins's visit to her cousin, Arthur Turvy, for whom, on every second Monday, everything is upside down. (One curious omission: Mary's signature parrot-headed umbrella.)

Perhaps most interesting is the inclusion of the anti–Mary Poppins, Miss Euphemia Andrew. (The Miss Andrew character is also in the *Mary Poppins* stage-musical version, while in the film, the departing Katie Nanna serves as a contrast to practically perfect Poppins.) As in the book, the threat is neatly dispatched; in an impressive example of early video effects, the magical nanny shrinks the nasty nanny down to the size of a bird—a remarkable feat for both Mary Poppins and live television in 1949.

A typically fine *Studio One* cast embodies Travers's characters. E. G. Marshall (later the star of the groundbreaking TV series *The Defenders*, which originated on *Studio One*) is Mr. Banks. Tommy Rettig (soon to find TV immortality in *Lassie* as Jeff Miller, the original owner of the famed collie) plays Michael, while Iris Mann, who would go on to be a radio journalist on National Public Radio, portrays Jane.

Another Mary, beloved character actor Mary Wickes, portrays the all-important lead role. Having already established herself as a comedic performer in a number of Broadway plays and classic Hollywood films, including *The Man Who Came to Dinner* and *Now, Voyager* (both 1942), Wickes had already been featured on several live television dramas when she was cast as Mary Poppins. (In fact, she had appeared in *Studio One*'s debut teleplay the year before.) The skilled actor, who'd later appear in some of the other highly regarded programs of the period, such as *Playhouse 90* and *Philco Television Playhouse*, painstakingly prepared for the role of Mary Poppins, combing her own copy of *Mary Poppins* to glean personality

and visual details of the character.

Tall in stature and tart of tongue, Wickes in some ways more closely resembled the literary character (or some readers' perception of the character) than Julie Andrews. Travers considered Mary Poppins to be "plain" and Wickes had a plain-Jane quality well suited to the wisecracking housekeepers and acerbic nurses she often played. In her prickly characterization, Mary Wickes portrays Poppins—described by Travers as a person "who never wasted time being nice"—with a sternness and a sharp tongue, but who at the same time adeptly conveys a certain degree of whimsy underneath it all. Wickes captures the no-nonsense nature of the authoritative nanny, while also conveying a sense of magic that is always on the verge of happening.

Wickes and the other "Mary Poppins" performers rehearsed for one week before a one-day rehearsal with cameras, followed by a dress rehearsal and the live performance, broadcast from CBS Studio 42 then located in New York's illustrious Grand Central Terminal building. The resulting show was a success; CBS claimed that more fan letters were received for "Mary Poppins" than any of its other shows. Unfortunately, relatively few saw this fascinating production, since there were only approximately four million television sets in American homes.

Wickes naturally desired to repeat the performance, attempting for years to interest other producers. This beloved character actor would go on to perform in several Disney productions, notably as Katie (one of Wickes's patented housekeeper roles) in the "Annette" serial on the *Mickey Mouse Club* in 1958, and as the live-action model for the animated Cruella De Vil in *One Hundred and One Dalmatians* (1961). Her final role was also in a Disney production, as the voice of Laverne the gargoyle in *The Hunchback of Notre Dame* (1996).

While acting on two *Zorro* episodes in 1958, Wickes even encouraged Walt Disney to consider producing *Mary Poppins,* apparently unaware that he had been actively pursuing the property since 1944. According to the extensively researched biography *Mary Wickes: I Know I've Seen That Face Before* by Steve Taravella, "Mary was having lunch [at the Disney

Studio commissary] . . . when Disney came in. 'I kind of smiled at him and he said, 'May I join you?' I said, 'Oh, please.' He sat down and we chatted . . .' She pushed *Mary Poppins* so enthusiastically that she came to believe it was she who got him to proceed with the project, although she acknowledged at least once that someone else had already mentioned it to him."

When Walt finally produced *Mary Poppins*, Wickes felt overlooked, but once he decided the film was to be a full-fledged musical, he needed—and found—a major musical talent to play the lead. But before Julie Andrews and Emily Blunt, as well as before Laura Michelle Kelly and Ashley Brown (and the other stage Marys), Mary Wickes was the first to portray Mary Poppins. According to Taravella's biography on Wickes, the actor said at various times to several of her friends and associates, "I was the original Mary Poppins—nobody did it before me!" In that regard, the television Mary Poppins was irrefutably accurate—and so was someone else. Forgive me, Nana. You were correct. As usual.

Jim Fanning

is an internationally published writer and historian specializing in Disney. The author of books such as The Disney Book, The Disney Sing-Along Book, *and* The Disney Poster, *he is a regular contributor to Disney twenty-three Magazine and the D23 website, and has also written documentaries, articles, stories, comics, and a variety of other works. In addition, he has provided research, consulting, and writing for officially commissioned projects for many departments of The Walt Disney Company, including Publishing, Educational, Home Entertainment, Online, Interactive, and Consumer Products.*

CHAPTER TWO

EMMA THOMPSON

TOM HANKS

PAUL GIAMATTI

JASON SCHWARTZMAN

AND COLIN FARRELL

DISNEP

SAVING MR. BANKS

WHERE HER BOOK ENDED, THEIR STORY BEGAN.

DISNEY PRESENTS EMMA THOMPSON TOM HANKS "SAVING MR. BANKS" A RUBY FILMS/ESSENTIAL MEDIA AND ENTERTAINMENT PRODUCTION IN ASSOCIATION WITH BBC FILMS AND HOPSCOTCH FEATURES A JOHN LEE HANCOCK FILM PAUL GIAMATTI JASON SCHWARTZMAN BRADLEY WHITFORD AND COLIN FARRELL MUSIC SUPERVISOR MATT SULLIVAN MUSIC BY THOMAS NEWMAN COSTUME DESIGNER DANIEL ORLANDI FILM EDITOR MARK LIVOLSI A.C.E PRODUCTION DESIGNER MICHAEL CORENBLITH DIRECTOR OF PHOTOGRAPHY JOHN SCHWARTZMAN ASC EXECUTIVE PRODUCERS PAUL TRIJBITS CHRISTINE LANGAN ANDREW MASON TROY LUM PRODUCED BY ALISON OWEN p.g.a. IAN COLLIE PHILIP STEUER SOUNDTRACK AVAILABLE ON Walt Disney Records WRITTEN BY KELLY MARCEL AND SUE SMITH DIRECTED BY JOHN LEE HANCOCK

IN CINEMAS SOON

Facebook.com/SavingMrBanks

Saving Mr. Banks

Something Is Brewing, About to Begin . . .

The transportation of the P. L. Travers books to the movie screen by Walt Disney presented a "myth on the subject of mythmaking" too irresistible to be ignored by filmmakers. In the 2013 theatrical feature *Saving Mr. Banks*, Tom Hanks played Disney and Emma Thompson played Travers in a fictionalized story about the origins of *Mary Poppins*. John Lee Hancock directed this acclaimed film that examined the backstory behind the strained collaboration of two brilliant but obstinate creative visionaries. This story crafts a moving tale of two titans who must reach into their complicated childhoods in order to discover truths that enable them to allow their beloved mutual creation to take flight.

Thompson mused at how Travers herself might have seen this film. "I reckon this was a woman who kept on saying, 'I don't want anything. I don't want a biography. I don't want anyone to know anything about me,'" the actor ponders. "Meanwhile, she kept everything she wrote and sent it the archives at a Brisbane university. I'm certain she felt that she was an important contributor to the artistic culture and wanted to have it preserved. I think what she would say about [*Saving Mr. Banks*] is, 'This is an absolutely ridiculous film! It has no relationship, whatsoever, to what was happening. But, it's about me. And the clothes were really rather nice.' I think that's what she would have said."

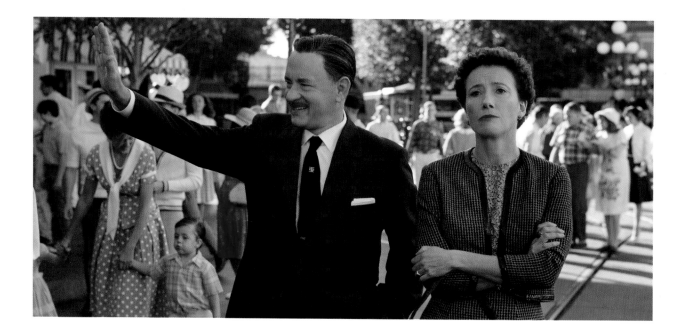

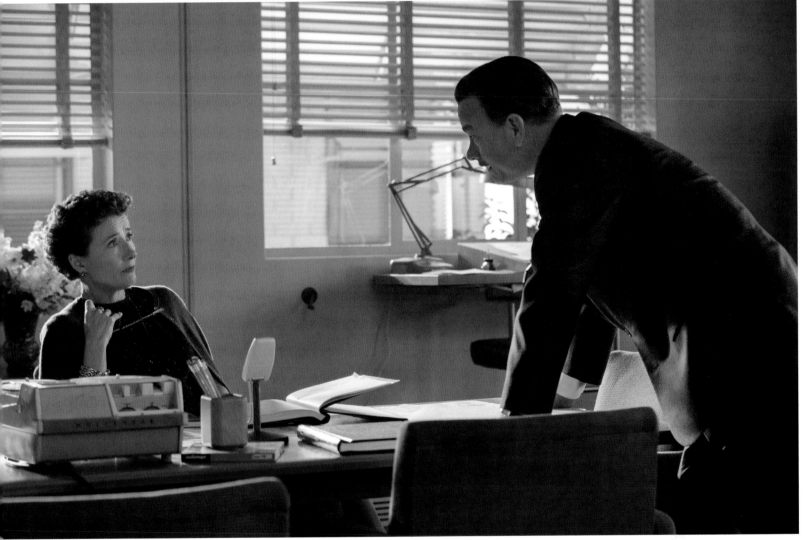

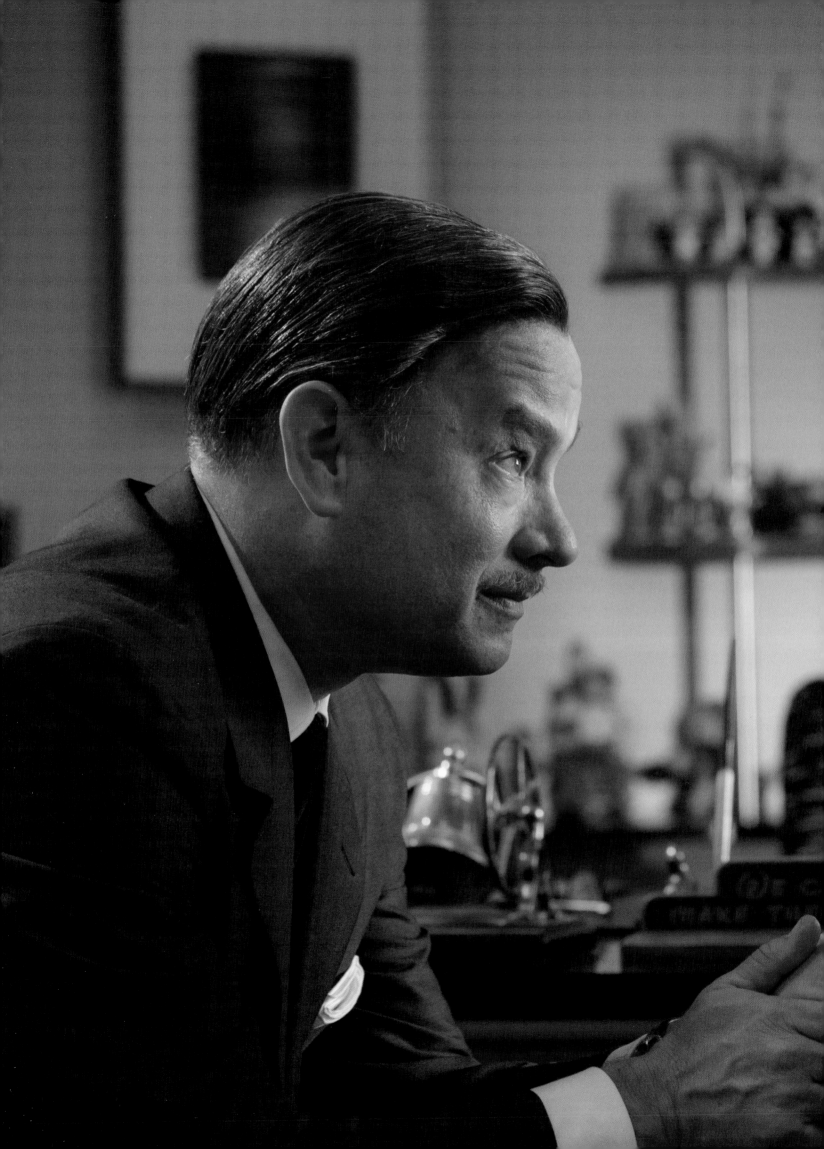

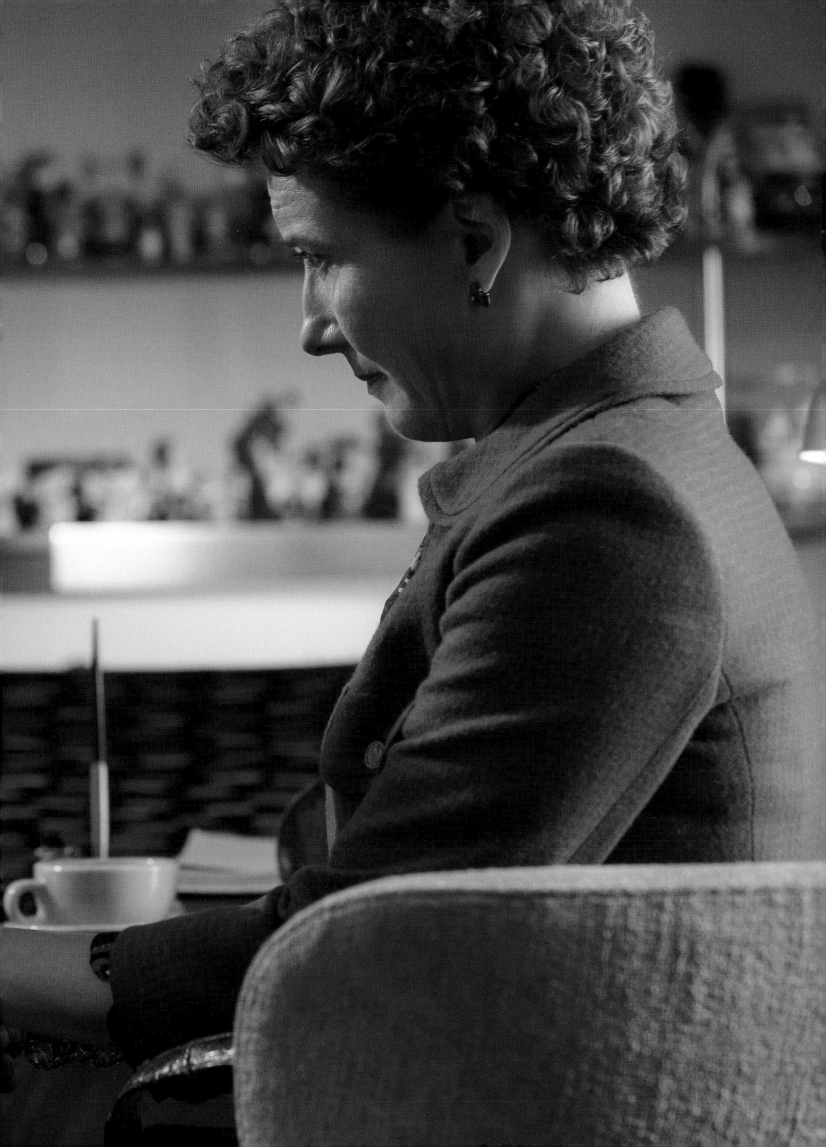

Mr. Disney
Opens the Door

"One evening in 1939, Walt Disney came home to find his daughter chuckling over a book," press notes for *Mary Poppins* at the time of its initial release related. "It was *Mary Poppins* by P. L. Travers, and this was his first introduction to one of literature's most beloved and delightful heroines." Diane Disney Miller recalled the incident exactly, but with one differing detail—the book she was "chuckling over" was a Winnie the Pooh volume by A. A. Milne! "I was only about six in 1939," Diane recalled.

As with so many creation stories, the meeting of Miss Poppins and Mr. Disney has been told and retold so many times that the facts of the matter have been lost, obscured, or misstated.

Walt's introduction to Mary Poppins appears to have been in 1934, when Eugene Reynal, of publishing firm Reynal & Hitchcock, sent a copy of a new book to Walt, with the inscription, "To Walt Disney—Not another 'Mickey' but I think you should like our Mary."

After the blockbuster success of *Snow White and the Seven Dwarfs*, the Disney Studio appears to have looked at . . . well, looked at *everything*. The Studio Library shelves groaned with dozens upon dozens of books—including well-worn and often-borrowed copies of the Travers novels. Walt also pursued film options on dozens of popular children's and fantasy titles, from *Peter Pan* to *Alice's Adventures in Wonderland* and its sequel, to the L. Frank Baum follow-ups to *The Wizard of Oz* (Walt's friend,

famed producer Samuel Goldwyn, had already snapped up the film rights to the first Oz book).

Not surprisingly, in 1938 the Studio looked into the availability of screen rights for the Mary Poppins books, but the inquiry was rejected. Meanwhile, some other entertainment luminaries expressed interest in the character and stories. Before Walt's interest, singer and comedienne Beatrice Lillie had already begun a decade of ultimately unsuccessful attempts to acquire the rights and create a Mary Poppins stage musical.

Then in 1943, the third Poppins book, *Mary Poppins Opens the Door*, was released in the United States. "I was close to eleven years old," Diane Disney Miller recalled, "and it would have been just my kind of thing." It appeared to have piqued Walt's interest again, because in 1944 he dispatched his brother Roy to meet with Travers, who was in New York working for the British Office of War Information. The author remained uninterested in the Disney entreaty. Director Vincente Minnelli and producer Samuel Goldwyn were likewise sent packing by the eccentric author.

According to Disney historian Jim Korkis, "Several months later, Walt phoned [Travers] himself and, by 1946, thought he had an arrangement—but Travers balked at the last minute."

A breakthrough finally came in 1959, when Walt visited Mrs. Travers in person at her London home. Walt

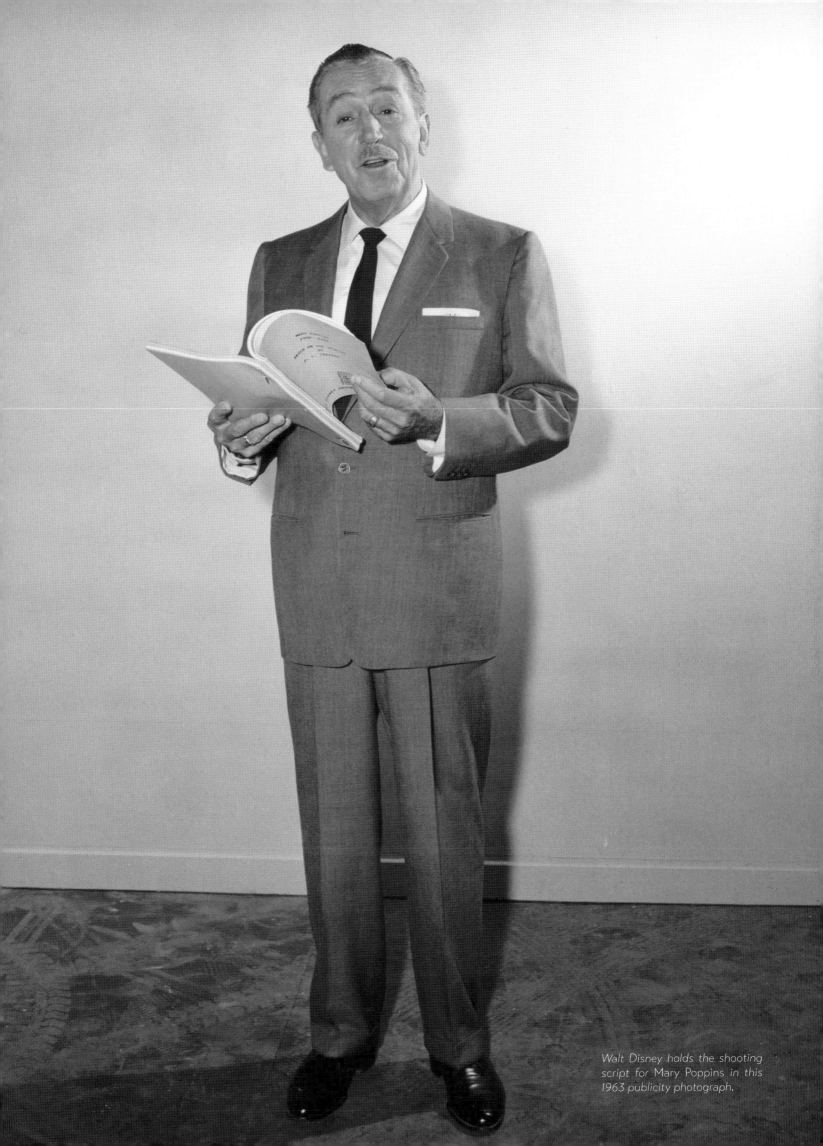

Walt Disney holds the shooting script for Mary Poppins in this 1963 publicity photograph.

WALT DISNEY PRODUCTIONS

INTER-OFFICE COMMUNICATION
P-138

RECEIVED
JAN 29 1944
WALT DISNEY PROD.

TO_____Walt Disney_____

FROM___Roy Disney (New York)_____

DATE_____January 24, 1944_____

SUBJECT____Mary Poppin Stories_____

Dear Walt:

In my previous memorandum I mentioned that I had an appointment to see Mrs. P. L. Travers, the author of the Mary Poppins stories. She resides at 142 East 52nd Street, New York City, and her telephone number is PLaza 5-5460.

We had a very nice talk, and she seemed glad to see me. She said in years back she was a contributor to several English magazines, and on a couple of occasions had written about Walt Disney pictures. I told her quite frankly that I had nothing to discuss except the fact that you were intrigued with Mary Poppins, and felt that if she was interested, you would like to consider (and have her consider) the possibility of working with us on the writing end of the screen adaptation. This, she said, she would be very glad to do, but I didn't attempt to talk money with her at all. I told her now, it was only an idea, and that was my reason for coming to her first.

Summing it up;- she is a woman about forty-five or forty-eight years of age, sort of an Amelia Earhardt type of person, with an English accent. She was very flattered over your interest - on the other hand, quite cagey in her talk. She seems like a very intelligent person, and I think the best way to follow this up is for you to call her on the phone sometime and have a conversation with her.

Excerpts from a January 24, 1944, Walt Disney Productions inter-office communication from Roy O. Disney to Walt.

seems to have been able to thoroughly charm her, and at last to explain how the film would be made as a live-action story with only certain fantasy elements being created in animation and special effects. As Travers recalled, "It was as if he were dangling a watch, hypnotically, before the eyes of a child."

The legalities and negotiations were then happily left to the author's lawyers and the Disney representatives. In an agreement dated June 3, 1960, author and historian Brian Sibley reports, "Travers was not only to receive a $100,000 advance [estimated to be close to $2 million today] against five percent of the film's gross receipts, but she would also be allowed to write a treatment for the film, have consultation rights on casting and artistic interpretation, and—uniquely—be given script approval. It was something that had never happened before: the Disney studio working with an author on the transition of a

book from page to screen. The authors of stories made into Disney films were usually safely dead and beyond consultation and, where they were still living, were generally content to leave Walt to work his cinematic magic on their books as he thought best."

Live-action filming of *Mary Poppins* began at the Walt Disney Studios in May 1963. For everyone involved, it appeared to have been an exceptional professional and personal experience.

"Walt had an infallible gift for spotting talent in people," Julie Andrews says. "I should add the word 'decency' as well. Down to the lowliest gofer in his vast organization, I never met one soul that wasn't kind, enthusiastic, and generous. The Disney aura touched everyone on the studio lot in those days. . . ."

Disney biographer Bob Thomas, in his authoritative biography *Walt Disney: An American Original*, reported:

The *filming* of Mary Poppins, *although lengthy, proved to be as smooth and pleasant as had been the making of Dumbo. Some of the sequences had been designed for combination live-action and cartoon, and Walt instructed Robert Stevenson not to concern himself about the animation; that would be filled in later.* "Don't worry," Walt said, "whatever the action is, my animators will top it." He *was challenging them, and they knew it.*

Walt made a habit of "walking through" the sets after they had been built, searching for ways to use them. Bill Walsh described a visit by Walt to the Bankses' living room in search of reaction to the firing of Admiral Boom's cannon: "Walt got vibes off the props. As he walked around the set he said, 'How about having the vase fall off and the maid catches it on her toe?, Or, 'Let's have the grand piano roll across the room and the mother catches it as she straightens the picture frame.'"

Dick Van Dyke recalled, "In my opinion, the movie's unsung hero was the online producer and cowriter, Bill Walsh . . . As with any great film, there's always someone responsible for the spirit the audience experiences, and as far as I'm concerned, Bill created the lighthearted atmosphere that let us forget we were working and instead feel like we were floating a few feet off the ground through a Hollywood playground, as if we had embarked on a jolly holiday."

On September 6, 1963, after 105 days of shooting, the live-action production of *Mary Poppins* wrapped. Elaborate special effects and the complex marriage of animation to live-action scenes, as well as the laborious preparation of physical prints by Technicolor, would take a further eleven months to complete.

"There have been only two times in my career when I have known that I had a chance to be involved in something special," Dick Van Dyke says. "The first was *The Dick Van Dyke Show*, and the second was when I read the script for *Poppins*."

"In the production of *Mary Poppins*," author and historian Christopher Finch wrote, "all of the Studio's resources were pooled to produce a motion picture that probably could not have been made anywhere else."

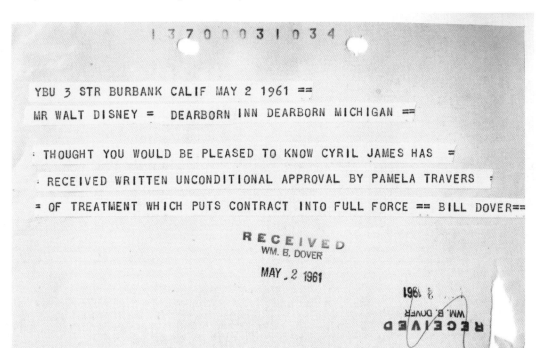

Bill Dover's enthusiastic telegram confirming that the years-long pursuit of Mary Poppins at last led to its acquisition.

FOLLOWING: A colorful and moody concept piece from a Disney Studio artist captures the film's aura of fantasy.

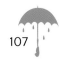

A Most Amazing Gallery

The Art and Artistry of Mary Poppins

I gaze at the painting in front of me and, in its brushstrokes, I am transported. The dome of St. Paul's Cathedral beckons through a gauze of nostalgia in my mind. I am in London. It is 1910. It is the age of King Edward VII—it is the Age of Men. Beholding it a moment or two longer, I can almost see a prim and proper nanny floating toward me beneath her umbrella. It is the magic of art that can call forth so much of my imagination.

Of course, I am looking at one of the marvelous paintings Peter Ellenshaw created for *Mary Poppins*. An undetermined number of years ago, the painting had been trimmed to fit into a picture frame by the Walt Disney Studios' Art Props Department and displayed in a company building.

Rescued from any further harm, it now hangs in the collection of The Walt Disney Company's Animation Research Library (ARL). On any given day while in the ARL, I can visit this painting and not only recall an indelible movie moment, but along with other matte paintings, background paintings, story sketches, and concept art from *Mary Poppins* (which are protected in both the ARL and the Walt Disney Archives collections), I can marvel at the incredible artistry of those who worked on this landmark film.

The making of a motion picture, especially one the caliber of *Mary Poppins*, is truly an art. Yet it is an art that requires a combination of so many other art forms all working in sync to create a successful whole. Music, costume design, set design, storytelling, visual effects, and animation all can dazzle individually. But they must mesh in service of the larger story. For *Poppins*, the union of all the arts is even greater than their sum in a most practically perfect way.

In the dozens of matte and process paintings for *Mary Poppins*, Ellenshaw (a veteran of films such as *Treasure Island* and *20,000 Leagues Under the Sea*) sought to portray in his works not the photo-realistic depictions of London, its streets, and its rooftops, but more

lyrical portrayals of the city on the Thames—all in keeping with the mysteriously magical spirit of the story. Whether painted on glass, with pinholes through which light can shine for twinkling effects, or on hardboard for certain establishing shots, his impressionistic creations visually blend the realm of reality with fantasy.

Contrasting the lush efforts of Ellenshaw's contributions are the joyous background paintings for the film's animated sequence. These colorful works by Al Dempster, Bill Layne, and Art Riley, from initial layouts by Don Griffith—and all under the supervision of MacLaren Stewart, the art director of the animated sequence—whisk us to a "Jolly Holiday" where animals join in song, one can order tea from penguin waiters, and carousel horses win the derby. Through their brushwork, never was a musical stage so grand—indeed, one has never "seen the grass so green or a bluer sky." Wielded in drybrush fashion, strokes of gouache, an opaque water-based paint, take on the vivid hues and textures of chalk, giving the sequence its playful, handmade quality.

As appealing as the backgrounds are to view, though, many of the paintings look incomplete. Their odd edges end in indiscriminate fashion, giving them an interrupted character. The reason for this is simple: unlike backgrounds for routine animated shorts or features, which often are painted in variations of squares or rectangles and were the stages solely for animated characters, many of those for *Mary Poppins* were designed specifically to blend with live-action elements filmed previously on soundstages. It would take additional cinematic wizardry through the use of the "sodium vapor process" and optical printing to complete the scenes as they were intended. Forty years after the live-action antics of a girl named Alice amidst animated characters in the Alice Comedies—and nearly twenty years after such efforts in the 1940s—the jolly frolics of Mary, Bert, Jane, and Michael through these paintings would elevate the magic of visual effects to Oscar-winning heights and the art form of cinema itself to new summits.

The story sketches and story-concept pieces that remain in the collection of the Walt Disney Archives and the ARL provide glimpses into the creative efforts of story men such as

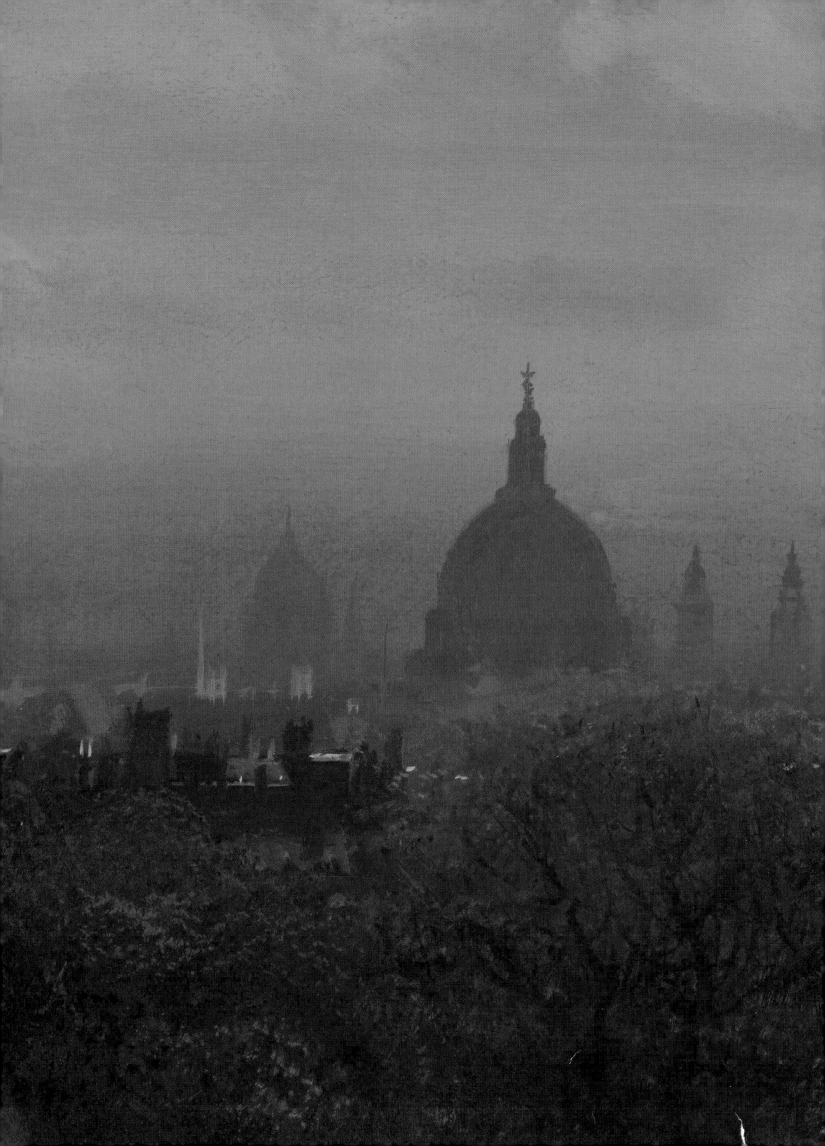

Joe Rinaldi, Don DaGradi, X. Atencio, and Bill Justice. Quick sketches on paper in graphite or charcoal were crucial in developing the story and visualizing moments brought forth in the film's script and songs. In addition, small concept paintings rendered in gouache and watercolor gave the filmmakers (and today's archivists) insight into those same story beats, and also choices in color, mise-en-scène, and the editorial rhythms of the film.

Interestingly enough, upon completion of filming, many of the story sketches from the "Jolly Holiday" sequence were physically glued (rather than pinned) to storyboards and protected with clear plexiglass for display at Disneyland to help promote the film. Their use as illustrative "props" for the public does not, however, minimize their crucial importance to the production itself, or as a window into the creative process. In an industry such as Hollywood filmmaking—where the elements of creation are often disposed of or cast aside— to have such artwork preserved is indeed a treasure.

All of which brings me back to that painting of London, and of St. Paul's Cathedral. Once again I return to lose myself in Ellenshaw's dabs of paint, and in his elegant brushstrokes. A singular, wondrous work of art reminds me of all of the others. Richard and Robert Sherman's melodies return to mind as well. I know that just like Mary Poppins herself, I cannot stay away too long.

Fox Carney

is a twenty-six-year veteran of The Walt Disney Company, plying his skills for twenty-three of those years at the Animation Research Library. As manager of research at the ARL, he leads a team that assists clients within and outside The Walt Disney Company in studying and working with the artistic heritage of the Walt Disney Animation Studios. He has written articles for Disney twenty-three Magazine as well as given multiple presentations about the Disney legacy at D23 Expo.

PRECEDING PAGE: An entrancing matte painting by Peter Ellenshaw depicts the skyline of 1910 London where we first meet Mary Poppins floating into view.

LEFT: Mary and Bert settle down for some tea in this concept piece rendered in gouache, paint, and color pencil.

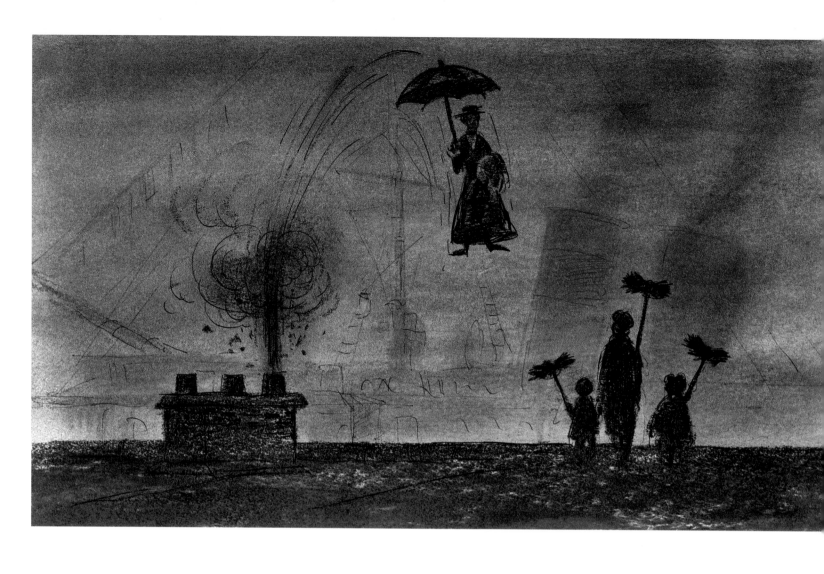

ABOVE and OPPOSITE BOTTOM: Fanciful moments of the film are visualized in these concept pieces.

OPPOSITE TOP: A chimney sweep's dream among the rooftops of London as seen in this Ellenshaw matte painting.

FOLLOWING: Cherry Tree Lane, where our story begins is rendered in this concept piece, possibly created by Peter Ellenshaw

PAGES 120-121: It's a jolly 'oliday indeed in this concept piece. Such pieces deliberately echoed the style of chalk drawings that Bert creates on Cherry Tree Lane.

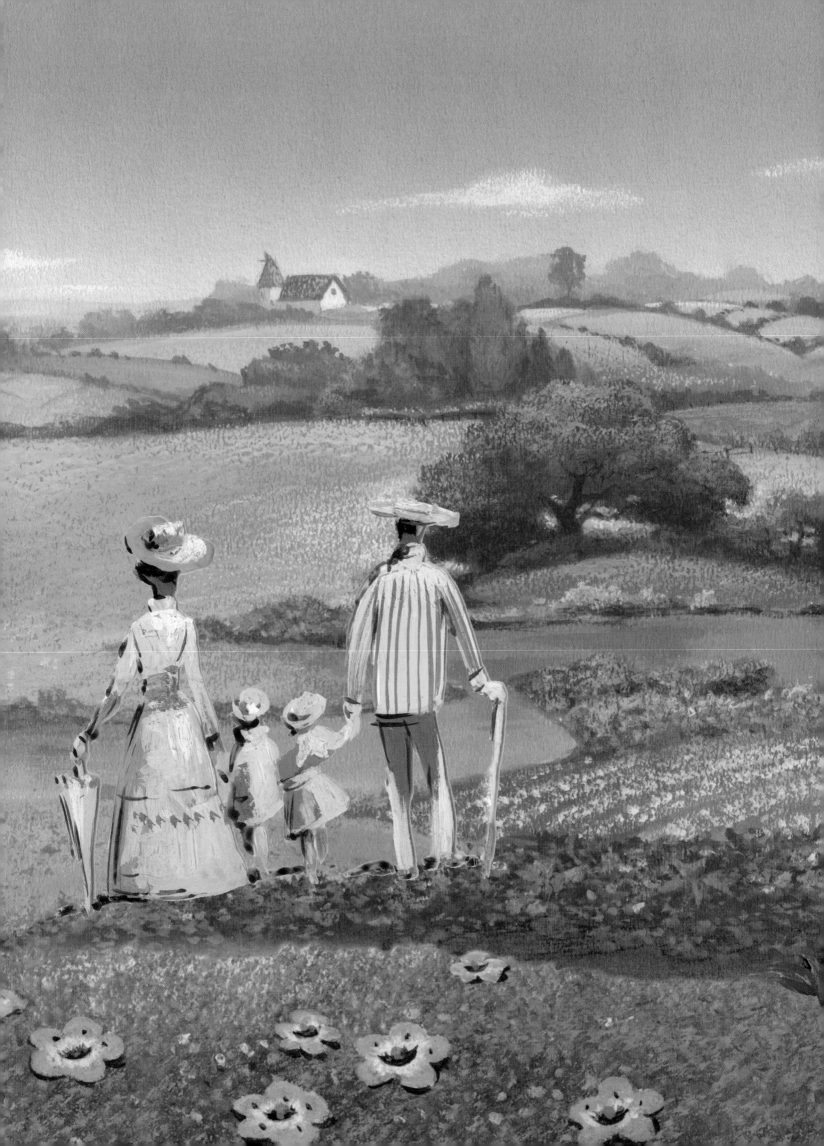

Say It with Music

Developing a Screen Story in Song

Walt Disney saw a couple of key assets in the songwriting team of Richard M. and Robert B. Sherman. One was their enthusiasm to create—they loved what they did and the work in itself brought them satisfaction. Another was their understanding of how to use music as an engine for narrative and experience. Characters can be described in songs, songs can create the engine for story action—music propels all the storytelling forward.

Walt teamed the Shermans with story man extraordinaire Don DaGradi, and the three began tackling the screen story of *Mary Poppins* through music and visuals. Their key challenge was weaving Travers's memorable episodes into a cohesive story. "She gave the world a wonderful collection of little stories that had no story line," Richard says. "You have to have a curve, a story line. But Walt knew she had the substance of a wonderful piece of entertainment."

ABOVE: Don DaGradi story drawing from the "Jolly Holiday" sequence.

The Shermans realized there had to be reasons behind the story's events. Why did Mary Poppins suddenly arrive on Cherry Tree Lane? What was her purpose? Richard recalls that he and Robert developed "a story line where the father, who was a closed individual, realizes family is the most important thing in life. That wasn't in her books."

Going through the story drawings for the "Jolly Holiday" sequence, for instance, a group of Tea Shoppe waiters who served Mary and Bert enchanted Walt. "He said, 'You know, those tuxedos and tailcoats remind me of penguins,'" Richard recalls. In short order, the waiters *became* penguins in one of the most memorable musical sequences in movie history.

Robert B. and Richard M. Sherman, Walt's sibling songwriting team whom he often referred to as "the boys."

"Julie and I both loved performing 'Supercalifragilisticexpialidocious," Dick Van Dyke recalls. "How could you feel otherwise? The Sherman brothers said that extraordinary word stemmed from their plays with double-talk. It also had the catchy bounce of an old English musical number. It made the kid in me smile the first time I heard it, and it has continued to make kids everywhere smile."

Robert Sherman recalled a simple DaGradi drawing of a chimney sweep. "He was just walking down the street, whistling a tune, his brooms and brushes slung over his shoulder." He and Richard both exclaimed, "That's a song!"

That simple inspirational drawing led to a classic song, some unforgettable movie moments—and an Academy Award.

7.

EAST WIND
SEQUENCE # 1

EARLY PART of 20ᵗʰ CENTURY
LONDON

LONG SHOT-CHERRY TREE LANE.

FATHER OPENS DOOR
SEES UNRULY
CHILDREN — HOUSE-
HOLD IN UPROAR —
NANNY LEAVING.

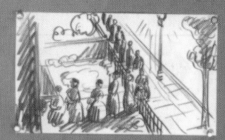

JANE:
"WANTED... ONE NANNY..."

MR. BANKS —
"MY ADVERTISEMENT
STATES SEVEN O'CLOCK
SHARP AND I WON'T INTER-
RUPT MY BREAKFAST
ONE MINUTE SOONER."

MR. BANKS —
"YOU MAY SHOW THEM
IN — ONE AT A TIME."

MARY —
"I'VE COME ABOUT THE POSITION."

MR. BANKS —
"REFERENCES?... I'M A
FINE JUDGE OF CHARACTER."

DAY OUT
SEQUENCE # 2

MICHAEL:
"AHOY! ADMIRAL BOOM!"

ADMIRAL BOOM:
"AHOY SHIPMATES! —
WELL BLAST ME GIZZARD
IF IT ISN'T MARY POPPINS!"

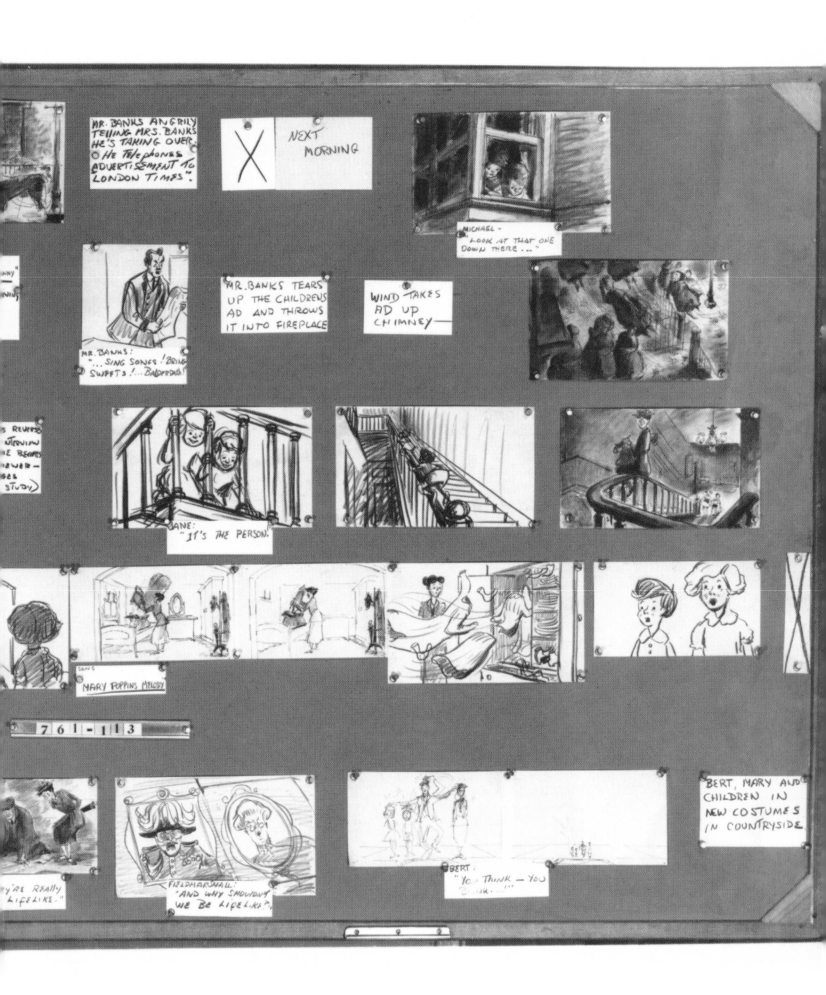

ABOVE: An early storyboard illuminates the method by which the Sherman brothers and Don DaGradi built the narrative and musical structure for Mary Poppins.

Animation

Creating a Destination for a "Jolly Holiday"

"Walt always had felt there was a special fascination in combining live action with the cartoon, as he had done in his very first shorts back in 1923 with the Alice pictures," Frank Thomas and Ollie Johnston wrote in their landmark book *Disney Animation: The Illusion of Life*. "Together, the two mediums create a different kind of fantasy with a potential far beyond what anyone has done."

From the very first thoughts of it, Disney saw *Mary Poppins* as combining live action and animation. Travers never saw it as an animated film, either, and Roy had assured the author as early as 1944 that "it might be best for *Mary Poppins* to be produced in a combination of live-action and cartoon, using the animation to get at the fantasy and illusion of the Mary Poppins character."

Thomas and Johnston understood that this technique wasn't simply a technical contrivance of combining layers or elements. "New restrictions are placed on all the participants, because they are not simply adding another dimension to the familiar product; they are now working in what is actually a third medium. It must be planned more carefully, conceived with even more imagination, and budgeted realistically, but the results can be pure magic."

The elaborate animated "Jolly Holiday" sequence was designed after the style of English cartoonist Ronald Searle, a graphic style that had first been used in *One Hundred and One Dalmatians*. It seemed to evoke a kind of "English" feel but was sophisticated in shape language and simplified style that looked better with the Xerox cel outline printing method.

"Milt Kahl dominated all final designs in those days, and that's a good thing," says famed animator and Disney Legend Andreas Deja. "As Brad Bird said, without Milt's influence, the late Disney movies would look styleless. Without any particular graphic approach."

Milt Kahl also animated much of the fox hunt, along with John Lounsbery. The Tea Shoppe scene was animated by Frank Thomas and Ollie Johnston; Ollie did most of the introductory scenes with the penguin waiters, and Frank did the famous dance with Dick Van Dyke and the birds. The top talents in Disney Animation—Ward Kimball, Eric Larson, Cliff Nordberg, Hal Ambro, Jack Boyd—also created the unforgettable character animation under the direction of Hamilton Luske.

The challenges created by the animation being conformed to already-filmed live action were many, in staging, scale, perspective, and appearance. "Of course, Walt knew exactly what would happen, Thomas and Johnston said. "The animator would fuss and complain and call a few names, but in the end he would become more inventive and more entertaining than he would have been if everything had been made easy for him."

ABOVE: *Frank Thomas and Ollie Johnston play the part of penguins fro two colleagues.*

ABOVE: A penguin performs a softshoe in these clean-up animation drawings from a scene by Frank Thomas.

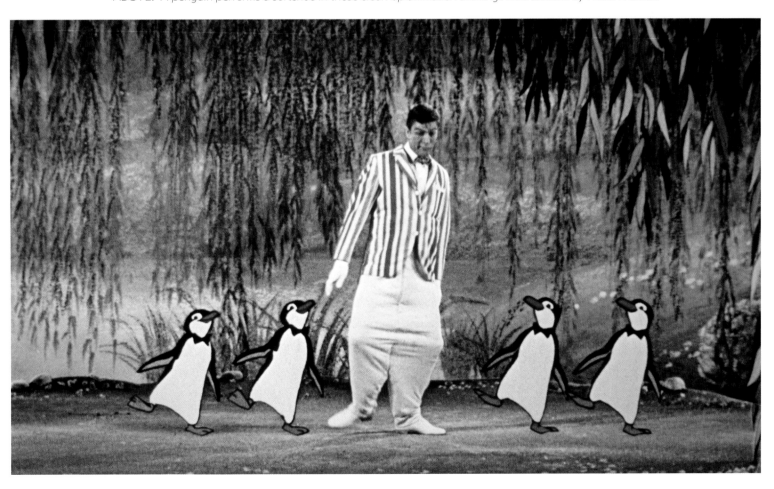

ABOVE: A final frame from one of the film's most iconic scenes.

Casting About

Finding Players to Fit the Play

"The process of casting a film is either a mystery to or misunderstood by a great many people," says casting director Matthew Jon Beck.

Much of the assignment of actors to roles on *Mary Poppins*, like so much of what happened on his studio lot, originated with Walt Disney—and every casting decision had to meet with his approval. "The casting process typically involves a combination of 'list-making' (popular actors or marquee 'stars') and auditioning or interviewing for supporting or smaller parts. I'm guessing that no one had to actually *audition* for their roles in *Mary Poppins*," Beck says, "and Maude Spector, who had cast several Disney films produced in England, was possibly consulted."

Certainly, Walt has been well-documented as the primary force behind the casting of Ed Wynn as Uncle Albert, and Jane Darwell as the Bird Woman. Karen Dotrice and Matthew Garber had already charmed Walt (and audiences) in *The Three Lives of Thomasina*.

"Another consideration, of course, is who is popular with audiences at the time. Walt Disney was certainly very keen in his knowledge of this. Dick Van Dyke was probably the biggest television star at the time and was certain to bring in crowds."

In the end, the entire primary cast of Mary Poppins, except Dick Van Dyke and Ed Wynn, was British. Many of the best British character actors working in Hollywood at the time were recruited. It was a "British Invasion" of the United States a year before The Beatles hit the colonies.

FEB. 27, 1961
XXXX NL

MISS MARY MARTIN
450 EAST 52nd STREET
NEW YORK N.Y.

DEAR MARY -

I AM PRESENTLY WORKING ON A TREATMENT OF
PAMELA TRAVERS BOOK, MARY POPPINS, WHICH
I HOPE TO DO A YEAR FROM NOW AS A LIVE ACTION
MUSICAL STOP IN MAKING YOUR LONG RANGE
COMMITMENTS, WILL YOU PLEASE HOLD YOURSELF
OPEN TO CONSIDER PLAYING THE ROLE OF MARY
 YET
FOR US? THE TREATMENT IS NOT/FINISHED SO
AM UNABLE TO SEND IT TO YOU BUT HOPE TO HAVE
XXXHOPEXXOXXXXX SOMETHING IN THE WAY OF
SONGS AND THE GENERAL STORY IDEA FIRMED UP
WITHIN THE NEXT COUPLE OF MONTHS STOP I WILL
BE IN NEWYORK MARCH 20 AND WHILE THERE WANT
TO CATCH YOUR SHOW AND PERHAPS WE CAN HAVE
A FEW MOMENTS TOGETHER TO BRIEFLY DISCUSS
MARY POPPINS. BEST REGARDS.

 WALT DISNEY

What's interesting to see in *Mary Poppins*, too, is how flawlessly secondary and walk-on roles are filled, in a manner that appears mainly to rely on exceptional and memorable *faces* such as Marjorie Bennett, Cyril Delevanti, Queenie Leonard, Don Barclay, Alma Lawton, and Marjorie Eaton. It creates a plausible population of this fantasy London, since every person who appears onscreen was carefully considered.

"Assembling a good cast involves ideas and opinions from many fronts, but in broad terms, and in final analysis, casting is *chemistry*," Beck says. "That which occurs between the actor and the role, and also between fellow cast members. The most important consideration in casting is choosing actors who will best bring the characters to life—within the vision of the producer or director, of course."

Naturally, casting ideas for *Mary Poppins* began as soon as the project was being discussed. Over years of development, dozens of names were considered for the principal roles.

Renowned Oscar-winner Bette Davis (RIGHT) was considered at the outset of development; her maturity and crisp onscreen demeanor seemed very much in keeping with the Mary Poppins of Travers's writing. But the filmmakers worried about Mary being too harsh. "Beauty gets away with murder," Robert Sherman said. "It always has. In the books, as well as the movie, Mary Poppins was often curt at the expense of being courteous. You could believe that Bette Davis would make the Poppins-esque comments that that character does. But only Julie Andrews could actually get away with making those comments . . . and you still love her!"

As development continued and the predominant musicality of the film began to take shape, it became apparent that a musical star would be needed for the title role. In

a February 1961 telegram, Walt approached three-time Tony Award–winning actor Mary Martin (LEFT), who was then starring on Broadway in *The Sound of Music*. Ultimately Martin's busy schedule and commitments to stage productions prevented further consideration.

Angela Lansbury (RIGHT) was considered for the role of Mary Poppins, she was certainly English, and at the time was unsettled between roles that were somewhat beneath her in Hollywood films such as *Blue Hawaii* and stage work where her charm and versatility were much more evident. In the end, she was passed over, but she would return to Disney in another big-screen Sherman brothers musical fantasy directed by Robert Stevenson, *Bedknobs and Broomsticks*.

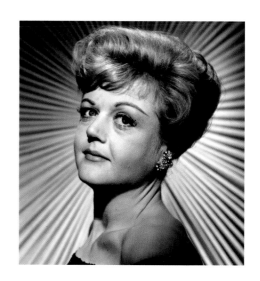

Even as late along as April of 1962, Mrs. Travers suggested Tony Award–winning stage, screen, and television actor Julie Harris to Walt, saying, "I believe she could not fail, and she has always longed to play the part."

In September of 1961, while Walt was in London at the end of a European trip, he and Travers had a phone conversation during which they discussed English actor, singer, and songwriter Anthony Newley (LEFT) for the role of Bert. Newley seemed a natural for the part; he was English—for Travers that was vital—and he'd been a child actor and a pop star. (As a recording artist, he enjoyed a dozen

Top 40 entries on the UK Singles Chart between 1959 and 1962, including two number one hits.) Newley's name was brought up again in a May 18, 1962, letter from Walt to Travers.

In the same letter, Walt made an impassioned case for Cary Grant (LEFT) as Bert Mrs. Travers immediately replied on May 21." I was on the verge of writing to you when your letter arrived. I was going to suggest Cary Grant!!! But not for Bert. There is not enough of Bert to make the part worthy of him, and only an English writer could build him up to any reality. . . . No, I was going to suggest Cary Grant for Mr. Banks, who is, if you read the book closely, the obvious opposite to Mary Poppins. . . "

Ultimately, at the urging of the Sherman brothers and Walt's secretary, Tommie Blount, Walt saw *Camelot* on Broadway on a visit to New York City. He was charmed by its star and went backstage afterward to pitch his casting idea directly to her. And the rest, as the saying goes, is history.

May 18, 1962

Dear Pamela Travers -

In reply to your letter of April 18th from Rome, I am sorry to report that "Mary Poppins" is just about the same as it was when you were here last year.

As you remember, after your visit with us, it was your wish to go back to England to give it some thought before signing the contracts. This, of course, meant that the boys who were working on the story at that time had to be assigned to another project. In fact, since that time they have both worked on two projects. Now, however, these are in production and we have just this week got back again on "Mary".

I don't feel that you should be too concerned about some of the things you mentioned in your letter because, after all, during your visit here we had ample opportunity to discuss "Mary" with you and get your feelings about the story.

As regards casting -- it will be a little while before we actually start to cast the story. First we must get the picture in better shape. Also, we are reworking the musical numbers.

The thought of Antony Newly for Bert is still in our minds... although it is our hope that we may be able to interest Cary Grant, who has a great international following. He is English and in his early years was a song and dance man in the English musical comedies. A case in point is a picture he did a good many years ago called "The Hasty Heart". But, of course, he would be interested only if the part of Bert is equal to that of Mary. This would be good for the screenplay as well. So we are going to see if we can develop Bert into a more important role hoping to interest Cary. We talked with him on the phone about it and he seemed to like the idea. But, naturally, he will have to see the script first and we plan to present the general idea to him when he returns from Europe in July.

Miss Pamela Travers -2- May 18, 1962

What all this boils down to is that we really haven't got the the point of making any firm decisions as yet. When we have the story line more fully developed we will begin work on casting.

With all good wishes.

Sincerely,

Miss Pamela Travers
50 Smith Street
Chelsea SW 3, England

WD:tb

P.S. I stand corrected on the title of the picture Cary Grant was in. It was "None But The Lonely Heart" with Ethel Barrymore. Incidentally, I may be in England toward the latter part of August and at that time, I should be able to tell you more about the story treatment.

A Practically Perfect Performer

From "Fair Lady" to Cherry Tree Lane

"Ever since Julie Andrews danced into the hearts of everyone lucky enough to see her legendary creation of Eliza Doolittle in *My Fair Lady*, she has remained one of the world's most 'favorite things.' Julie was practically born in a trunk, making her professional debut at the age of eleven on December 5, 1946, in front of the then Queen (later the Queen Mother) and Princess Margaret (late younger sister of Queen Elizabeth's) at the Stage Door Canteen in London. Her first starring role was to be only two years later at the Prince Edward Theatre (then known as the London Casino), playing the title role in *Humpty Dumpty*.

"Over the next few years, Julie appeared all over the country in theaters and on television and radio, plus returned to the Prince Edward to star in *Aladdin* in 1951. In 1954, Julie made her Broadway debut as Polly in Sandy Wilson's *The Boy Friend* (the same year another British musical, Julian Slade's Salad Days, was to change my life by inspiring me to become a producer). Her success as Polly brought her to the attention of Alan Jay Lerner and Frederick Loewe and won her the role of Eliza opposite Rex Harrison's Higgins in *My Fair Lady* in 1956. Andrews followed that with *Camelot* in 1960, when she played Queen Guenevere to Richard Burton's King Arthur. It was to be her last stage role for more than thirty years.

"Julie's extraordinary popularity really took off worldwide after the phenomenal success of the films *Mary Poppins*, for which she won an Oscar, and *The Sound of Music*. She took Hollywood by storm, making many successful movies, often directed by her husband, Blake Edwards, including *Victor/Victoria*.

"Julie's timeless appeal remains as fresh as when she first flew into Cherry Tree Lane and has remained practically perfect ever since."

Cameron Mackintosh

has produced more musicals than anyone in history, including the three longest-running musicals of all time, Les Misérables, The Phantom of the Opera, and Cats, which are still running extraordinarily successfully across the world. Joining this list of legendary titles, his co-production with Disney of Mary Poppins continues to break records and disperse her magic globally. The foregoing is an excerpt from an essay he wrote for a benefit performance hosted by Julie Andrews in 2005.

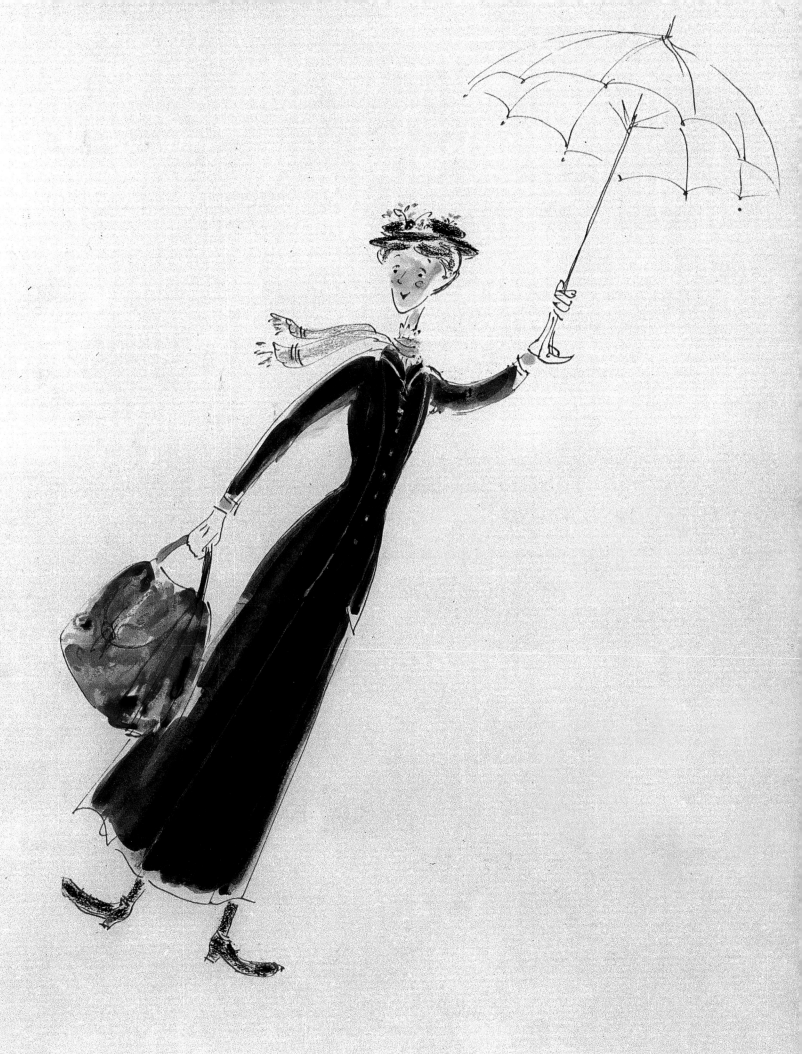

MARY POPPINS

Tony Walton's "traveling outfit" costume
design drawing for Mary Poppins.

When You're with a Sweep You're in Glad Company

Gavin Lee Appreciates Dick Van Dyke

While I played the character of Bert, the chimney sweep and familiar of the magical Mary Poppins—for two years in London, another two on Broadway, then around the United States for a year and a half—reporters and audience members in every city all along the way asked me one question more than any other: Do you know Dick Van Dyke?

Well, of course I knew him, as we all do—Dick Van Dyke was, and is, a show business icon. After beginning in radio, live comedy, and early television, the Dick Van Dyke "legend" truly launched in the smash 1960 Broadway musical *Bye Bye Birdie*, for which he won a Tony Award. (He reprised his role in the 1963 movie, too.) From 1961 to 1966, Van Dyke starred in the popular CBS series *The Dick Van Dyke Show*, for which he won three Emmy Awards as Outstanding Lead Actor in a Comedy Series, while the show itself received four Emmy Awards for Outstanding Comedy Series.

Van Dyke has also starred in a number of beloved films throughout the years, including *Chitty Chitty Bang Bang*, *Fitzwilly*, *Dick Tracy*, *Curious George*, *Night at the Museum*, and *Night at the Museum: Secret of the Tomb*.

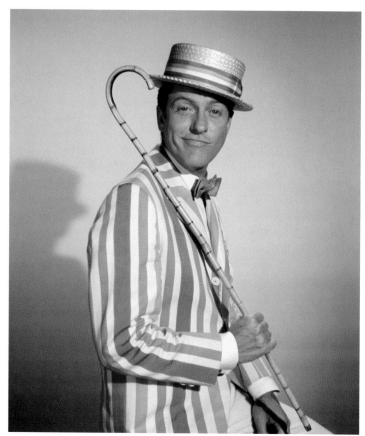

Naturally, as a kid I'd seen *Mary Poppins*, but only two or three times. In England, *Chitty Chitty Bang Bang* seemed more "present"; it was on television almost every Christmas. In my memory, one year you'd sit down and watch *The*

Wizard of Oz, and the next year it was *Chitty Chitty Bang Bang*. So I knew Dick more as Caractacus Potts than as Bert. It was only as I got a little older that Dick Van Dyke became more associated with *Mary Poppins*. Later on, I learned about the rest of his storied and remarkable career.

When I had an audition for the *Mary Poppins* stage musical production back in 2003, I obviously prepared by watching the film of *Mary Poppins* on video. I was enthralled by Dick's fantastic, iconic performance—and naturally built my own version of Bert from his portrayal of the character in the movie.

But in six years of standing in Dick's sooty footsteps on the rooftops of London (and Broadway—and all over), I hadn't *actually* met him. Not in person. In every city I was asked, "Have you ever met Dick Van Dyke?" And every time I had to say, "No, unfortunately." Dick hadn't been able to make it to London, or to New York (at least not when I was in the show).

Then, in 2010, when the national company of the stage show came to Los Angeles, I was asked to go to the Walt Disney Studios and have lunch with none other than Dick Van Dyke! The fact that he wanted to meet me just humbled me, and as my wife and I visited with him over our meal, I just wanted to ask him all about his career. But at least half of the time, I was answering *his* questions about *my* career—he was so humble and seemed sincerely interested in what *I* had done.

After lunch, they had asked me to participate in an on-camera interview. I thought, *Oh, how cool, Dick and I are going to be interviewed* together *for* Entertainment Tonight! As we got set up on the studio lot and they were putting microphones on us, the segment producer said, "Okay, Gavin, we'll start the shoot here, and we're gonna walk down Mickey Avenue here, down to the soundstages. . . ." It was only then that I understood that it was *me* who was going to be interviewing Dick, by means of a conversation as we took a walk!

Luckily, I had a couple of things in my favor—we'd just had a lovely, relaxing, and informative lunch together; and Dick is a true professional and an expert raconteur. He and I walked through the Disney Studios lot as if we were the oldest and most familiar of

friends, which is the way he made me feel. His memories and anecdotes of the making of *Mary Poppins* seemed to dovetail effortlessly with my own actual curiosity and questions about the subject.

At first, I was afraid that it would seem stiff and staged, but in reality, because of the type of guy that Dick is, and the stunning breadth of his career, he can just talk about such great things, and is happy to engage in the sharing of stories.

The day after meeting Dick, the next reporter that I met asked that same question: "Have you ever met Dick Van Dyke?" and finally, honestly, I could say, "Yes." Not only had I met him, but I felt as if I'd actually had a reunion with a good old pal, or a favorite uncle. So, yes, I have met this fantastic guy, whose gigantic shoes I've had to try to fill in this role for the last six years. And I can say that it only enhanced the rest of my performances, having met the actual, real Bert from *Mary Poppins*.

A few nights later, Dick and his family attended our Los Angeles opening night. He was as thrilled to be there as any member of the audience. As he had been before, he was so "up" and excited (it seems as if he's always doing a little jig). A friend of mine was his VIP escort that night; he told me later that it was as much fun to watch Dick's reaction to the show as the show itself—and every time the music came up, Dick's feet would start moving, and he'd

CHAPTER THREE

dance as he sat! Throughout the show, a beaming smile never left his famous face.

In the times I've seen him since, the truth is I've never seen him just walk into a room and say "hello." He *moves* from place to place as a dancer does, always accompanied with pleasure, and excitement—eye contact, a smile, a "pleased to see you" attitude. Even in his nineties, he's just alert and upbeat and energized and natural at all times it seems.

I found out during our visit that Dick had gone to school in Danville, Illinois, with—and had been friends with—Donald O'Connor. That they'd know each other didn't surprise me. It did get me to thinking about Dick as a physical entertainer, as a dancer, as a man who uses his long, lean form and natural grace to inform everything he does in character. He and Donald O'Connor perhaps represent a "last generation" of song and dance men, with roots back to the days of vaudeville, where mime and dance and slapstick can all merge to create one unnameable art form. Dick was a huge fan of silent movie comedy, too, and had become good friends with his childhood idol, Stan Laurel. (I think there's some Stan Laurel in Bert.)

I think this sense I had of him, all of the traits I'd observed, and what I knew of the joyous showman he was, culminated for me on our opening night in Los Angeles. He was genuinely thrilled when the assembled company called him up onstage to share our curtain call; he so sweetly and graciously fell to one knee before me and "passed the cap" of Bert to me in a moment I'll never forget. Backstage, of course, everyone wanted to meet him, and he exclaimed, "I just wanted to be up here onstage with all of you!"

Some sharp fellows in our Disney Theatrical group heard that, and a few months into our run, Dick *did* join us up there onstage! Our publicity folks went back to Dick and asked him if he'd like to do a special "cameo" appearance in one of our performances and use it as a benefit for the charity he's been so involved with, the Los Angeles Midnight Mission. Dick leapt at the chance. Our tour producer, Anthony Lyn, crafted a moment at the bank in the second act, where the (unseen in our production) chairman of the bank, Mr. Dawes, emerges at a critical moment and engages with our Mr. Banks, Karl Kenzler, in a spirited reprise of "Supercalifragilisticexpialidocious."

Unlike when he played the old banker in the film, Dick required no "old-age" makeup, and he entered into rehearsing and performing this role with the commitment and relish of a true professional. Of course, all of us in the company had convenient excuses for why we just happened to be in the theater and backstage—and onstage—during his rehearsal: so we could see Dick in action.

We didn't announce that Dick would be in our show that night—the single clue was a note slipped into the evening's program that read, "At this evening's performance, the role of Mr. Dawes, the Elder, will be played by Nackvid Keyd" (an homage to his end credit for the same role in the original film).

When the time came, the two big doors opened up in the back of the bank set, and Dick Van Dyke entered. Some in the audience (the biggest fans) immediately understood, and gasped, and began to applaud. As the rest of the audience began to get it, they applauded, and rose to their feet, and cheered. It stopped the show cold like nothing I've seen before or since. (I was just upset because Bert isn't in that scene.) I got to watch it all from the wings, and bathe in the glow of affection from that audience, for a man who has truly earned his beloved stature in entertainment.

That outpouring of love and excitement made me realize that so much of the character of Bert is because of Dick himself: his lanky postures, his way of leaning on his sweep's brush or screever's stick, the sprightly way he moves the length of his body. An ease of movement, a sort of grace mixed with a bit of comedy. These are just simple, physical signatures that became a part of how I also interpreted the character.

Dick also infused Bert with humor, mischief, intelligence—and a mysterious quality. He's also a gentle soul, who looks after children and gently tells uncomfortable truths to grown-ups.

I never tried to imitate Dick Van Dyke or duplicate what he did on film. That would have been foolish and unsuccessful. I did try to bring those wonderful *qualities* to my performance, though. To follow his lead wherever I could. Because *no one* could ever bring to the character

of Bert what Dick Van Dyke did—his unmistakable personality, his inimitable presence, his remarkable skill, and decades of the well-deserved respect and love of colleagues and audiences everywhere.

Gavin Lee

originated the stage role of Bert in the London production of Mary Poppins, a role he also played on Broadway and the first national U.S. tour (earning Tony and Olivier nominations, and Drama Desk and Theatre World awards). He has been seen on Broadway as Squidward *in* SpongeBob SquarePants: The Broadway Musical, *and* Thenardier *in* Les Misérables. *His other theater work includes* Show Boat *(Carnegie Hall) and* Holiday Inn *(World Premiere, Goodspeed). He has been seen in London in* Top Hat, Crazy for You, Peggy Sue Got Married, A Saint She Ain't, Me and My Girl, Oklahoma! *and* Contact.

Dick Van Dyke joined Gavin Lee and Ashley Brown in a special performance of Mary Poppins on January 22, 2010.

Glynis Johns
as Winifred Banks

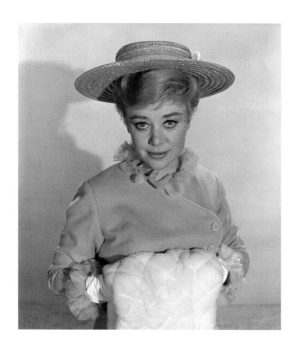

With her unique combination of a husky voice and breathy delivery, and a wide-eyed prettiness, British stage, television, and film actor, dancer, pianist, and singer Glynis Johns has charmed audiences for decades. She was born in Pretoria, South Africa while her parents, a stage actor and a pianist, were on tour. Her best-known film role is no doubt that of Winifred Banks, but she also created the role of Desiree Armfeldt in *A Little Night Music* on Broadway, for which she won a Tony Award. In both roles, she sang songs written specifically for her: "Send in the Clowns," by Stephen Sondheim, and "Sister Suffragette," by the Sherman Brothers. She is also an Oscar nominee for the 1960 film *The Sundowners*.

Hermione Baddeley
as Ellen, the Maid

A beloved English character actor on stage, screen, and television, Hermione Baddeley was usually cast as brash domestics or brassy commoners. She made her theatrical debut in 1918 and became popular on the London stage prior to World War II, and had a long professional relationship with Noël Coward, appearing in many of his plays throughout the 1940s and 1950s. She appeared in several films after her screen debut in 1927 and was nominated for an Academy Award for Best Supporting Actress for *Room at the Top* in 1959. She was nominated for the Tony Award for Best Performance by a Leading Actress in a Play for *The Milk Train Doesn't Stop Here Anymore* in 1963. She was familiar to American audiences for TV roles in *The Patty Duke Show*, *Bewitched*, *Rod Serling's Night Gallery*, *The Love Boat*, *Charlie's Angels*, *Little House on the Prairie*, and *Maude*. In the same year as *Mary Poppins*, she played Buttercup Grogan in *The Unsinkable Molly Brown*, and in 1967 played another stalwart Disney domestic in *The Happiest Millionaire*. Baddely also provided the voice of Madame Bonfamille in Disney's *The Aristocats*.

CHAPTER THREE

Ed Wynn
as Uncle Albert

Ed Wynn was a legendary comedian and actor in vaudeville, theater, motion pictures, and on radio and television. In addition, he was a producer, author, and songwriter.

Wynn made his professional debut with the Thurber-Nasher Repertoire Company in Norwich, Connecticut in 1902. In 1921, he wrote, directed, produced, and starred in a revue titled *The Perfect Fool*, a nickname and character he carried forward for years. During the 1930s he starred in a nationwide radio show based on his vaudeville persona, *The Texaco Fire Chief Program*, and his voice became familiar to millions of listeners. (His appearance in Disney's *The Absent-Minded Professor* as the Medfield Fire Chief was a gag inspired by this program.) His early films included *Rubber Heels*, *Follow the Leader*, and *The Chief*.

Wynn took on unforgettable dramatic roles in the 1950s, won a 1956 Emmy Award for *Requiem for a Heavyweight*, and was Oscar-nominated in 1959 for the feature *The Diary of Anne Frank*. For Walt Disney, Wynn was an idol who became a good-luck charm; in addition to voicing the Mad Hatter for *Alice in Wonderland* and the aforementioned *The Absent-Minded Professor*, Wynn appeared in Disney's *Son of Flubber*, *Babes in Toyland*, *Those Calloways*, *That Darn Cat*, *The Gnome-Mobile*, and the TV film *For the Love of Willadean*. Other guest starring work on television included *The Twilight Zone*, *General Electric Theater*, *The Red Skelton Show*, *77 Sunset Strip*, and *Bonanza*. His later films included *The Greatest Story Ever Told*. His son, Keenan Wynn, became a well-known actor, and his grandson, Tracy Keenan Wynn, a screenwriter.

Reginald Owen
as Admiral Boom

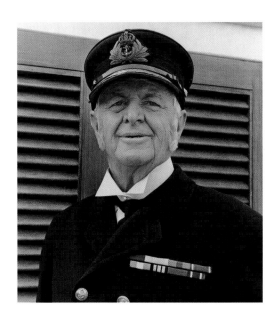

English character actor Reginald Owen was a familiar face to British and American moviegoers and TV audiences for decades, from the silent film era until his passing. Today, he may be best remembered for his role as "Scrooge" in the 1938 film version of *A Christmas Carol*. Late in his career, he was a frequent guest star on such series as *Maverick*, *One Step Beyond*, *Bewitched*, *It Takes a Thief*, and *McCloud*. Following his role in *Mary Poppins* he appeared in Disney's *Bedknobs and Broomsticks* (his final movie role).

Reta Shaw typically played one end of the spectrum or the other: hard-with-a-heart-of-gold domestics, or wealthy and domineering matrons. Her staunch characters benefitted from her roots in Maine; her father was a well-known New England orchestra leader. A graduate of the Leland Powers School of the Theater in Boston, Shaw appeared on Broadway in the original production of *The Pajama Game*, *Gentlemen Prefer Blondes*, *Picnic*, and *Annie Get Your Gun* with Mary Martin. She had featured roles in several motion pictures, including *Picnic*, *The Pajama Game*, *Pollyanna*, and *The Ghost and Mr. Chicken*. Shaw became a staple of TV programs, appearing in *The Ann Sothern Show*, *Alfred Hitchcock Presents*, *The Millionaire*, *The Lucy Show*, *Wagon Train*, *My Three Sons*, *Bewitched*, *I Dream of Jeannie*, *That Girl*, and *The Odd Couple*. For two seasons she was "Martha" on the series *The Ghost & Mrs. Muir*. Her final screen performance was in Disney's *Escape to Witch Mountain*.

Reta Shaw
as Mrs. Brill, the Cook

Elsa Lanchester
as Katie Nana

After studying dance as a girl, British actor Elsa Lanchester began a long career in theater, film, and television. Shortly after the First World War she established herself in stage and cabaret, over the following decade. She met the actor Charles Laughton in 1927, and they were married two years later. She began playing small roles in British films, and Laughton's success in American films led the couple to relocate to Hollywood. There she was a standout as the title character of James Whale's *Bride of Frankenstein*, and she subsequently played dozens of supporting parts throughout the 1940s and 1950s. She was Oscar-nominated for Best Supporting Actress in 1949 for *Come to the Stable* and in 1959 for *Witness for the Prosecution*, the last of a dozen films in which she appeared with Laughton. Following his death in 1962, she remained active in film and television work, at Disney in *That Darn Cat!* and *Blackbeard's Ghost*, in the horror film *Willard*, and in the Agatha Christie parody *Murder by Death* (1976).

CHAPTER THREE

Jane Darwell
as The Bird Woman

With appearances in more than a hundred motion pictures over fifty years, Jane Darwell is perhaps best-remembered today for two roles: her poignant portrayal of Ma Joad in the film adaptation of John Steinbeck's *The Grapes of Wrath* (for which she received the Academy Award for Best Supporting Actress), and her role as the Bird Woman in *Mary Poppins*. Making her stage debut at age 33, Darwell was almost 40 when she made her first film in 1913. In her movie work she often played kindly grandmothers, dowagers, or plain country folk. She appeared in films ranging from classics such as *Gone With the Wind* and *The Ox-Bow Incident* to B-movies, and TV programs such as *Maverick*, *The Real McCoys*, *Wagon Train*, *Lassie*, and *Burke's Law*. When she was living in the Motion Picture Country Home, Walt Disney personally asked her to join the cast of *Mary Poppins*, her final film role.

Arthur Treacher
as Constable Jones

Well-known for years of playing butlers, manservants, and other stereotypically "English" roles, Arthur Treacher was a perfect fit for the part of London policeman Constable Jones. Active from the 1920s to the 1960s playing stiff-upper-lip and domestic roles in films such as *Thank You, Jeeves* (and a sequel) and opposite Shirley Temple in *Curly Top*, *Heidi*, and *The Little Princess*, Treacher became familiar to a whole new generation and audience in the 1960s as the announcer/sidekick to talk show host Merv Griffin. He also learned the value of his "brand," and lent his name to a home services business and the highly successful Arthur Treacher's Fish and Chips chain of restaurants.

Karen Dotrice
as Jane Banks

Karen Dotrice was born into a family of prominent stage actors. Her father, Roy Dotrice, first brought the four-year-old to the stage to perform in the Royal Shakespeare Company's production of Bertolt Brecht's *The Caucasian Chalk Circle*. While performing in that production, Karen was spotted by a Disney scout and, soon after, appeared in *The Three Lives of Thomasina*. That led to her being cast as Jane Banks, followed by the role of Elizabeth in *The Gnome-Mobile* with Walter Brennan.

By 1968, she had returned to England and went on to appear in such features as *Joseph Andrews* in 1976 and *The Thirty-Nine Steps* in 1978, for which she received accolades for her lead performance as the English aristocratic love interest opposite Robert Powell. She also played Lily in the popular English television series *Upstairs, Downstairs* in 1971. Other television appearances include the miniseries *Napoleon and Love* in 1974 and *She Fell Among Thieves* in 1978, which appeared on *PBS's Mystery!*

Karen returned to the United States in 1980, and four years later, after playing Desdemona in *Othello* on Broadway, she retired from acting to focus on motherhood. She was named a Disney Legend in 2004.

Matthew Garber
as Michael Banks

Matthew Garber is best known for his role as Michael Banks, his second of three Disney films with Karen Dotrice, along with *The Three Lives of Thomasina* and *The Gnome-Mobile*. Garber was considered a spirited and bright boy in a 1967 Disney press release that noted his enjoyment of pulling practical jokes on his friends, playing sports, and reading adventure, mythology, and poetry books.

After *The Gnome-Mobile*, Garber retired from the screen and returned to school in England. He contracted hepatitis on an overland trip to India in 1976–77, and by the time he was brought back to England it had become pancreatitis. He died at the age of 21. Garber was posthumously named a Disney Legend in 2004. His younger brother, Fergus Garber, accepted on his behalf.

CHAPTER THREE

To Carve His Niche in the Edifice of Time

An Appreciation of David Tomlinson

"A man has dreams of walking with giants, to carve his niche in the edifice of time." So the lyrics by the Sherman brothers attest. Those who worked on the film *Mary Poppins* certainly have made their mark in cinematic history. Who can forget Julie Andrews's practically perfect, Academy Award–winning performance as the title character or Dick Van Dyke's breezy turn as the jack-of-all-trades Bert? For me, however, the performance that always grabs at my heart and brings me to tears is that of British thespian David Tomlinson, with his marvelously nuanced portrayal of perturbed patriarch Mr. George Banks. At times comedic and deliciously over the top, while at other times poignant and intimate, it is the often-overlooked performance by Tomlinson that steals the show—and has made this my favorite Disney film.

I never saw *Mary Poppins* when I was young. Though the first movie I had ever seen in my life was a Disney movie, and as a youth I went to the theater to see every animated re-release, I had long harbored reservations about watching this story about a practically perfect nanny, a chimney sweep, and a pair of British children on a jolly holiday in chalk paintings. It had just never piqued my interest. It wasn't until I was in my mid-twenties that I first saw the film on a local television station. I soon realized that the story was not about children or their seemingly magical caretakers, but how a dutiful, yet absent, father learns that loving his children is his true purpose. The titular larger-than-life nanny was merely a means to bring about that epiphany. The father's arc, so deftly delivered by Tomlinson, amidst all of the dazzling effects, visual design, memorable music, and rousing choreography, is the touchstone of the entire film.

Though Tomlinson was a veteran of over thirty-five British films and a longtime fixture of the British stage, *Mary Poppins* was his debut in an American film. In his biography, *Luckier Than Most*, Tomlinson shed light on how Walt had already been familiar with Tomlinson's

work even before Bill Walsh, the veteran producer assigned to *Mary Poppins* (and the one who claimed he "discovered" David for the role of George Banks in the film), had shown Walt the reels for *Up the Creek*, a whimsical British comedy in which David had a starring role.

Unbeknownst to Walsh, Walt had already met Tomlinson and had seen him onstage two years prior in Wynyard Browne's *The Ring of Truth*. According to Tomlinson, it was "typical of Walt to be one jump ahead." At the time of Tomlinson's casting as the Banks patriarch, the actor had been engaged in a two-year stint onstage as a French lothario in the London production of *Boeing Boeing*, a bedroom farce by playwright, Marc Camoletti. Now his role would involve children, chimney sweeps, proper nannies, and learning the value of tuppence.

Though he had served with courage as a flight instructor for the RAF during World War II, joining the cast of *Mary Poppins* was a daunting prospect to the actor, as Tomlinson had never performed in a musical before, and had no vocal training. Irwin Kostal, musical director of the film, related that Tomlinson had "a well-modulated, but untrained baritone voice." Engaging in some vocal practice with Kostal, though, soon put Tomlinson in fine singing form as his opening number, "The Life I Lead," readily demonstrates.

Through his thirty days of filming, starting in 1963, David struck just the right notes as George Banks. From assuredly proclaiming in song how good it was to be an Englishman in 1910, to his befuddled reaction to his increasingly higgledy-piggledy household, to the despondent loss of his station—and to the ultimate revival of his spirit upon exclaiming a fourteen-syllable nonsense word—Tomlinson humanized the realization of a distant father and his need to connect with his children.

The moment when George Banks, standing beside his fireplace, confesses to Bert his desire to "walk with giants and to carve his niche in the edifice of time" is played so honestly, so *personally*, that it utterly reveals the vulnerability of man unsure of what he was once so certain. Even as Tomlinson's Banks simply *listens* to the gentle dressing-down delivered by the sweep, Tomlinson's thoughtful and intelligent—and silent—reactions fill the screen with honesty and character.

Having endured and persevered through a personal loss—the death of his first wife and their children while he was an ocean apart from them—one wonders if such experience informed his noble interpretation of George Banks. When the character loses his station at the bank, Tomlinson's portrayal reveals that identifiable loss suffered by a good man in confusing circumstances. George's discovery of purpose and redemption is all the more rousing for the insightful acting choices made by David throughout all of his scenes.

In August of 1963, Tomlinson capped his duties on the soundstage with recording sessions for a number of the animated characters in the film. If one listens closely enough, one can hear his voice as one of the penguin waiters, a turtle helping Mary and Bert cross the stream, a soaked huntsman's horse—and, in superb counterpoint, Mary's own parrot-headed umbrella admonishing the stern nanny about her love for the Banks children.

Ironically enough, Tomlinson did not think much about his work on *Mary Poppins* or even of the film itself. In his autobiography, he writes that after seeing a rough cut of the film, he felt the film was "appallingly sentimental and that it must be a failure," adding he very nearly said to Disney himself, "Well, Walt, you can't win them all." However, Tomlinson admitted how very wrong he was about *Mary Poppins*. Though he may have been too proper and humble to admit it, Tomlinson was wrong about the appeal of his own work, too. Tomlinson at once makes the role of George Banks real and truthful, which is the apex of the actor's profession.

Later appearing in *Bedknobs and Broomsticks* and *The Love Bug*, Tomlinson became a familiar face in Disney films, though his performance in *Mary Poppins* is, for me, unparalleled. He was posthumously inducted as a Disney Legend in 2002. Tomlinson has indeed walked (and danced) with giants.

Fox Carney

is a twenty-six-year veteran of The Walt Disney Company, plying his skills for twenty-three of those years at the Animation Research Library (ARL). As Manager of Research at the ARL, he leads a team that assists clients within and outside The Walt Disney Company in studying and working with the artistic heritage of the Walt Disney Animation Studios. He has written articles for Disney twenty-three *Magazine as well as given multiple presentations about the Disney legacy at D23 Expo.*

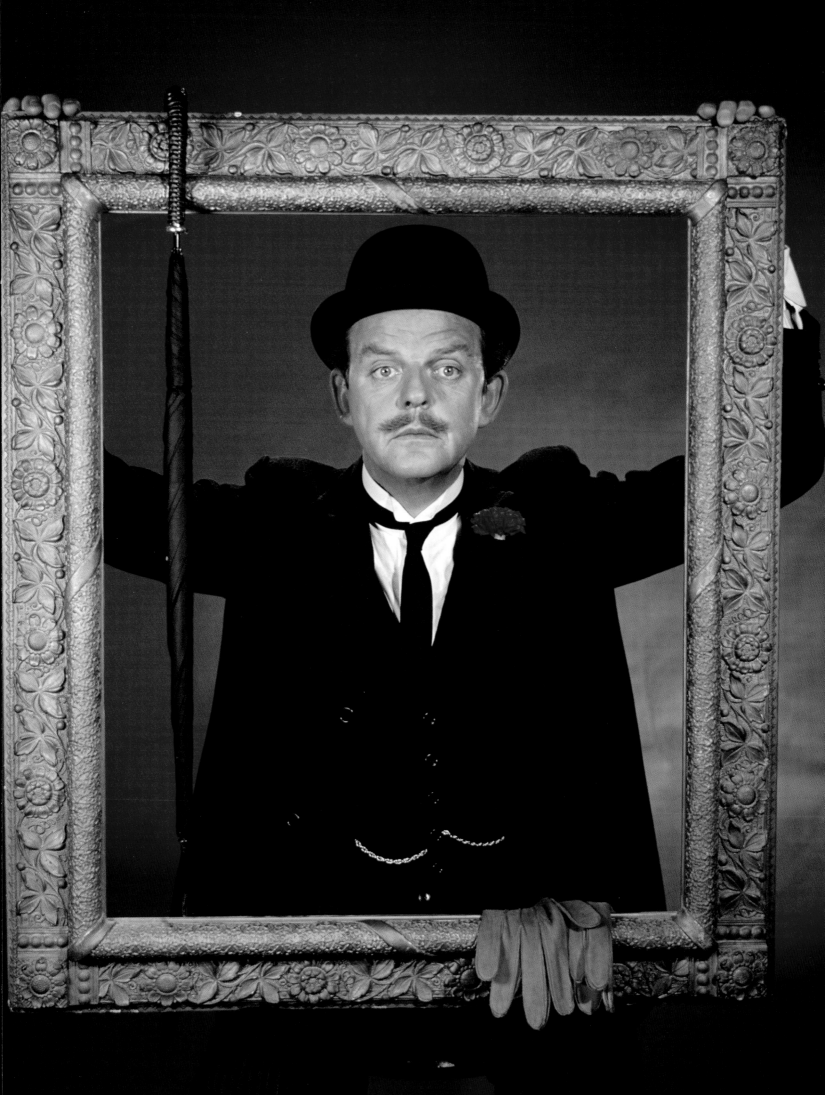

An Artist of Highest Degree

John Myhre on Tony Walton

I'm a big fan of Tony Walton.

As a lifelong film aficionado and a production designer both, I couldn't help but be immersed in his work.

Now our careers have crossed significantly twice.

If you don't know who Tony Walton is, he's an English set and costume designer. He began his career in 1957 with the stage design for Noël Coward's Broadway production of *Conversation Piece*, and during the late 1950s and early 1960s, he designed for Broadway and the London stage.

He entered motion pictures as costume designer and visual consultant at the behest of a fellow called Walt Disney, for a picture Walt was making with Tony's then-wife, Julie Andrews: *Mary Poppins*.

Julie remembers it very simply: "Walt took one look at his work and signed him on the spot, commissioning him to design the film sets for Cherry Tree Lane and the Banks household, plus all the costumes . . ."

For this, his very first film, he received an Oscar nomination.

After an uncredited gig on *Fahrenheit 451* in 1966, Tony went on to design films such as *A Funny Thing Happened on the Way to the Forum*, *Petulia*, *The Sea Gull*, and Ken Russell's *The Boy Friend*.

His work has such range. The staid, handsome, almost claustrophobic *Murder on the Orient Express* was followed by the unexpectedly naturalistic *Equus*, then the indescribably fantastic and remarkable meeting of Manhattan and imagination in *The Wiz* (he was Oscar nominated for both costume design and set decoration/art direction for that).

He won an Oscar for *All That Jazz*, and an Emmy for an acclaimed TV version of *Death of a Salesman*.

His work on the stage is prolific and varied—and just remarkable. He's won three Tony Awards as Best Scenic Designer: in 1973 for *Pippin*, in 1986 for *The House of Blue Leaves*, and in 1992 for *Guys and Dolls*. He's also been Tony-nominated *thirteen* other times: as Best Costume Designer (for *The Apple Tree* and for the 1987 revival of *Anything Goes*), and as Best Scenic Designer, for *Chicago*, *A Day in Hollywood/A Night in the Ukraine*, *The Real Thing*, the 1987 revival of *The Front Page*, *Anything Goes*, *Lend Me a Tenor*, *Grand Hotel: The Musical*, *The Will Rogers Follies*, the 1994 revival of *She Loves Me*, *Steel Pier*, and the 2000 revival of *Uncle Vanya*.

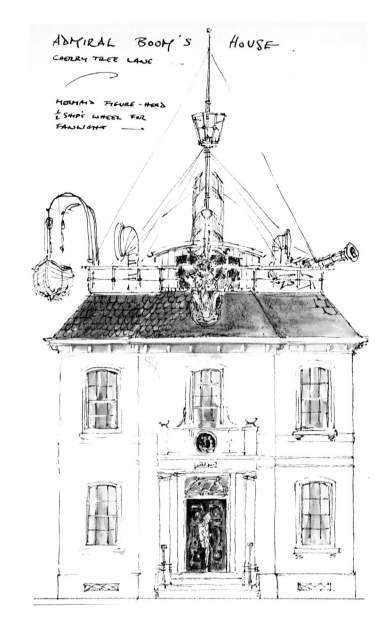

Our paths crossed first on the film version of *Chicago*. Tony had designed the original production on Broadway. Although our approach was in the end much more cinematic with a very different look, it was still fun and enlightening to go through the research and see the choices that he had made, the palettes he had chosen, the visual environments he favored, and what he had discovered in how to help tell the story.

Rob Marshall had brought up *Mary Poppins* to me ten years ago, when we were working on *Nine*. We were driving somewhere, maybe on a location scout, and he said, "You know, the film I really want to do with Disney is *Mary Poppins*. We'll come up with a whole new look, and all-new music, a whole new story." So, it was fun when I got the call from him all those years later.

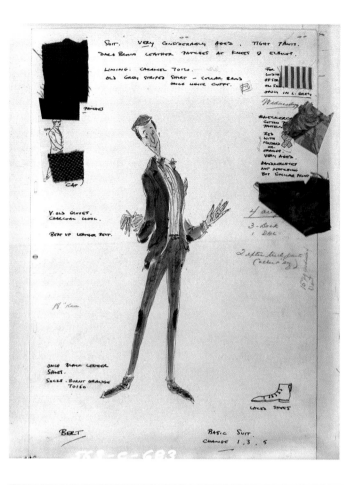

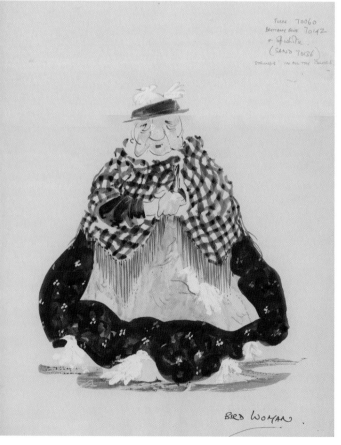

When Rob and I finally sat down to talk about *Mary Poppins Returns*, he said very firmly, "We're not 'remaking' *Mary Poppins*. It's a whole new story told twenty years later; I really want to make it our own." But we talked about the original film's design, which we love and is so beautiful. We started our conversations by really just looking at what Tony Walton had done.

Long before the movie started up, Rob told me that he was having dinner with Tony Walton and Julie Andrews, and Tony started talking about *Mary Poppins*. One of the things Rob learned was all the real places in London that were inspiration to Tony for what became fanciful and theatrical designs for the movie. There's an area in Chelsea called the Boltons; it's two crescent shaped streets with a private park in the middle. The street is lined with Edwardian white buildings with black accent details.

He also told Rob about a house on a hill, overlooking one of the parks, that looks like a boat. It's called the Admiral's House, in Hampstead; an eccentric eighteenth-century naval officer named Fountain North built it with a full ship's quarterdeck on the roof. It inspired P. L. Travers to create Admiral Boom, and Tony Walton's vision of the character's house.

I also spent hours in the Walt Disney Archives looking carefully at all of Tony's remarkable and

beautiful drawings and poring over the notes he had written on them. When I went to London to start scouting *Mary Poppins Returns*, I remembered all that. The lessons I took away were nuances of shape, scale, and most of all, *feeling*. I found that walking in the footsteps of Tony's inspirations really helped me, odd as it might seem, to establish a vision for *our* Mary Poppins's London that was all our own—but rooted in the magnificent and enduring work of Tony Walton.

John Myhre

is an Academy Award– and Emmy Award–winning production designer. He received his first Academy Award nomination, for Best Art Direction, in 1998, for Shekhar Kapur's Elizabeth, *bringing him to the forefront of Hollywood production designers. Credits have included* Ali, The Haunted Mansion, Pirates of the Caribbean: On Stranger Tides, *and* X-Men: Days of Future Past, *as well as* Chicago *and* Memoirs of a Geisha, *both for director Rob Marshall, and both of which won him the Academy Award for Best Art Direction. Myhre's production design work for* Dreamgirls *and* Nine *were Oscar-nominated. Other projects have included Emmy-nominated work on* The 84th Annual Academy Awards, *an award he won for* Tony Bennett: An American Classic.

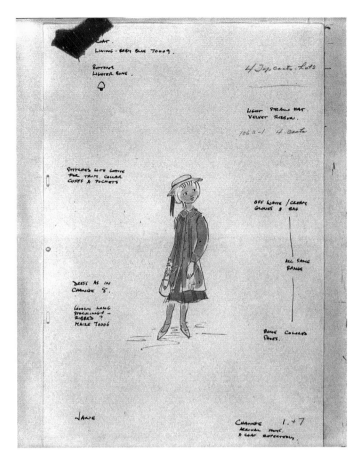

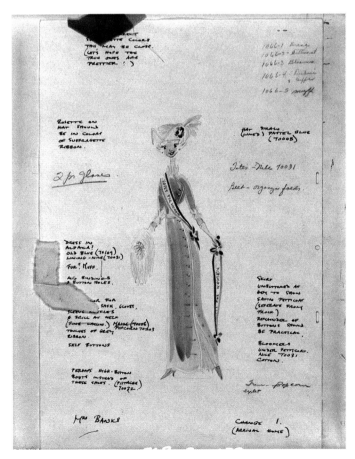

153

MR. DISNEY OPENS THE DOOR

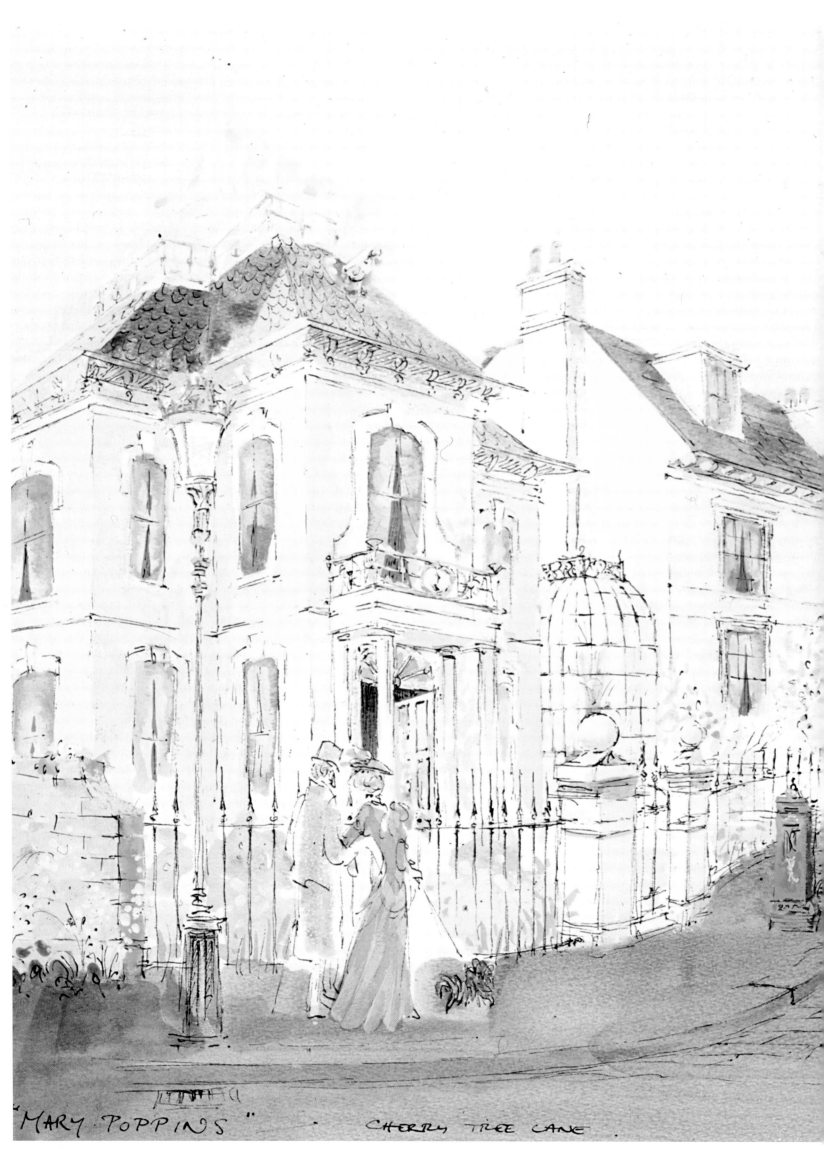

"MARY POPPINS" · CHERRY TREE LANE.

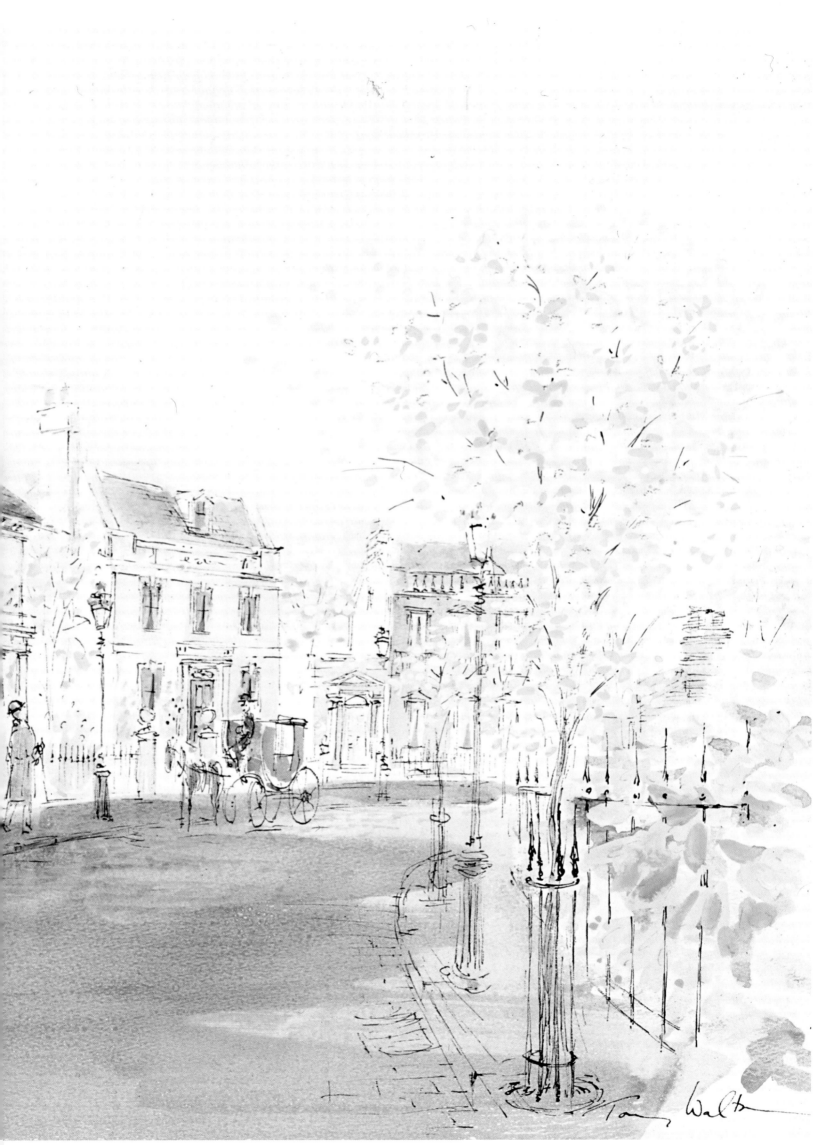

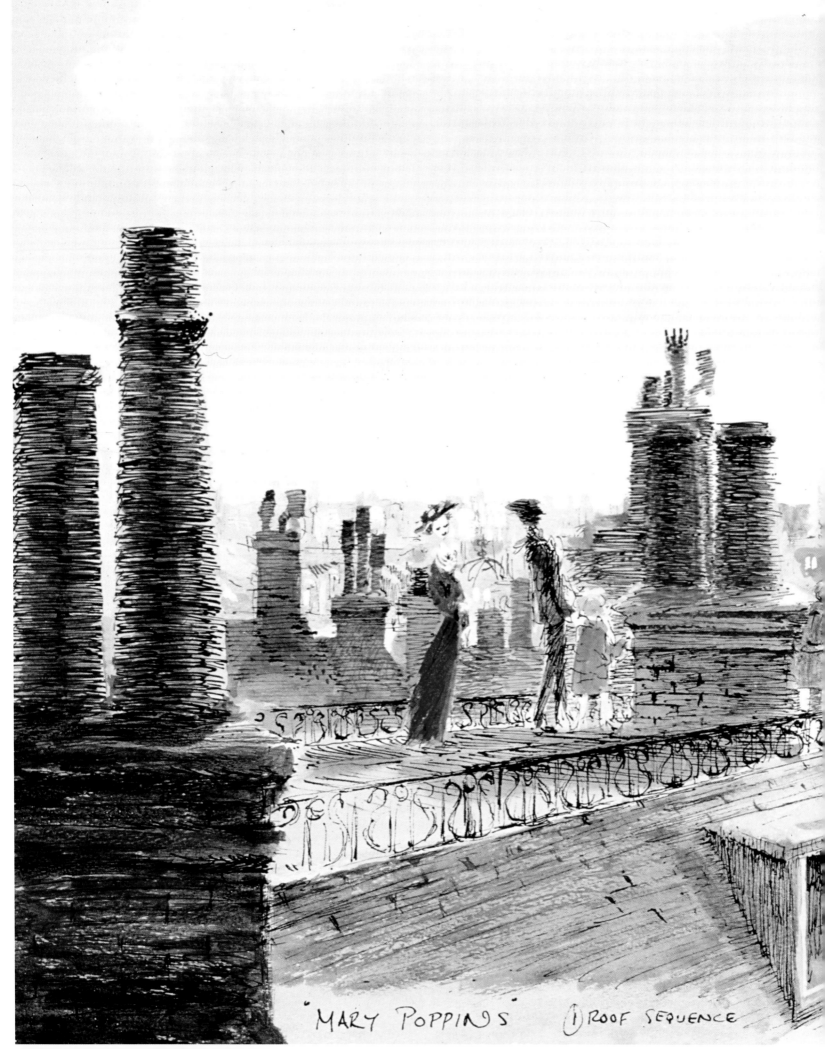

"MARY POPPINS" ① ROOF SEQUENCE

Memorable Music and Magic

The music of *Mary Poppins* is enduring. "Richard and Robert Sherman wrote the music of my generation," says Thomas Schumacher, president and producer at Disney Theatrical Productions. "We grew up on their tunes and stories of their songs and the optimism and hope of a postwar generation. At the center of all things Disney in those days, there were the Sherman brothers."

The Shermans' score to *Mary Poppins* was a unique one, and in the spirit of the greatest and most timeless film and Broadway show scores, it served its more "internal" purpose of supporting and enhancing the storytelling of the project, but also had a robust and long-lasting "external" life as well.

Interestingly, the first known composer to tackle bringing music to P. L. Travers's tales was none other than legendary Tony– and Oscar–winning composer and lyricist Stephen Sondheim.

As a youth, like most aspiring composers, Sondheim's influences were many and varied, from operetta to classical to Broadway. But it was a chance meeting with lyricist and librettist Oscar Hammerstein II that set the young Sondheim on his career path. "I wanted to be whatever Oscar was," Sondheim has said. "I think if Oscar had been a geologist, I would have become one, too."

Hammerstein saw raw talent in the teenager's writing. He taught him fundamentals of the "book musical," how songs must be integrated into scenes, and how they must move the plot or enhance the characters in order to work well.

Sondheim later said, "I learned more about musical theater in an afternoon with Hammerstein than most people do in a lifetime."

Then Hammerstein offered a challenge: the youngster should try to write four different musicals (the first based on a well-written play, the second from a *badly* written play, the third from nonmusical source material, and the fourth musical would be entirely original).

Sondheim spent the next four years on this musical theater experiment. For his third work, from nonmusical source material, Sondheim chose P. L. Travers's *Mary Poppins.*

The youngster wrote four songs: "Ad," "Tea," "Miss Andrew," and "The Sun Is Blue," which gives a flavor of the characteristic song sensibilities he derived from the stories ("The Universe is small/The sun is blue/And summer follows fall/While spring is freezing . . .").

"I did about two-thirds of it," Sondheim said, "and realized I couldn't complete it because I could not solve the problem of taking disparate short stories, even though they are interconnected, and making a larger form."

That solution would have to wait for the Sherman brothers.

OPPOSITE: There was much to promote in advertising Mary Poppins. *This fourth poster design, Style D, gave focus to the wildly popular and award-winning musical score.*

Story, Songs, and Shermans

The Musical Making of a Masterpiece

"Bob and I were story guys," says Richard M. Sherman. "We developed characters through songs."

Richard M. and Robert B. Sherman had scored a big hit in 1958 with the song "Tall Paul," sung by Annette Funicello, which caught Walt Disney's attention. He brought the young siblings in to work on some spot songs in developing features, including *The Horse Masters* and *The Parent Trap*. Then in 1960, impressed by the way they approached writing their music and lyrics, he asked them to read P. L. Travers' 1934 book, *Mary Poppins*.

"The boys," as Walt would affectionately dub them, dug in and began intense story development and prolific songwriting. Then, in the midst of their burst of inspiration and creativity, Richard and Robert attended a Studio screening of *Babes in Toyland*, Walt's first full live-action musical. As the film finished and the lights came up, a disappointed Walt walked past the Shermans and muttered, "Well, I guess Disney doesn't know how to make musicals."

The Shermans were shocked, and certain that Walt's pronouncement spelled doom for the nascent *Poppins* project. Fortunately, Walt's attitude was short-lived, and the Shermans and Don DaGradi (a lead scriptwriter for the movie) continued the development of the *Mary Poppins* screen story by means of musical incident and visual highlight.

The trust and faith that Walt placed in the Shermans was not only a compliment to their perpetual success in creating exactly the kind of work that defined "Disney Music," it was representative of Walt's own experience and innate musicality.

"He couldn't read music, or play an instrument," Richard recalls, "but he was innately musical, and understood immediately where music could help the story he wanted to tell. He wasn't effusive with praise, but we knew we'd hit the mark if Walt said, 'That'll work.' It meant we'd created something he felt good about."

CHAPTER FOUR

Although the screen version of *Mary Poppins* was created from a musical foundation, initially the song score was virtually ignored in publicity materials, selling the achievement of Walt Disney, stars Julie Andrews and Dick Van Dyke, and the color and humor of the "Jolly Holiday" sequence—with the music as ancillary support. The first (Style A) one-sheet poster did not even have the songwriters' credit in the billing block. "It wasn't contractually required," Richard explains.

Once Walt and his team realized that the music was really sending the picture into the stratosphere, and talk of awards and honors for the music began, the poster was reprinted— and all further publicity blocks carried the Shermans' song and score credits. The Style D poster carried the banner, "See It Again and Again . . . with That Supercalifragilistic MUSIC!"

With *Mary Poppins* being "Acclaimed by Everyone as Walt Disney's Greatest Achievement" (an ad line on posters, trailers, and newspaper ads that was actually not just hyperbole), Oscar attention seemed inevitable. But even the proud and confident Disney team was stunned when the nominations were announced, and the "practically perfect" *Poppins* earned thirteen Academy Award nominations. (That year marked the only time in Oscar history where three films got twelve or more nominations. *Becket* and *My Fair Lady* both earned twelve.)

"We were amazed to be nominated, because it was our first time out with a major motion picture," Richard recalls.

"It was like we were walking on air," Robert said.

On a warm and clear April evening at the Santa Monica Civic Auditorium, the air crackled with the excitement and anticipation of the awards to come. Bob Hope returned as the host of the awards after a two-year absence due to his own spokesman contract conflicts with the ABC network sponsors of the awards show. The presence of the three heavily nominated British-set films and the competition between *Mary Poppins* and *My Fair Lady* were part of a comical opening monologue from Hope, which included the wry greeting, "Welcome to Santa Monica on the Thames."

OPPOSITE: *The Sherman brothers. After presenting their music ideas for* Mary Poppins *to Walt, he responded simply, "You fellas really like to work, don't you?"*

As is still typical for the Oscar show, various performers gave special renditions of the nominated songs. For "Chim Chim Cher-ee" Randy Sparks's American folk music group the New Christie Minstrels gave a pop-folk rendition of the popular tune.

"Chim Chim Cher-ee" was a nominee for Best Original Song, up against "Dear Heart" by Henry Mancini, with lyrics by Jay Livingston and Ray Evans; "Hush . . . Hush, Sweet Charlotte" by Frank DeVol, lyrics by Mack David; and two Jimmy Van Heusen/ Sammy Cahn collaborations that have become standards, "My Kind of Town" and "Where Love Has Gone." The ever-elegant Fred Astaire was the award presenter, and the Sherman brothers were the seemingly surprised recipients.

The Best Original Score award was presented by MGM musical star Debbie Reynolds (who in later years would provide the voice of the title spider in the Sherman brothers' version of *Charlotte's Web*). The *Mary Poppins* score was nominated alongside Laurence Rosenthal's score for *Becket*, Frank DeVol's bittersweet score for *Hush . . . Hush, Sweet Charlotte*, Dimitri Tiomkin's epic *The Fall of the Roman Empire*, and Henry Mancini's distinctive score for *The Pink Panther*.

The award wins were transforming for the formerly unknown songwriters. "Overnight, every doorman, every maître d', every waiter, knew our names," Robert recalled wistfully.

At the end of that April evening more than fifty years ago, *Mary Poppins* was the second-biggest Oscar-winner with five of the prizes—and certainly the jewel in that crown was the triumph of Julie Andrews as Best Actress in her screen debut.

But Julie had only been cast because of the need created by the work of Richard and Robert Sherman! A Broadway-caliber score such as *Mary Poppins* required a Broadway musical star to bring it its due.

"The next day, we went to Walt's office, to thank him," Robert recalled.

Walt congratulated the Sherman brothers. "Well, boys, you hit a home run!"

But he tempered his enthusiasm (and theirs) with a calm bit of humility.

"But remember, the bases were loaded."

Finding a Sound

Walt, the Shermans, and Irwin Kostal

When we started thinking about orchestrations for the songs in *Mary Poppins*, we did a lot of research on Broadway musicals. We noticed that many of them had been orchestrated by a man named Irwin Kostal.

At that time, Irwin was working as arranger and conductor on the Garry Moore television show. The more we listened to Irwin's work, the more we realized that he had a real facility for writing authentic and exciting period arrangements for whatever year it was supposed to be—1913, 1937 or whatever.

Up to this point, Walt had been planning to use his regular staff musicians and arrangers on Mary Poppins, but we felt his confidence in us was such that we could take the chance on expressing our thoughts on how the music should be handled. We told him that this film needed a dynamic Broadway sound, but in a 1910 music hall style—exactly the kind of sound Irwin had demonstrated he could create.

As we explained our thoughts, Walt listened carefully—and as he did, we suddenly realized who we were talking to! Just a few years earlier we had been a couple of struggling songwriters, keeping afloat by earning hourly wages at a variety of odd jobs. Bob had been working at the post office and Dick had been tying plastic leaves on tree branches for the Jungle Cruise attraction at Disneyland. Now here we were, telling Walt Disney how to produce the music for his biggest film!

When we were done. Walt thought for a moment, then told co-producer Bill Walsh to go ahead and call Irwin.

We sighed a big sigh of relief.

—*Richard M. Sherman and Robert B. Sherman,*
excerpted from Walt's Time: From Before to Beyond

OPPOSITE: *Oscar-winner Irwin Kostal supervised four more of the Sherman brothers' musical film scores after* Mary Poppins.

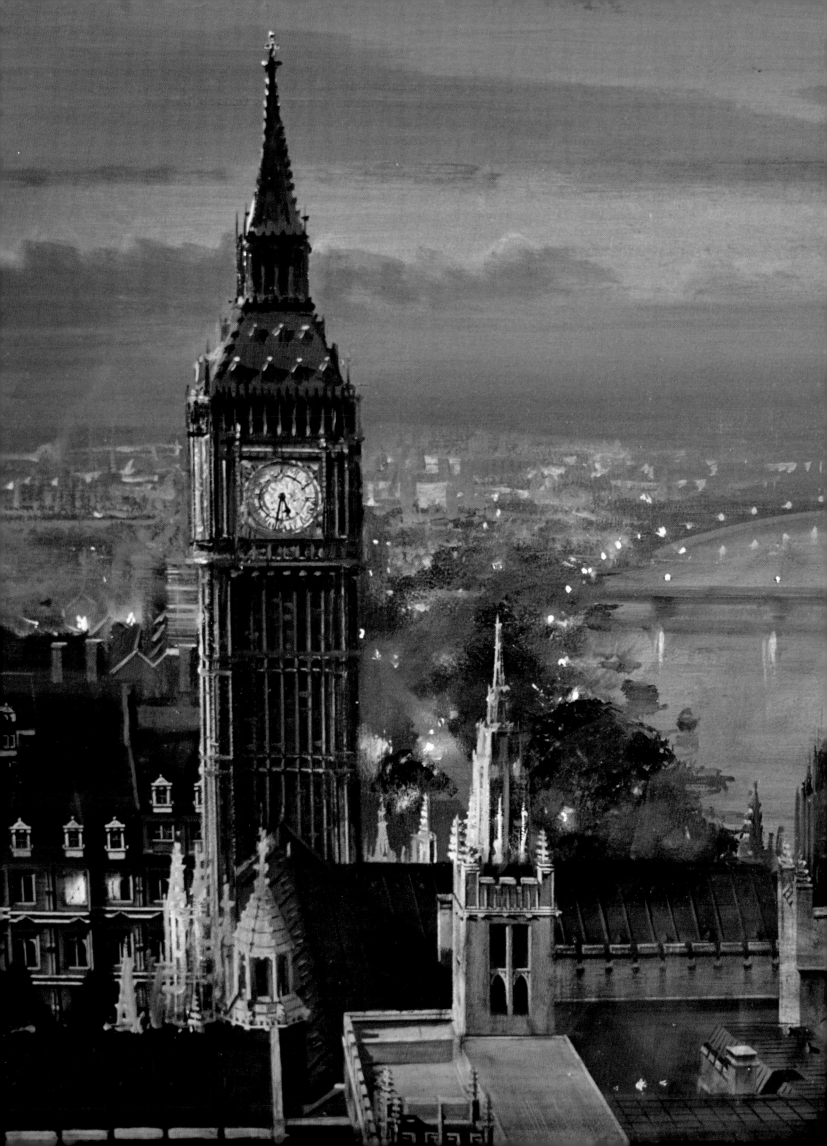

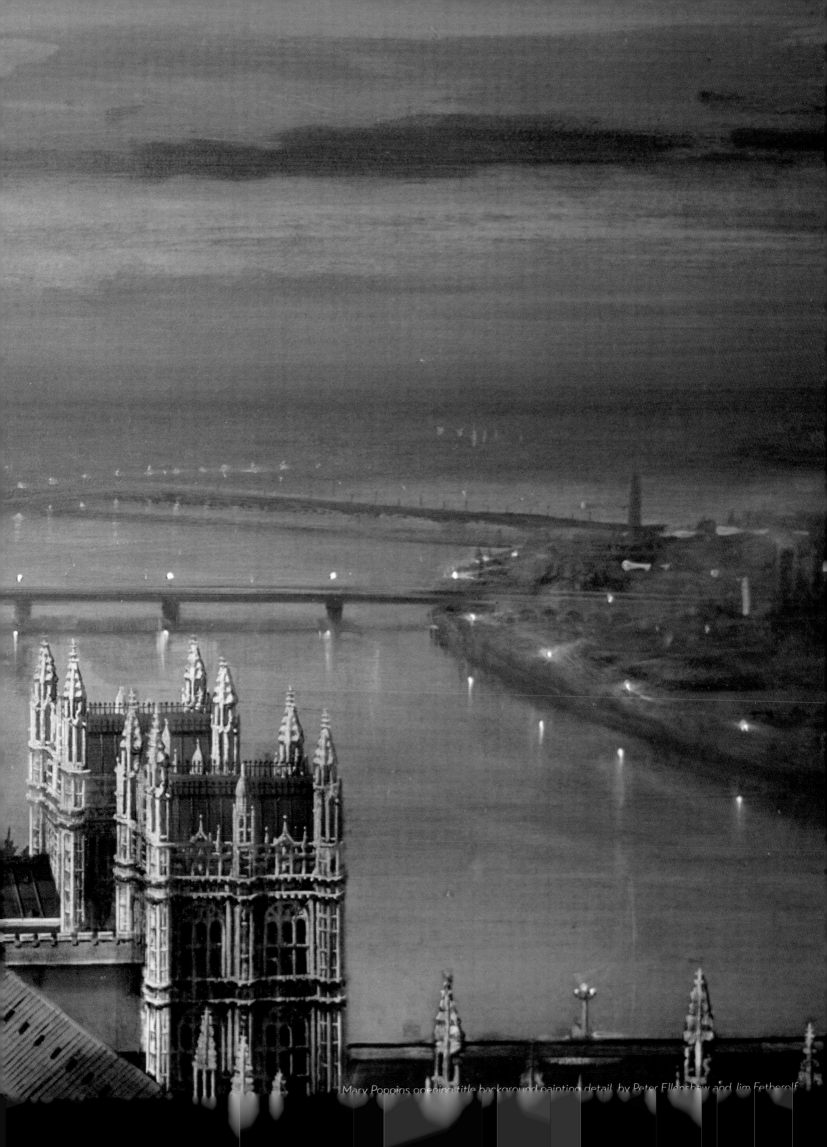

Mary Poppins opening title background painting detail, by Peter Ellenshaw and Jim Fetherolf.

A Man Has Dreams of Walking with Giants

An Appreciation by Marc Shaiman

Everything I ever needed to know I learned from the Sherman brothers.

Although I got an equivalency diploma at age sixteen and ran off to NYC—and showbiz—when people ask me where I went to school, I happily say, "The soundtrack album to *Mary Poppins*." All these decades later, I still put all that I gleaned from the glorious hours, and years, I've spent listening to that album to frequent use.

With the Overture acting as a sort of like homeroom, I would start my day at "The Sherman Brothers School" by placing the needle on the vinyl to be instantly transported by the spine-tingling sound. Right away, the lesson begins! (I later learned this captivating shimmering was created by tremolo-ing strings forming a perfect G chord triad—which is exactly how I start my own score for *Mary Poppins Returns*!)

(This leads me to point out that what George Martin was to the Beatles, Irwin Kostal was to the Sherman brothers. Irwin's arrangements and orchestrations elevated the brothers' songs to an even higher level—which would almost seem impossible. One only has to listen to the Overture to Mary Poppins to understand Mr. Kostal's deep understanding, and thus glorification, of what the Sherman brothers were doing as songwriters. But I digress . . .)

OK, now off to first period: "Sister Suffragette." Right away, the Shermans show no sign of pandering to a child's ears. Whether it's their use of "big boy" words like "dauntless" or their wonderful way of explaining the entire women's rights movement within one song, I was fascinated, and needed to hear more!

"The Life I Lead." So many new words for my four-year-old brain to take in! "Astride his noble steed," "the sov'reign, the liege," and who can forget "noblesse oblige"!? With this song, the Sherman brothers create a theme for Mr. Banks that will be reprised throughout the film, ultimately in the most emotional way. But I'm getting ahead of myself!

"The Perfect Nanny." Well, all I can say is that I thought I actually was Michael Banks.

I sort of looked like him and had the same personality. Even now, when Scott Wittman and I talk about our lyrics, I have to stop myself from saying, "That's the part I put in!"

Next up, the song that truly takes us over the moon: "A Spoonful of Sugar." Has there ever been a melody as lilting and catchy, or lyrics more challenging and enchanting? (The answer is no!) And what about that wonderful whistle counterpoint? Many years later I found out that it was his learning to play flute that gave Richard Sherman a fascination with the contrapuntal.

For recess, we step into a chalk painting for the charm and wit of "Jolly Holiday," and the wonderful stuff and nonsense of "Supercalifragilisticexpialidocious." Even just typing that title made my brain explode with happiness!

And then on to what is my secret favorite song, "Stay Awake." What an ingenious idea, to write a song where Mary Poppins gets the children to go to sleep by imploring them to do just the opposite. The Sherman brothers must have been very crafty parents!

(I recently talked to Michael Bublé about working on an album, and I suggested he do a sexy, bossa nova version of "Stay Awake." Think about it . . . very swoon-worthy! I also sent him an arrangement of "A Spoonful of Sugar" with a much more Dean Martin attitude towards exactly what kind of liquid is in that spoonful. I clearly cannot stop trying to join forces with the brothers!)

Once again, I digress. . . . Where was I?

Ah, yes, taking classes at the Sherman Brothers School. After a proper lunch period (tea party on the ceiling, anyone?), we move on to "I Love to Laugh." A total delight, and that middle section about different kinds of laughter is pure genius. How'd they think of that? And how perfect are the performances of Dick Van Dyke and Julie Andrews here?! And there! And everywhere!

"A British Bank." Mary Poppins takes Mr. Banks's song and turns it upside down and "tricks him into taking the children on an outing!" Brilliant!

"Feed the Birds." What can one even say. Not just "practically" perfect, more like

ABOVE: *Irwin Kostal supervises David Tomlinson's recording of "A Man Has Dreams," 1963.*

"actually" perfect. (I seem to be using that word "perfect" a lot here. Well, if the umbrella fits . . .). In this moment, the Sherman brothers give us their own gentle (not gentile!) Sermon on the Mount, teaching the children the importance of charity and empathy and subsequently moving entire generations to tears.

"Fidelity Fiduciary Bank." Just the opposite of "Feed the Birds," and equally important to the storytelling.

"Chim Chim Cher-ee." Well, this is where it shows up on the soundtrack album, but it's all throughout the film. My personal favorite part of it is when they are looking up the chimney, and Irwin Kostal envelops Julie Andrews and Dick Van Dyke with the most luscious and haunting orchestral surroundings. (How I wondered what those chords and those instruments were. Thankfully, over the years I learned, and I have tried to bring that knowledge to my own score for *Mary Poppins Returns*.)

"Step in Time." With a tip of the hat to "Knees Up, Mother Brown" (Google it!), the brothers once again join forces with Irwin Kostal (as well as dance arranger Nat Farber) to create yet another exuberant tour de force of joy.

And now we come to my favorite class, the one called "A Man Has Dreams." As a four-(and five-, and six- and so on) year-old, I probably should have been inclined to lift the needle and move on to "Let's Go Fly a Kite," but the melancholy mood that the melody, the lyric, the chords, the orchestration, and the lovely performances joined forces to create just got to me; it touched me so deeply:

CHAPTER FOUR

A man has dreams of walking with giants

To carve his niche in the edifice of time

Before the mortar of his zeal

Has a chance to congeal

The cup is dashed from his lips

The flame is snuffed aborning

He's brought to wrack and ruin in his prime

I think I listened to this cut more than any other. Those solemn and introspective string chords that start it out (thank you Mr. Kostal!) and the profound way the brothers—by reprising two of their songs—allow Bert to so gently and subtly show Mr. Banks what he is missing, ending up with a changed man, well, it really got to this little boy's Jewish soul.

(And it was that Jewish soul that was also brought to sobs in a movie theater, decades later, when I took in *The Boys: The Sherman Brothers' Story*, the most stunning and moving documentary about Richard and Robert . . . and made by their sons. What a story: siblings, parents, sons, spouses, family, creativity at odds with personality, Walt Disney, mentorship, war veterans! What can I tell you, I was awash in tears; my friends had to practically carry me out of the theater.)

Wow, that was a big digression! And I was almost at the end of the school day!

And so, last but certainly not least, the magnificence that is "Let's Go Fly a Kite." Simple and heartwarming, it's the perfect ending to a perfectly told story.

What a glorious curriculum!

In the years that followed, I now remember I did an a cappella vocal arrangement of "It's a Small World" for some outdoor event in high school (the one year I went!) that I am certain no one in the bleachers could hear. And when I first moved to New York City and became music director for Bette Midler's backup girls, "The Harlettes," I suggested they start a medley about harmony with the brothers' great song "We Got It," from their Broadway show

Over Here!, featuring these playful lyrics:

> "*Who'll sing the top and who'll sing the bottom?*
>
> *Who'll sing the boop-boop, dit-dat and dottom?*"

I also now remember that at Nathan Lane's fiftieth birthday party, I performed special lyrics that I wrote to "I Wan'na Be Like You" from Disney's *The Jungle Book*. When you add all this together, plus the fact that—because of my nature to see the glass as half empty—Scott Wittman often calls me "Eeyore," you can see that my life has always been (and always will be) one guided by the Sherman brothers.

So, you can only imagine how I felt when I heard that Scott and I had won the gig of writing the songs, for director Rob Marshall's *Mary Poppins Returns*. Through our songs and the underscore (that I am in the middle of composing as I write this tribute!), my and Scott Wittman's intention is to write one endless love letter to the Sherman brothers as a way to say "thank you" for a lifetime of enriching music and lyrics.

Thank you for the songs that taught me everything I ever needed to know.

I speak for both Scott and myself when I say working on *Mary Poppins Returns* has been the greatest honor. And I hope that Richard M. and Robert B. (one of whom is in Beverly Hills, and one who is up in Heaven) can take pleasure in the way we exalt them with every note, every lyric, every chord, every orchestration, and with every emotion.

Marc Shaiman

is a pianist, composer, lyricist, arranger, orchestrator, musical director, conductor, writer, producer, actor, and general all-round musician working in films, television, and musical theater. He has contributed in some capacity or another to fifty-two films and television shows, composed two full Broadway musicals, and won numerous honors, including two Tony Awards, two Drama Desk Awards, seven ASCAP Awards, and an Emmy. In addition, he has accrued five Oscar nominations.

OPPOSITE: This 1963 photo captures the joyous conviviality of the friendship and collaboration felt between the Shermans and Irwin Kostal.

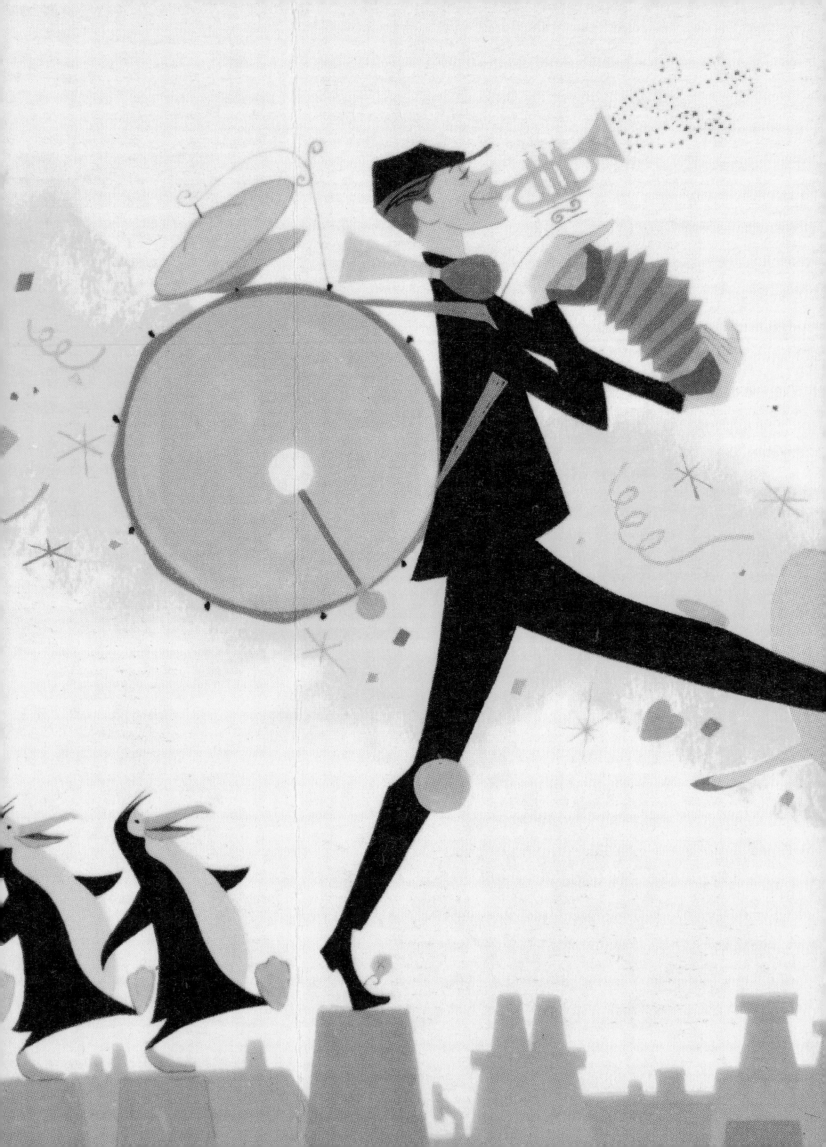

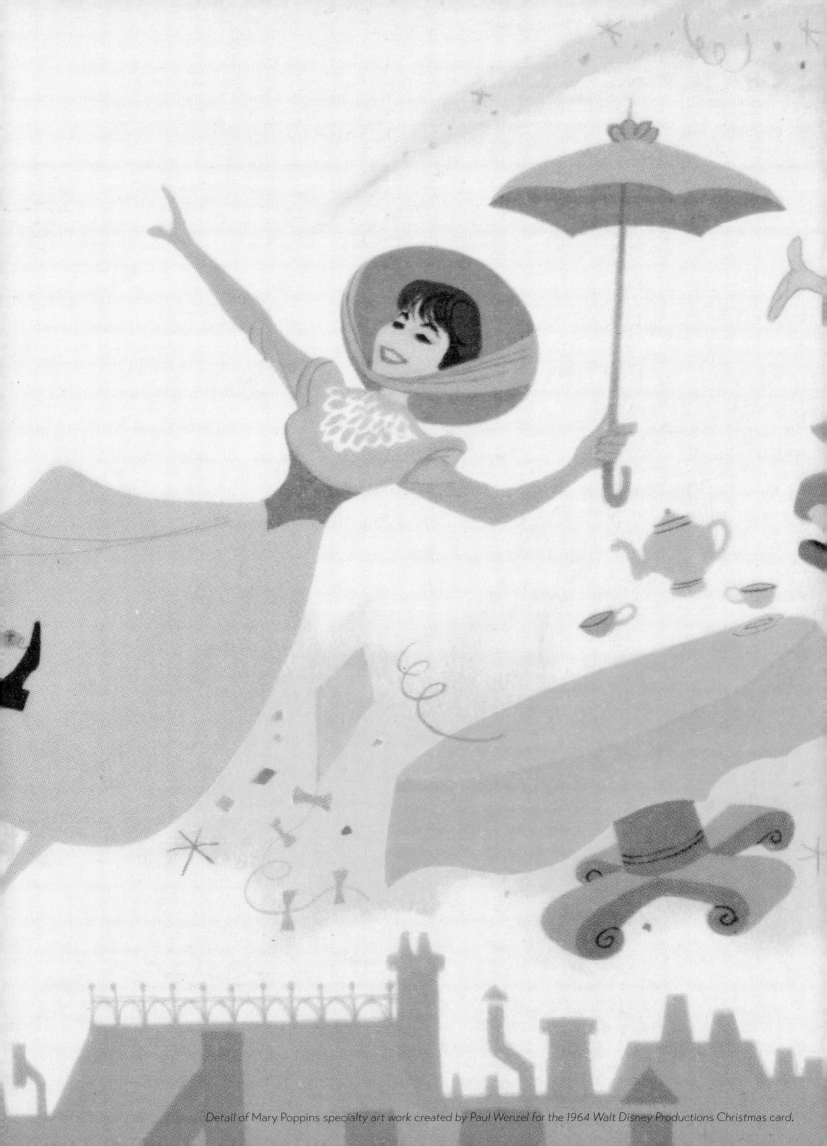

Detail of Mary Poppins specialty art work created by Paul Wenzel for the 1964 Walt Disney Productions Christmas card.

Mary Poppins on the Record

An Abundant Anthology of Audio Artistry

In its early decades, the Disney organization neither published music nor created and marketed its own records. In the days of the Silly Symphonies, *Snow White*, and *Pinocchio*, the Disneys turned over their music business to Irving Berlin and his partner, Saul Bourne. Roy O. Disney was later able to repurchase the rights to such scores as *Bambi* and *Song of the South*, but music from earlier films, including the signature tune "When You Wish Upon a Star," remained with Saul and his eponymous Bourne Company, as they are to this day.

One of the reasons *Mary Poppins* was such a landmark for the Walt Disney Studios was its emergence as the company was establishing its own in-house music publishing and record companies, retaining creative control and reaping far greater financial benefits for its own works.

In 1950, *Cinderella* became the first animated feature with songs owned outright by the recently formed Walt Disney Music Company. The film was a massive success, and the songs were popular in its pre-rock 'n' roll era. But with no record company, Disney was seeing those profits going to others. The same thing happened with *Lady and the Tramp*, the Davy Crockett series, and the *Mickey Mouse Club* TV show in 1954 and 1955. After years of encouragement from Walt Disney Music Company president (and Disney Legend) Jimmy Johnson, Roy Disney cut the ribbon on Disneyland Records in 1956.

As exceptional as the early Disneyland Records were, there were problems with manufacturing, distribution, and target marketing leading to lackluster sales. Things began to pick up in 1959 with the re-branding of Disneyland Records as a children's label and the establishment of Buena Vista Records for pop, classical, jazz, blues, and soundtracks. The success of Annette Funicello as a top ten recording star on Buena Vista was also keeping the record company going. Annette's hit songs also brought the Sherman brothers to Walt Disney's attention, which led to their involvement with *Poppins*.

Still, there were rumblings about shutting down the in-house record company. Jimmy was counting on *Mary Poppins* to solidify the division.

Other major labels were interested, too. Industry buzz was so positive on *Mary Poppins* and the potential of the Shermans' score that some heavy hitters in the record business approached Jimmy—including the legendary Goddard Lieberson, who helmed Columbia Records and is credited with developing the Broadway cast album format. After his meeting with Lieberson, Jimmy called a meeting with Roy.

As he revealed in his autobiography, *Inside the Whimsy Works: My Life with Walt Disney Productions*, Jimmy said to Roy, "We've been in the record business seven years now, and while we have had some very tough times, we've turned the corner now." He then followed with, "We've got to have this big hit to put on top of our already strong catalog . . . with our Disney know-how in merchandising, we can run rings around what RCA or Columbia might do. We've got to keep the album on Buena Vista!"

"That's what I thought you were going to say," Roy replied. "Go ahead. Sell the hell out of it!"

Coining the phrase "Original Cast Sound Track," Jimmy produced Buena Vista's *Mary Poppins* album (1964) and wrote the liner notes. He packaged the LP in an attractive gatefold cover illustrated with photos from the film. The cover featured Paul Wenzel's poster art featuring the smiling heads of Julie Andrews and Dick Van Dyke with the title and names in "lights." The disc was engineered, recorded, and mastered at Sunset Sound on Hollywood Boulevard. This legendary recording facility, founded by Disneyland Records Artists and Repertoire director (and Disney Legend) Tutti Camarata, is still thriving today under the direction of Tutti's son, Paul.

A complete line of Disneyland *Mary Poppins* records was recorded at Sunset, in addition to the soundtrack. They were sourced in one way or another from *10 Songs from Walt Disney's Mary Poppins* (1964). Produced by Tutti, it is what Disneyland Records called a "second cast" album, but more commonly known in the industry as a "studio cast," "cover version,"

or more pointedly, a "knockoff." A studio version can be an approximation of the soundtrack arrangements, entirely new arrangements, or an artist or group's specific interpretation of a score.

Johnson's experience in merchandise and publishing had taught him that offering a wider range of product options to consumers could maximize sales. Simply selling one soundtrack album wasn't enough. First of all, it was premium priced (about $4 to $5, a lot of money in the mid-1960s). A Disneyland children's album could cost roughly $1.35 in a discount store (a dollar or so more for a "Storyteller" book-and-record set). Budget children's records might be eighty-eight cents, while 45 and 78 rpm singles for kids could be twenty-nine cents or less.

While *10 Songs from Mary Poppins* isn't as richly orchestrated as the soundtrack album, it featured top Hollywood talent. The presence of two major Hollywood "ghost singers" makes it especially notable. Marni Nixon was the preeminent female offscreen singer—stepping in for Audrey Hepburn in *My Fair Lady*, Natalie Wood in *West Side Story*, and Deborah Kerr in *The King and I*.

Bill Lee was Marni's male equivalent, singing for John Kerr in *South Pacific*, Tom Drake in *Words and Music*, Christopher Plummer in *The Sound of Music* (in which Nixon appeared on camera as Sister Sophia), and even Daws Butler in Hanna-Barbera's *Hey There, It's Yogi Bear!*

Bill was also a member of The Mellomen, a favorite quartet for Disney demo recordings, as well as many memorable performances, like the dogs in *Lady and the Tramp* and the theme singers for the *Mickey Mouse Club* and Davy Crockett series.

For "I Love to Laugh," Tutti hired an actor who seemed unable to get the performance to the level that he and Robert and Richard Sherman wanted. To show the actor how to do it, Richard went through the whole song for him—doing it so well that they paid the actor, sent him packing, and used Richard's performance instead.

All ten of the songs on this particular album were released on five 45 and 78 rpm singles

(among the very last Disney 78s ever released), a seven-inch read-along set, and a 33 rpm extended play record. In addition, Disneyland Records released an album-sized Storyteller LP record-and-book set with Dal McKennon narrating in the role of Bert. The Storyteller also included Bert's "One Man Band" music, and the finale of "Let's Go Fly a Kite."

During the heyday of twentieth-century musical theater and film musicals, a measure of success was indicated by the number of recordings a score could command. The songs from *Oklahoma!*, for example, have been recorded and reissued hundreds of times and are still available in numerous versions today. To that end, Jimmy began an aggressive sales campaign to convince artists and label personnel to record the *Poppins* songs.

Louis Prima cut the first 45 rpm single, "A Spoonful of Sugar" and "Stay Awake," using the former to close his Las Vegas act. A year later, he recorded a full album, *Let's Fly with Mary Poppins*, for Buena Vista. Two years later he would appear on another best-selling Disneyland album as King Louie in *The Jungle Book*.

The first 33 rpm LP album was *Songs from Mary Poppins and Other Favorites* (1964), on Kapp Records. It featured the Do-Re-Mi Children's Chorus, a group of young New York performers assembled by arranger/conductor Richard Wolfe. As a special guest star, Broadway and live TV legend Mary Martin also appeared on the LP to sing two songs.

This album is especially notable because Martin was among the actors whom Walt had considered for the role of Mary Poppins. It's fascinating to hear her take on "A Spoonful of Sugar" and especially "Feed the Birds," which takes on a very different tone in her contralto voice, and is no less emotionally touching than Julie Andrews's soprano performance.

Jimmy was dauntless in his pursuit of top artists for recordings of the *Mary Poppins* score. "Deciding that nothing could give the score the stature around the world that it deserved as would a Duke Ellington LP, I contacted the Duke and talked about the film and its music," Jimmy wrote. "He was delighted with the music and agreed to do an album on the Reprise label. Perhaps not so surprisingly, he didn't want to see the film before doing the album—not wanting to be influenced by the visual image. . . ."

CHAPTER FOUR

Music critic/historian Will Friedwald calls the finished recording, "an underrated gem of an Ellington album, one of the best to result from the Duke's association with pal Frank Sinatra's Reprise Records. Although ostensibly a purely 'commercial' project," he says, "the arrangements of Ellington and longtime musical partner Billy Strayhorn prove that there's no reason that a set of songs conceived purely for the marketplace can't also be incredibly satisfying on a musical level as well.

"A few high points are the recasting of 'A Spoonful of Sugar' as if it were a shovelful of the blues," Friedwald continues, "Johnny Hodges style, [with] Paul Gonsalves's wailing interval tenor sax solo on 'SuperCal' (you spell it!), and one of the very few Ellington waltzes, 'Chim Chim Cher-ee.' There is also a particularly unique version of "Step in Time," done almost completely in rhythmic patterns that build slowly from a 'sawing' musical effect to soaring horns, with bongos accentuating the journey." Friedwald adds, "This album is also notable because it features actual cover photography from the film, something that is rare among Disney cover-version albums. The influence of Johnson and the stature of Ellington must have made it possible."

Jimmy's instincts were correct. "The Ellington album . . . certainly had the desired effect internationally, where the Duke was perhaps more honored than at home," Johnson wrote. "It also helped tremendously in the U.S.—what other Broadway show or Hollywood musical had the benefit of the Ellington treatment so early in the game? The album came out in the fall of 1964, foreshadowing the big *Mary Poppins* music boom of 1965."

Jimmy must have been elated to share each new recorded version of *Mary Poppins* with Walt and Roy Disney. As a matter of fact, the Ellington album and several other *Mary Poppins* "cover version" records are located in Walt Disney's actual office, which the Walt Disney Archives meticulously restored a few years back to exactly as he had left it in 1966.

Three other *Poppins* albums in Walt's restored office were recorded by Ray Conniff (Columbia, 1965), Lawrence Welk (Hamilton, 1965), and Ray Walston (Vee-Jay, 1964).

The distinctive Conniff sound is most familiar today during the holiday season,

when such songs as "Here Comes Santa Claus" and "Christmas Bride" are heard from his multimillion selling albums. Conniff combined *Poppins* songs with two other hit musicals of the day, *My Fair Lady* and *The Sound of Music*, to great success.

Lawrence Welk led what was called a "sweet band" before he became identified with the "Geritol and Soup Group" for decades on TV. His *Poppins* album features members of the same "musical family" seen on his show, including famed soprano Norma Zimmer, who appeared on several Golden and Disney records, including Camarata's version of the *Snow White and the Seven Dwarfs* score.

Ray Walston's version of *Poppins* songs was a tie-in to his comedy-fantasy TV series, *My Favorite Martian* (1963–66). The album is also notable because the arrangements are by Jack Elliott, who would later arrange and conduct the Sherman brothers' scores for Walt's last film, *The Happiest Millionaire* (1967), and *The One and Only, Genuine, Original Family Band* (1968).

By 1966, nearly every major record label featured songs from *Mary Poppins*, as did countless low-budget and independent children's labels. Priced anywhere from seventy-seven cents to $1.99, these records were ubiquitous in supermarkets, discount stores, five-and-dimes, and convenience stores.

There were *Mary Poppins* albums and/or songs on LPs by the Living Voices (RCA Camden), England's Mike Sammes Singers (Society), and Alvin and the Chipmunks (Liberty/Sunset). A parade of uncredited singers and musicians recorded for such labels as Pickwick, Happy Time, Peter Pan, Rocking Horse, Crown, Somerset, Cameo, Parkway, Wyncote, Modern Sound, Twinkle, and others. Many of those labels were subsidiaries of each other. Some LPs contained as few as four songs in total and had running times as short as twenty minutes, while others offered one or two *Poppins* tunes but were filled out with songs and stories from back catalogs. The results were certainly varied, yet often they were surprisingly listenable.

Disneyland and Buena Vista continued to either reissue *Poppins* songs in various

formats or find new ways to present the songs in such albums as *Mary Poppins en Français*, and *March Along with Mary Poppins*. Jimmy even sent out a promotional LP pressed for the Wonderland Music Company called *The Music of Mary Poppins* that contained fourteen different renditions, including non-Disney label tracks from Ellington, Conniff, and the Big Ben Banjo Band.

The most bizarre album of all could very well be *Fred Flintstone and Barney Rubble in Songs from Mary Poppins* (Hanna-Barbera, 1965), based on the animated TV sitcom about a prehistoric family, *The Flintstones*, which was running on ABC in prime time when *Mary Poppins* was in theaters. The story finds Fred convincing Barney to join him and become a songwriting team, but the only tunes Fred can write are songs exactly like "Jolly Holiday" and "Chim Chim Cher-ee"—because the Flintstones and the Rubbles had just seen *Mary Poppins* at their neighborhood drive-in!

Fifty years after *Mary Poppins* was released, Walt Disney Records producer Randy Thornton put together a three-disc "Legacy Collection" CD combining previous releases of all the songs, 99.99% of the background score, actual recorded story meetings between the Shermans and author P. L. Travers, plus brand-new recordings of "Lost Chords"—songs written for the film but shelved for various reasons, though not for a lack of quality. One of the Shermans' most personal songs, "The Eyes of Love," was released in a fully orchestrated setting for the first time, bringing things full circle.

Somewhere in record heaven, Jimmy Johnson is beaming. "We really sold the hell out of it, didn't we?" we surmise Johnson saying, with Roy Disney acknowledging his statement with a long, thoughtful nod.

Greg Ehrbar

is a two-time Grammy-nominated and Addy-winning freelance writer/editor/producer with thirty years on staff with The Walt Disney Company and more than forty years professional writing and production experience—from national TV campaigns and TV specials to animated cartoons and promotional videos. Greg coauthored Mouse Tracks: The Story of Walt Disney Records *(published by the University Press of Mississippi); coedited* Inside the Whimsy Works: My Life with Walt Disney Productions *by Jimmy Johnson; contributed to* The Cartoon Music Book; *adapts major films into books; and has produced numerous recordings.*

The Mary Poppins Phenomenon

August 27, 1964—the night was *finally* at hand. After years of toil and experimentation, Walt Disney's *Mary Poppins* was ready for its star-studded premiere. After motoring down Hollywood Boulevard, the film's cast and crew turned toward Sid Grauman's fabled Chinese Theatre to witness the motion picture event that would become known as Walt Disney's cinematic magnum opus, even before the end credits rolled. "Inside the packed twelve-hundred-seat theatre," Caitlin Flanagan reported in *The New Yorker*, "the members of the audience responded to the movie with enthusiasm: they gave it a five-minute standing ovation."

Dick Van Dyke recalls, "At the after-party, silent film star Francis X. Bushman took hold of my hand and said, 'Sir, you are a national treasure.' Maurice Chevalier introduced himself and said he wanted me to play him in a movie. Julie was similarly overwhelmed with praise. All of us were."

The feature would remain for seventeen weeks at the Chinese Theatre, and then had another gala opening; this one was in New York City at Radio City Music Hall on September 24, 1964. (The film had a delayed opening in New York because of the unexpected holdover of *The Unsinkable Molly Brown*.)

A "Royal European Premiere" was held at the Leicester Square Theatre in London on December 17, 1964. (P. L. Travers was in attendance, as was Princess Margaret and Lord Snowdon, but Walt was not able to attend.)

Before the end of the year, the film opened in twenty more American cities, and continued to expand its run through 1965.

Reaction from the film industry and audiences was overwhelming. Every aspect of the film's production was celebrated by critics. The *Los Angeles Herald-Examiner* called it "The most triumphant musical fantasy ever filmed and the finest picture in the producer's distinguished career." The *Chicago Tribune* raved, "Probably Walt Disney's masterpiece . . . Miss Andrews is lovely and amusing. Dick Van Dyke is a lithe and expert clown . . . a thoroughly enchanting movie!" The *Dallas Morning News* said, "Disney brings a technical eloquence that matches most of the brightest words that have been written . . . " The *New York Journal-American* instructed, "Go see it and have yourself a wonderful time . . . "

And people did. By the millions, and all over the world. *Mary Poppins* was a blockbuster by industry standards, and for Walt Disney Productions it was a financial windfall the likes of which hadn't been seen since *Snow White and the Seven Dwarfs* nearly thirty years before. Today, the film has an adjusted gross revenue of more than $700 million.

The cultural ripples were also astounding. The characters and music of the film became common vernacular in TV, comic strips, political cartoons,

OPPOSITE: The original "Style A" one-sheet poster conspicuously lacked a credit for the songwriters and arranger. Walt quickly ordered a fix.

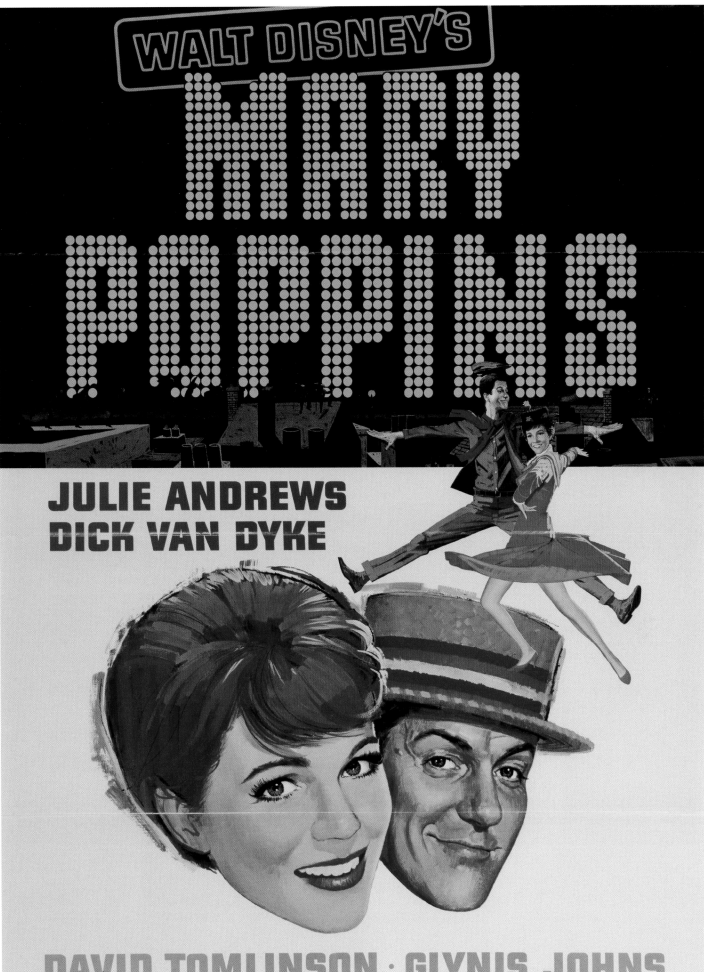

C/- Mrs M.W. Coward
R D. 2 Box 271
Mr Kisco, N.Y
1st September.

Dear Walt,

This is to say THANK YOU.

You will have known that my reason for coming to Hollywood
was not only to see, and enjoy, the first showing of the
picture but to make it clear to everybody that you and I
were in accord, author and film-maker in harmony.

The whole picture is a splendid spectacle and I admire
you for perceiving in Julie Andrews an actress who could
play the part. Her performance as Mary Poppins is beautifully
understated, which is what I would have asked for, anyway, and
she is excellent in both roles. For I think the picture
falls into two halves---the home scenes which keep some contact
with the books and the musical comedy scenes which are Disney
and Disney at his best! The character which to some extent
holds both parts together is Mr Banks and I do think that
David Tomlinson is absolutely right. I hope some time to
have an opportunity of congratulating him. I liked the
children, too, perhaps especially the little boy.

I know well that in translating a book to another medium
something has to be lost---or perhaps undergo a change.
The real Mary Poppins, inevitably, as it seems to me, must
remain within the covers of the books. And naturally, as
an author, it is my hope that your gay, generous and wonderfully
pretty film will turn a new public towards them.

It was a wonderful premiere---far grander than anything we
shall be able to do in England. Even so, it will probably
be good and it is my hope that the writers and the director
as well as the actors will be there---perhaps even you!--

Please thank everybody from me and give them ny congratulations,
not least the mudicians.

 Yours, with a bouquet of flowers,

ABOVE: Contrary to legend, P. L. Travers did have some
clarity on her uneasy relationship with Walt Disney's
adaptation of her work.

music, and every other incarnation of popular media.

Awards season came, and *Mary Poppins* was lauded over and over. The film received thirteen Academy Award nominations, including Best Picture, and took home five Oscars. Mary Poppins also had four Golden Globe nominations, including Best Motion Picture, and Best Actress, which Julie Andrews won. Multiple nominations and wins from BAFTA, Directors Guild of America, American Cinema Editors, and Writers Guild of America were also accrued; Grammy Awards for the score and soundtrack recording—and more— were added to the movie's impressive awards haul as well.

Of course, Walt Disney Productions itself was responsible for a great deal of the momentum that *Mary Poppins* enjoyed. After all, an organization whose founder had said, "I suppose my formula might be: dream, diversify—and never miss an angle" wouldn't let such an opportunity pass.

Reporting in a July 24, 1964,

LEFT: Walt's longtime friend, famed producer Samuel Goldwyn, may have been the biggest fan of Mary Poppins.

New York Times piece, Leonard Sloane wrote, "A major merchandising and advertising program designed to ballyhoo *Mary Poppins* into the *Davy Crockett* of 1964 is being planned by Walt Disney Productions."

Sloane reported that thirty-eight licensees had signed with Disney to produce merchandise, including girls' dresses, boys' apparel, dolls, housewares, toys, notions, jewelry, publications, books, and a syndicated newspaper comic.

The theatrical run of *Mary Poppins* continued through 1966 and beyond, and the property and its Disney association were forever sealed with the public.

The confluence of circumstances had brought an opportunity that was "practically perfect in every way" to create a genuine pop culture phenomenon. And it's one that continues to resonate even half a century later.

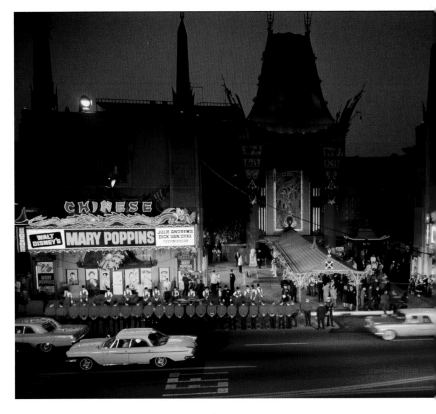

ABOVE: August 24, 1964, was a grand premiere in the Hollywood tradition.

"The most triumphant musical fantasy ever filmed and the finest motion picture in the producer's distinguished career . . . This picture is for everybody!"

—*Los Angeles Herald-Examiner*

"Wondrous blending of fantasy, music, comedy, and whimsy . . . there are all kinds of happenings too numerous to mention—and they're all delightful!"

—*Pittsburgh Press*

"Magic and music and laughter and fun. . .Disney's at his very finest . . ."

—*Philadelphia Daily News*

"*Mary Poppins* is that rare film—a completely enjoyable experience for all audiences . . . a bright, light, thoroughly entertaining musical fantasy!"

—*Denver Post*

"*Mary Poppins* is a rocket ride to euphoria and fun all the way!"

—*Salt Lake Tribune*

"*Mary Poppins* is a pure delight!"

—*Deseret News*

"A film of rare beauty . . . sheer joy all the way!"

—*Washington Daily*

CHAPTER FIVE

"An endearing and opulent fantasy . . . a sweetheart of a show!"
—*San Francisco Examiner*

"A lot of laughs, a tear here and there, a moment of breath holding or so and the warmth that is Walt Disney's—they're all in *Mary Poppins!*"
—*Boston Traveler*

"An entrancing blend of whimsicality, comedy, and song . . . three cheers for *Mary Poppins!*"
—*Toronto Globe and Mail*

"One of the most delightful, enchanting and charming pictures ever made!"
—*St. Louis Post-Dispatch*

"A lilting, magical music-and-dance extravaganza . . . Walt Disney's motion picture production wizardry soars to a new high!"
—*Atlanta Journal*

"Walt Disney has bestowed an eye-popping family package!"
—*Cue Magazine*

"New Disney film nears perfection . . . just magic for the sheer joy of magic!"
—*Christian Science Monitor*

"It's supercalifragilisticexpialidocious! Translated, that means it's the greatest!"

—*Hedda Hopper*

"*Mary Poppins* is the drollest Disney Film in decades, a feat of prestidigitation!"

—*Time Magazine*

"*Mary Poppins* is moviemaking at its best . . . the kind of joyous, fresh, expert and imaginative musical that leaves you glowing . . . topnotch entertainment for everybody!"

—*Good Housekeeping*

"Go see it and have yourself a wonderful time . . . Made with imagination, taste, talent and especially the Disney magic of make believe . . . It is superlative!"

—*New York Journal-American*

"An imaginative movie that abounds in music, dance, some really brilliant special effects and has a cast that could and does charm the birds off the trees!"

—*Philadelphia Bulletin*

"Enchanting . . . fresh, lively and funny . . . with typical Disney charm . . . its cast is superb!"

—*Houston Chronicle*

"Absolutely everyone is going to be in love with *Mary Poppins*!"
—*Chicago Sun-Times*

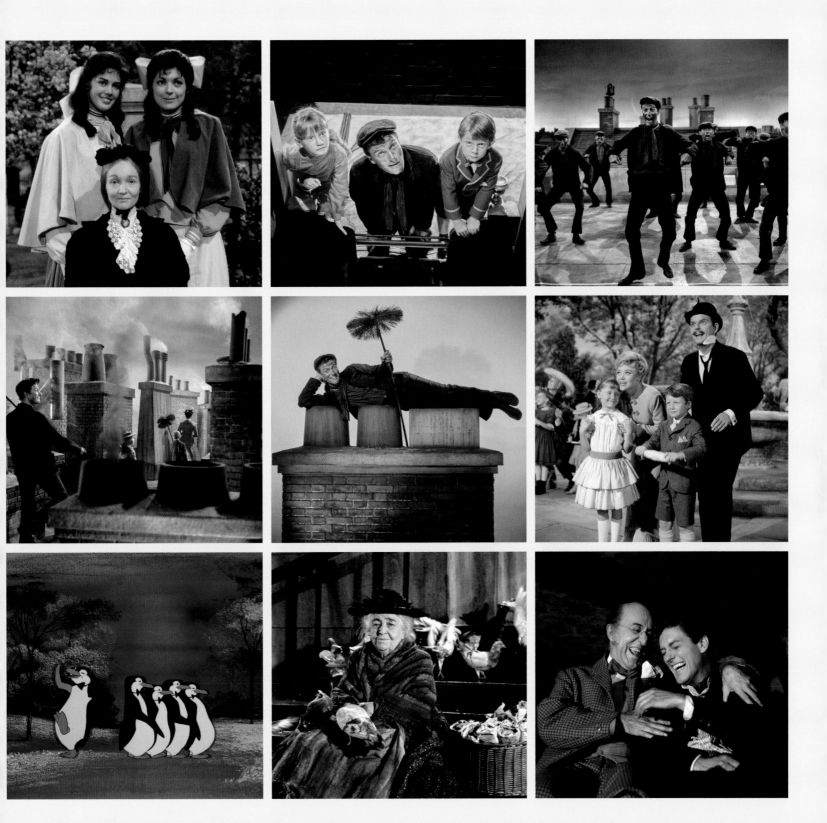

Elements of Fun

A Medley of Mary Merchandise

Under the headline "Mary Poppins Fad Designed," the July 24, 1964, issue of the *New York Times* trumpeted the wealth of products and tie-ins that shoppers could expect to coincide with the autumn release of the musical fantasy feature film.

"About the time the openings take place—backed up by an extensive advertising and exploitation campaign—the marketing activities will begin," the article stated. "A series of national tie-in ads will appear in print media, while manufacturers, licensed by Disney, will present the public with a wide variety of Mary Poppins merchandise . . . 38 licensees have been appointed by Disney to produce Mary Poppins merchandise. These are among the 100 manufacturers affiliated on a year round basis primarily to make merchandise based on such staple Disney characters as Mickey Mouse and Donald Duck."

Over the decades since, *Mary Poppins* merchandise has remained perennially popular in every way.

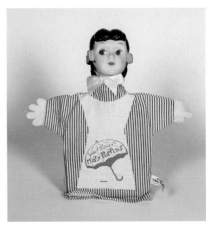

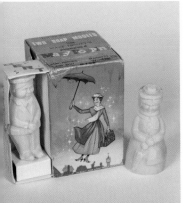
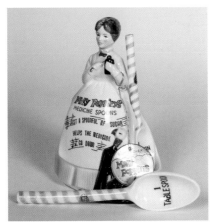
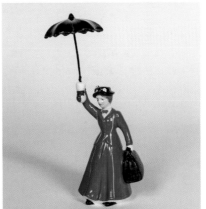

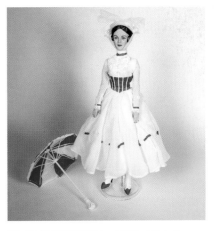

Perpetual Poppins

In 1944, things were pretty grim at Walt Disney Productions. World War II had depleted the company's funds: without foreign markets and with work sidelined is support of the war effort, income had become close to nonexistent. Roy O. Disney, Walt's brother and business partner, had an inspired idea. He realized that after seven years, a whole generation of audiences had not seen *Snow White and the Seven Dwarfs*. They knew its songs, and the characters had been sustained with merchandise and publications, but the film itself had not been in theaters for years.

What began as an act of pure financial survival created a uniquely "Disney" cultural practice—but one with roots in storytelling, religion, and family histories dating back centuries: a recurring and traditional reintroduction of stories and properties to new generations.

Naturally, as a film that quickly became regarded as a classic and is widely hailed as the cinematic masterwork of Walt Disney's long career, *Mary Poppins* continued this convention. For audiences, *Mary Poppins* is inextricably tied to emotional and personal experiences and events, feelings which support the passing on of the stories to new audiences.

Over the decades since its premiere, the film has enjoyed numerous foreign releases, theatrical reissues, and television airings.

Home video releases have brought abundant and fascinating documentary and archival materials to audiences whose appetite for more understanding

of the film's heritage and development seems unending, as well as newly made creative content that complements and continues the *Mary Poppins* story.

Naturally, the award-winning and beloved musical score has been an enduring audio presence; reissues on vinyl and then compact disc and digital platforms have offered expanded material and restorations, along with additional and supplemental musical elements.

The eight original P. L. Travers books, as well as Disney adaptations of the film story, have been in continual release, and a variety of Poppins merchandise—from collector's items to housewares to toys—always seems to be available, and desired by the public.

An award-winning and popular stage adaptation of *Mary Poppins* has led to professional productions and tours all over the world, and the creation of a licensed theatrical version of the show for regional theaters and amateur companies (which is performed just about everywhere, every day of the week).

The stars and creators of the 1964 film continue to be closely identified with their iconic roles—and enjoy and celebrate that connection even decades later.

Observances, events, and even monuments continue to celebrate the iconic character. And now, a refreshing new cinematic interpretation of the "practically perfect" nanny brings Mary Poppins into currency again for a new generation—and generations to come— to explore, to enjoy, and to share.

OPPOSITE: A villain who shall not be named is defeated by a cadre of approximately thirty airborne nannies during the 2012 Summer Olympic Games in London. This segment of Oscar-winning British director Danny Boyle's Olympic Opening Ceremony, entitled "Second to the Right, and Straight on Till Morning," highlighted the heroes and villains of English children's literature.

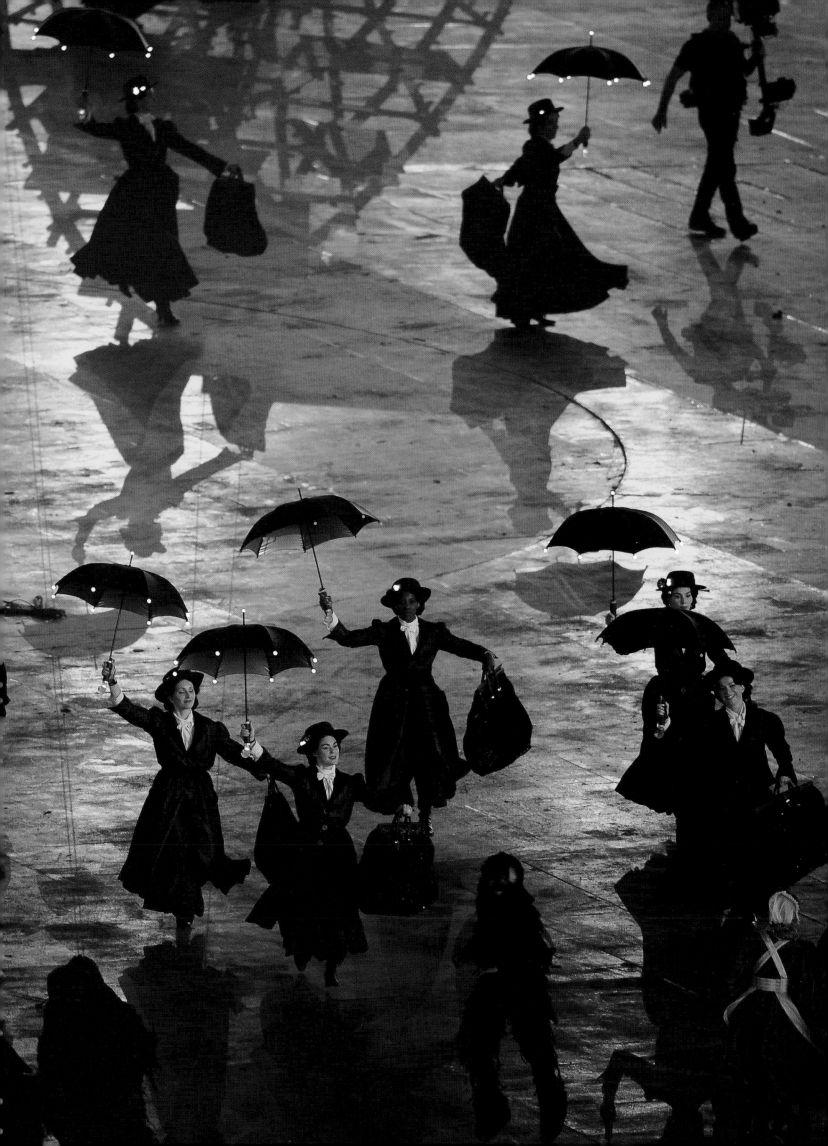

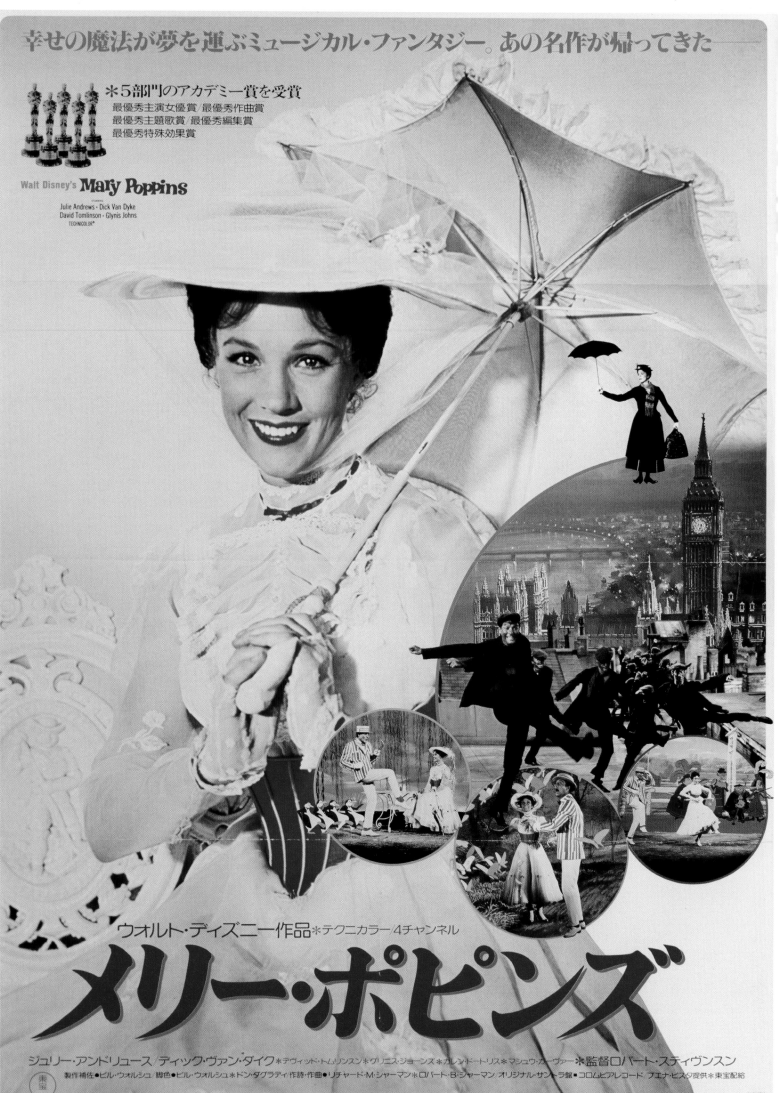

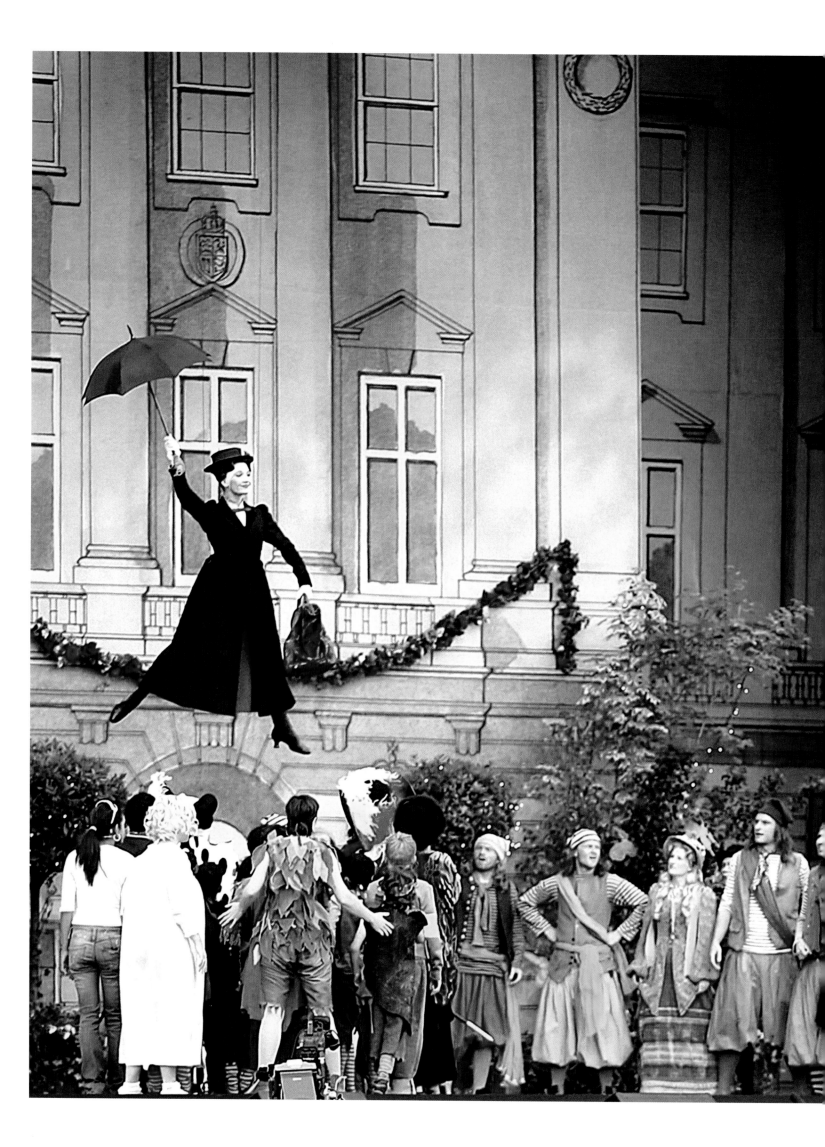

Mary Poppins descends to join the Children's Garden Party at Buckingham Palace, London, June 25, 2006.

RIGHT: A bronze statue of Mary Poppins sculpted by Dr. Rhyl Hinwood, located on Richmond Street, Maryborough, Queensland, Australia honors the birthplace of Helen Lyndon Goff (P.L. Travers).

INSET: The famed Blue Plaque of the English Heritage organization marks the home of P. L. Travers at 50 Smith Street in Chelsea, where she lived after returning from America in 1945 until 1962.

ABOVE: Examples of the various commercial audio recordings of the film and stage musical scores released over several decades.

PERPETUAL POPPINS

Mary Poppins on the Boards

"Mary Poppins's character was so extraordinary that I could never forget her, nor the wonderful Sherman brothers' songs," famed producer Cameron Mackintosh said. "Intrigued to read the original book, I was surprised to find that there were, in fact, several of them and many more stories, characters and adventures than those in the film."

It was some time in the 1970s when Cameron Mackintosh had begun to establish a name for himself as a producer with his first original musical, *The Card*, based on the book by Arnold Bennett, that he wrote a letter to the representatives of author P. L. Travers, asking whether he might acquire the stage rights to *Mary Poppins*.

Many theater producers would have liked to have gotten their hands on the literary property that had been the basis of the hugely successful Walt Disney movie and, it is said, many of them tried. The response to Cameron's request was a polite refusal—the musical stage rights in *Mary Poppins* were not available.

Actually, however, they were. What is more, the original author was keen to see a show made from her books. The trouble was she also had very clear ideas on what it should look and sound like, and was rigorously controlling all issues relating to any granting of those rights.

In 1981, P. L. Travers began negotiations on the project with Jules Fisher, then and now one of Broadway's leading lighting designers and an occasional producer. Fisher had recently staged three successful shows: *Lenny*, a play about the controversial comedian and satirist Lenny Bruce; *Beatlemania*, featuring the music of John, Paul, George, and Ringo; and *Dancin'*, with choreography by Bob Fosse, which was in the middle of a four-year run when talks began on *Poppins*.

Once again, the roll call of potential talent under discussion was impressive. To adapt the book for the stage, Fisher suggested Richard Wilbur, who had written an acclaimed translation of Molière's *Tartuffe*, or Jay Presson Allen, who had had dramatized Muriel Spark's *The Prime of Miss Jean Brodie* for the stage (as well as written the screenplay for *Cabaret*). For a composer, Fisher and Travers favored Stephen Sondheim, hot from his 1979 triumph (and a fifth Tony Award–winning score), *Sweeney Todd*.

By 1981, however, Sondheim was busy with other projects, including *Merrily We Roll Along*, and declined to get involved. For a composer, Travers then suggested Paul McCartney; and she was also keen to work with Alan Jay Lerner as the librettist; *My Fair Lady* was a favorite musical of hers and one that—along with *Camelot*—had been significant in the career of the screen Mary Poppins, Julie Andrews.

Actors discussed for the part of Mary Poppins included Vanessa Redgrave and Maggie Smith, who had

OPPOSITE: *Broadway's famed New Amsterdam Theatre was home to Mary Poppins for 2,619 performances from November 16, 2006, to March 3, 2013.*

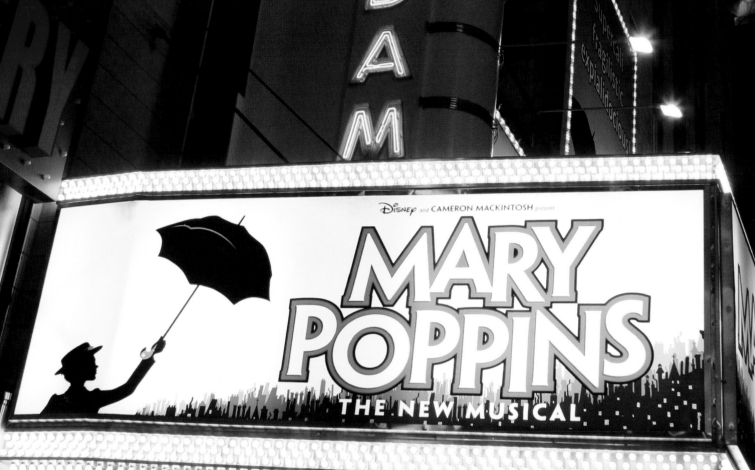

already played the role—to Travers's satisfaction—on a series of recordings.

It was to be another eight years (and, for Jules Fisher, several thousand dollars of development money) before the Poppins project was eventually abandoned. During that time, there was talk of involving, among others, Tim Rice, Jonathan Miller, Tom Stoppard, Peter Schaffer, David Storey, and, finally, the American playwright and cartoonist Jules Feiffer.

But however successful or distinguished the proposed collaborators—whether the actor/dramatist Wallace Shawn (whom Travers had seen in Louis Malle's film *My Dinner with Andre*) or Britain's "Renaissance Man," Jonathan Miller—the stumbling block was always the same: Travers's growing conviction, strengthened by her reactions to the Disney film, that she alone understood Mary Poppins and the way in which she might be brought to the stage.

A decade on from Jules Fisher's interest in the project, P. L. Travers was being courted by a new budding collaborator, David Pugh, a young producer who had enjoyed considerable success with *The Blues Brothers* (and who would later produce Yasmina Reza's much-vaunted play, *Art*). With a letter from the author indicating her enthusiasm, Pugh went to the man most likely to consider investing in a musical of *Mary Poppins*.

Cameron Mackintosh had an impressive track record of original stage hits, including *Cats* (Cameron's first collaboration with Andrew Lloyd Webber), *Song & Dance*, *Les Misérables*, *Phantom of the Opera*, and *Miss Saigon*; revues celebrating the work of Tom Lehrer (*Tomfoolery*), Stephen Sondheim (*Side by Side by Sondheim*), and the rhythm and blues songs of Louis Jordan (*Five Guys Named Moe*); and London productions of such Broadway shows as *Follies* and *Little Shop of Horrors*.

Despite the formidable credits, what Pugh couldn't have known when he asked Mackintosh if he was interested in being involved with the Poppins project was that over twenty years earlier, he had himself attempted to acquire the stage rights.

As a result, some time in 1993, Cameron Mackintosh visited P. L. Travers—by then ninety-three—at her London home at 29 Shawfield Street.

"I vividly recall that first meeting," says Cameron, "and I can see her sitting in the window of her Chelsea house, on a street looking remarkably like Cherry Tree Lane, a frail but extremely alert and sharp old lady. She obviously had some comprehension of who I was, and she eyed me up and down and asked me lots of questions about what I wanted to do with her characters. I asked her questions, too, but she told me less than I told her!"

Like others before him, Cameron encountered Pamela at her most unforthcoming: "I wanted to know more about George and Winifred Banks. 'What does Mrs. Banks do?' I asked, but was told that she didn't do anything other than be a wife and a mother. 'And Mr. Banks—what was his position at the bank?' But all she was saying was what was in the book: that he 'made money' by cutting out pennies and shillings and half crowns.

"Essentially, I think she had locked herself into reciting the same mantra over so many years in order to deal with people who wanted to know about things that she either genuinely had no knowledge of or simply didn't

wish to discuss," Mackintosh sensed. "It was, I think, the reflex response of all writers who have created a famous character towards whom they then have conflicting feelings: proud and, at the same time, slightly resentful at having to share the fame of their own creation."

Despite frustrating conversational dead-ends, it was to be the beginning of a relationship between Cameron and Pamela that would eventually lead to the realization of their shared dream of seeing *Mary Poppins* onstage. One thing was certain: the author was doing a little measuring up.

"I felt very much like Michael Banks in the book," recalls Cameron, "waiting to find out whether Mary Poppins will like him and his sister, Jane, and asking, 'Will we do?'"

Getting agreement for Cameron Mackintosh to develop the stage rights to *Mary Poppins* was one thing; the thorny question of what those rights, once obtained, actually represented, was quite another. Did they, for example, entitle the British producer to put on a stage version of *Mary Poppins* that didn't use the Disney music? This, at the time, was a crucial issue since although, as has been said, Pamela's attitude towards the Disney movie had mollified, she was still insisting that she would only give her approval to a stage version which featured new music and had no indebtedness to the film.

While the original contract between Pamela and Disney was, allegedly, only loosely worded regarding the issue of stage rights, the studio had not actively objected when, a decade earlier, Jules Fisher had begun work on a show based on the Mary Poppins books.

At the time when the original contract was drawn up—in the 1960s, and even when Fisher was in discussions with Pamela in the 1980s— Disney had no ambitions to present a version of *Mary Poppins* onstage. But by 1993 that situation had completely changed.

That year Disney's newly formed theatrical division was staging an out-of-town tryout for a stage musical based on the studio's animated feature, *Beauty and the Beast*, prior to opening the show on Broadway in 1994.

The success of *Beauty and the Beast* prompted Disney to look at other potential theatrical projects; one, *The Lion King*, was already the subject of serious discussion. *Mary Poppins*, however, was obviously another strong contender.

Cameron, well aware of the failure of previous attempts at putting together a stage version of *Mary Poppins* without making the Disney connection, was convinced that the show couldn't hope to succeed without including material from the film. He wanted to create an original show, but it was, he argued, unthinkable that any theater marquee bearing the name *Mary Poppins* would attract an audience if the show was totally divorced from the cultural memories which that name automatically evoked.

It was an argument that would have to be presented to Pamela Travers; but presenting it, Cameron understood quite well, was going to be a challenge.

Cameron decided to seize the moment: "Eventually, I asked her, 'What is it that you don't like about the film?' And she immediately responded that the filmmakers had never understood Mary Poppins.

"It was evident that she spoke her mind," notes Cameron," and I reckoned,

because of that, that she would have no objections to plain, straight talking. I continued: 'Whatever criticisms you may have of the film, I believe that it caught the essential essence of Mary Poppins—maybe not in the style you would have liked—but it did so all the same; otherwise it could never have caught the world's imagination.' She still said nothing.

"The fact is that any audience coming to see *Mary Poppins* as a musical on the stage—however brilliantly I might be able to do it— would be downright angry if it didn't include some of the songs from the film. If you are telling me that you won't allow anything from the Disney film to be in a stage version then, even if I am given permission to go ahead with just the rights to the books, I'd have to say to you that I wouldn't want to do it, because, for one thing, I don't feel that would be right, and, for another, I don't believe that anyone would want to come and see it."

Pamela Travers did not give her answer then and there, but when it came it showed that she had considered Cameron's argument and, doubtless,

saw that his proposal represented the only way forward if she was to realize her ambition—so long held—for Mary Poppins to take to the stage.

The deal was signed, but the burning question that still needed to be addressed was when and how to attempt securing Disney's involvement in the project—and what the studio's reaction was likely to be.

Initial approaches turned out to be unsatisfactory and unsuccessful. The studio, not unnaturally, considered *Mary Poppins* to be their exclusive property and saw no reason to collaborate on a project that wanted both to use elements from one of its top-grossing films but, at the same time, sought to adapt and amend what was universally regarded as a Disney "classic."

"It must have been bloody irritating," says Cameron, "that this title, as famous as Mickey Mouse and so totally associated with Disney, should have been held away from them, firstly, by an irascible old lady and then by a British producer."

Thomas Schumacher had joined Disney Animation in 1988 as a producer;

OPPOSITE: Cameron Mackintosh and Thomas Schumacher.

BELOW: Gavin Lee as Bert, whose kite will soon bring a welcome return from the sky.

and, by 1996, he was also heading Disney's theatrical division with his colleague, Peter Schneider. The duo was then producing what was destined to become one of the most innovative successful new musicals to open on Broadway—and later, throughout the world, *The Lion King*.

Tom and Cameron met, purely by chance, over lunch at the house of a mutual friend in St. Tropez. "Surprisingly, perhaps, we didn't actually talk about *Mary Poppins*!" Tom recalls. "But we did talk a lot about theater."

Then the two men parted without discussing the project that had, for so long, been the subject of negotiations between their two companies. "I'm sure he made a far bigger impact on me than I did on him," says Thomas. "He was Cameron Mackintosh, for God's sake; I was just some kid who worked for the Disney studio who'd produced a play, which at that time was still out of town and most certainly wasn't a hit yet!"

Four years later, Cameron Mackintosh was now solely in control

of the stage rights, with David Pugh having decided to bow out of the picture. It was at this point that Thomas Schumacher decided it was time to "make one last stab at *Poppins*.

"Cameron and I sat down together, and I said, 'Disney has done everything we can to get these rights; you've done everything you can to get these rights," Schumacher recounted. "'All that's happened is that we've reached a complete impasse and the show is never going to be made. But what I find curious is that—apart from meeting, by chance, over lunch in the south of France—we've never really gotten together and, more importantly, we've never even talked about what—if it *were* to be made—this show would be like.'"

Cameron remembers the meeting: "Tom wanted to know what my thoughts were about the *Poppins* show and I told him. Then he told me his thoughts and we started talking, exchanging ideas, and, [I] quickly realized, how much common ground we shared."

"We instantly got along," agrees

Thomas. "Cameron was charming beyond measure; it was impossible not to like him. We talked and talked, and as we did so, things just started to evolve."

It was a beginning.

Disney and Cameron Mackintosh's stage adaptation of *Mary Poppins* had its world premiere at the Bristol Hippodrome in Bristol, England, starting with previews, September 15, 2004, before officially opening on September 18 for a limited engagement until November 6. The production then moved to the Prince Edward Theatre in London on December 15, 2004, making it the only Disney musical to have premiered in the U.K.. The production closed on January 12, 2008, after a run of more than three years. It received nine Olivier Award nominations and won Olivier, Evening Standard, and WhatsOnStage Awards.

On November 16, 2006, the Broadway production opened, and received twenty-five major theatrical award nominations, ultimately winning Tony and Drama Desk Awards. It closed on March 3, 2013, after 2,619 performances over more than six years. With attendance totaling nearly four million guests, the show was seen by more people over that time than any Broadway show except *Wicked* and *The Lion King*.

Since then, *Mary Poppins* has been performed in Australia, Austria, Canada, the Czech Republic, Denmark, Estonia, Finland, Germany, Hungary, Iceland, Ireland, Italy, Japan, Mexico, Netherlands, New Zealand, Norway, Sweden, Switzerland, United Arab Emirates, the United Kingdom, and other places throughout the United States. And it has been translated into thirteen languages (Swedish, Finnish, Hungarian, Danish, Dutch, Czech, Estonian, Spanish, Icelandic, German, Norwegian, Italian, and Japanese).

More than eleven million people have seen the show worldwide.

Brian Sibley

is the author of more than a hundred hours of radio drama and has written and presented hundreds of radio documentaries, features, and weekly programs. He is widely known as the author of many movie "making of" books, including those for the Harry Potter series and The Lord of the Rings *and* The Hobbit *trilogies;* The Disney Studio Story *and* Snow White and the Seven Dwarfs: The Making of the Movie Classic *(with Richard Holliss); and* Mary Poppins: Anything Can Happen If You Let It *(with Michael Lassell).*

OPPOSITE: Ashley Brown played Mary Poppins on Broadway for two years, and then for another year in the National Tour.

FOLLOWING: The movement for the show-stopping "Supercalifragilisticexpialidocious" number was inspired by British sign language and co-choreographer Stephen Mears's partner, who is deaf. Choreographer Matthew Bourne describes it as "a tongue twister in movement."

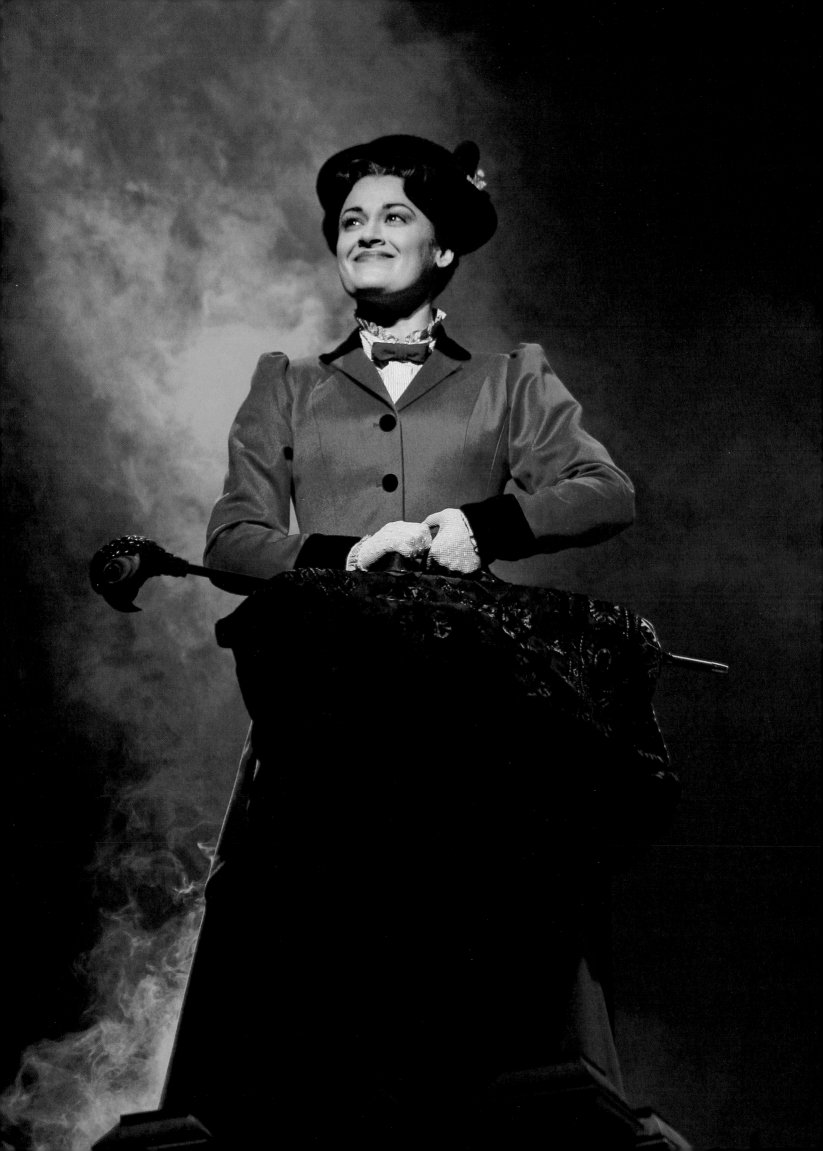

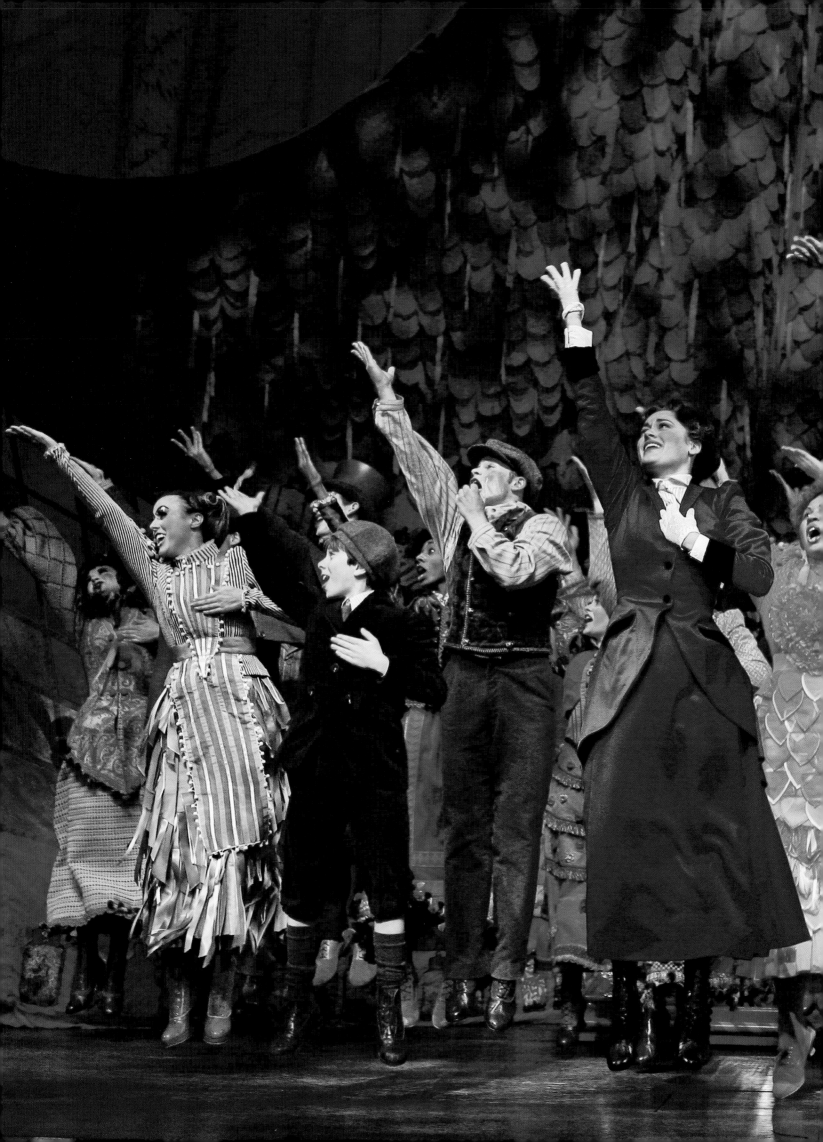

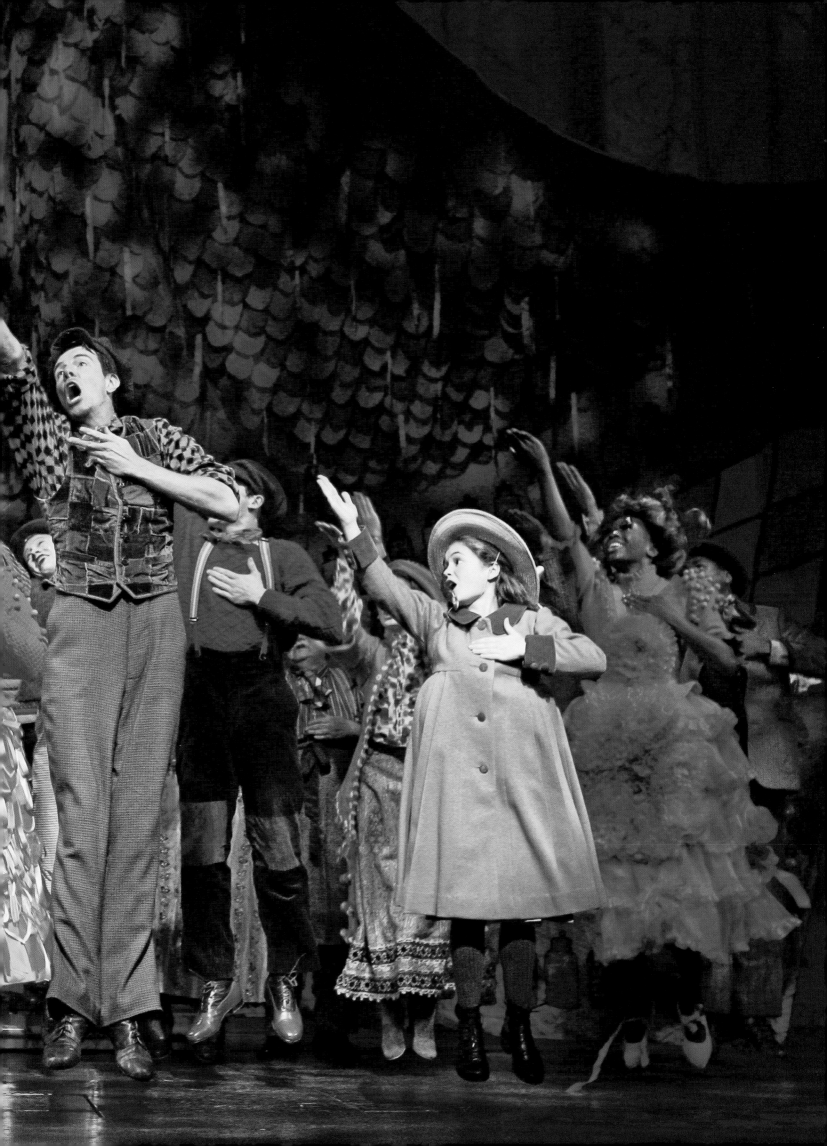

West Wind

"Dear Jane,

Michael had the compass so the picture is for you. Au revoir.

Mary Poppins."

She read it out loud until she came to the words she couldn't understand.

"Mrs. Brill!" she called. "What does 'au revoir' mean?"

"Au revoir, dearie?" shrieked Mrs. Brill from the next room. "Why, doesn't it mean—let me see, I'm not up in these foreign tongues—doesn't it mean 'God bless you'? No. No, I'm wrong. I think, Miss Jane dear, it means 'To Meet Again.'"

Jane and Michael looked at each other. Joy and understanding shone in their eyes.

Michael heaved a long sigh of relief. "That's all right," he said shakily. "She always does what she says she will."

When Jane and Michael Banks secretly wish that they might always remember Mary Poppins, the author tells us that mundane, obvious questions like, "Where and how and when and why" are totally beside the point because, "As far as she was concerned, those questions had no answers."

On one occasion, upon committing herself to writing, Pamela wrote this: "What is the book about? Its chief character is a young woman who arrives, apparently from nowhere, and proceeds to impose upon a small, modest, chaotic household her own ideas of order. Having achieved this, and in the process introduced the children to a world of magic, she takes off again apparently for nowhere, by means of a parrot-headed umbrella. It is as simple as that."

Or is it?

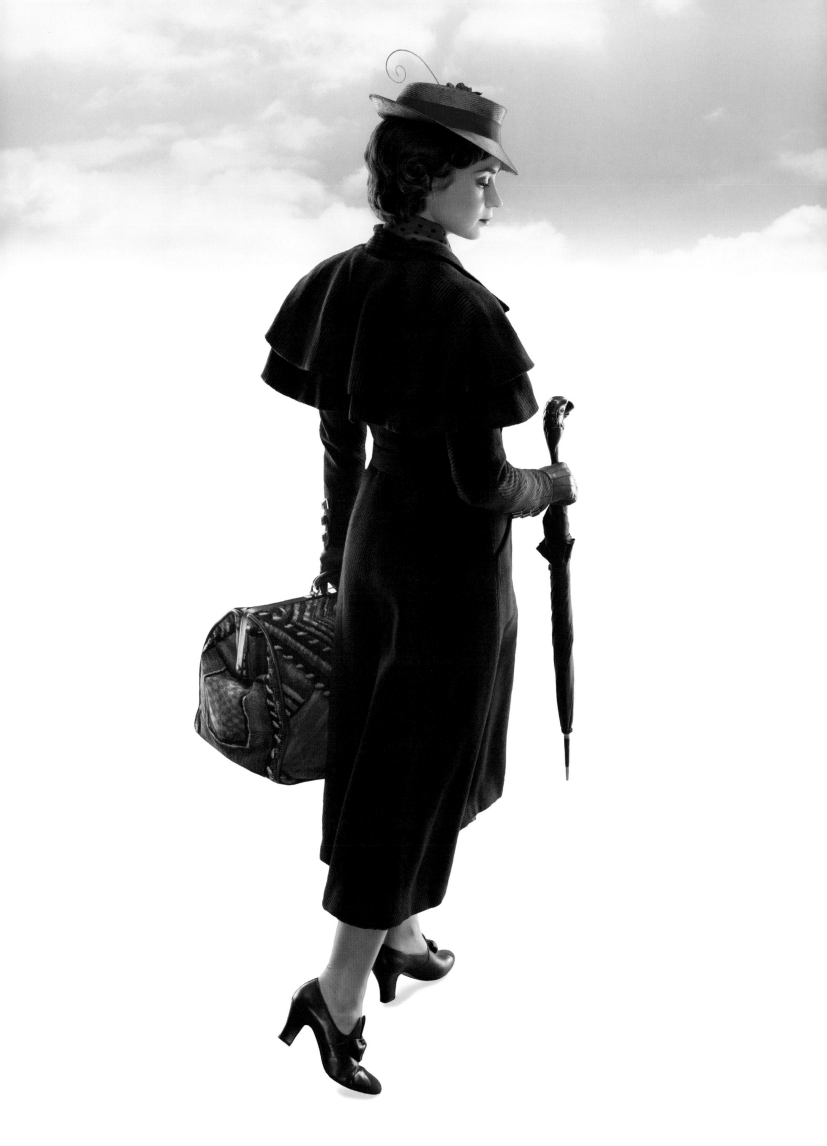

Out of the Blue . . .

P. L. Travers and Her Creation

Mary Poppins may *seem* to have arrived out of "nowhere," but the truth is that she came, at first, from the fertile imagination of thirty-five-year-old Pamela Travers—from her passion for poetry, myth, and fairy tale; from her love of music and dance; and from her fascination with the stars and with the mystery of what the author called the "connectedness" of all living things. Mary herself began arriving in 1934, illuminating the lives of a London family in the dull interwar years. (And she would continue to come and go until 1989, although neither she nor her charges ever got any older.)

Thirty years after her first adventures were published, Mary Poppins came to us again, this time via that popular peddler of tales, Walt Disney, a man with an unerring instinct for a good story and sufficient determination and persistence to pursue his vision across the twenty years that it took to secure the film rights to *Mary Poppins*.

Her journey to a big-screen debut was not without incident, since the original author was engaged as "consultant"—a hitherto unheard arrangement on a Disney picture. Undaunted by the ways of Hollywood, Travers brought to the consultation process numerous requirements and many objections that were to test the patience of Walt and his team.

For a while, the clash of two equally strong-willed individuals was sufficiently tempestuous enough to seriously jeopardize Mary Poppins's arrival: a great deal of diplomacy—and no small measure of compromise—was required before, in 1964, Mary Poppins was able to fly into the cinemas of the world. (This story itself was brought to the screen in 2013 in the feature film *Saving Mr. Banks*.)

With the author's permission, Mary now found herself landing in a picturesque version of Edwardian London, gaily splashed with Technicolor and decked out with song-and-dance numbers and clever visual effects. And, having arrived, she made a star of the film's leading lady, earned its producer a passel of Oscars, and won a place in the hearts of millions.

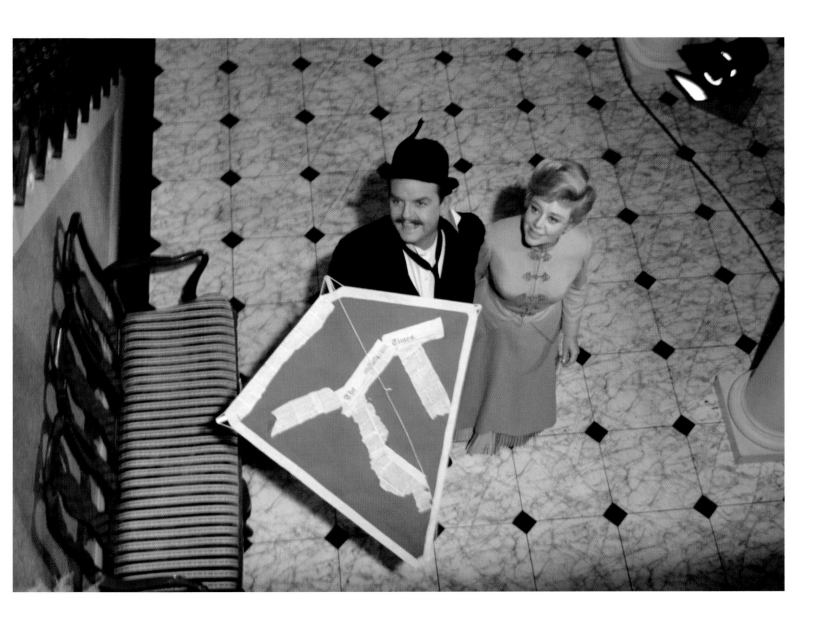

Though Travers repeatedly gave the impression that she was deeply disappointed and distressed by that process of change, the truth was that she had actually agreed to many of the transitions from page to screen that she would later denounce. It was only towards the end of her life—and then only to a few—that she conceded that the film was but another stage in that curious process by which literary characters occasionally migrate from the printed page to assume a mythic status.

Seventy years on from the publication of the first Mary Poppins book, she came to us once again and in a new incarnation, courtesy of impresario Cameron Mackintosh. Almost from the moment that Mary Poppins first appeared, Pamela wanted to see her take to the stage; she pursued that ambition throughout the rest of her life.

In a letter left to her literary executors on her death, she wrote, "It has always been my wish that we should have a stage dramatic play or musical of *Mary Poppins* . . ." With the author's blessing, and the collaboration of Mackintosh and Disney Theatrical leader Thomas

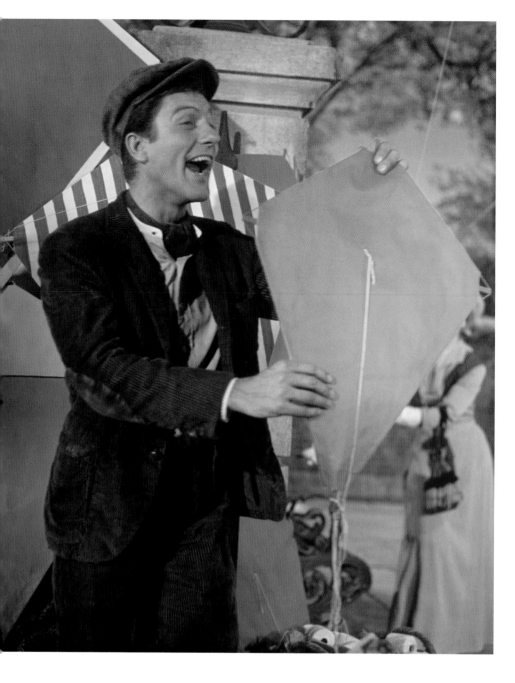

Schumacher, Mary Poppins now arrives and departs every single day on stages all around the world.

Now Mary Poppins has come to light up the cinema screens again, in a magical, musical new incarnation, *Mary Poppins Returns*. Under the creative leadership of the Walt Disney Studios, this Christmas gift for 2018, is a colorful and charming new story featuring an all-star cast and brought to life by a stellar creative team. In Depression-era London, a now-grown Jane and Michael Banks, along with Michael's three children, are visited by the enigmatic Mary Poppins following a personal loss. Through her unique magical skills, and with the aid of her friend Jack, she helps the family rediscover the joy and wonder missing in their lives.

What do each one of these Mary Poppins have in common? That they arrive out of the blue and stay for an all-too-brief period of time—until the wind changes or the chain breaks—whereupon they fly away again to, as Pamela Travers put it, "Apparently for nowhere."

When the author finished writing her third book, she decided to call it *Goodbye, Mary Poppins.* "At the time," Pamela told me, "I didn't think there was anything else to say, because you always feel like that at the end of any book."

Indeed, on its final pages, as Jane and Michael Banks watch the arc of a shooting star

CHAPTER EIGHT

coursing its way across the night sky, there comes a sudden, saddening realization that the speck of brilliance vanishing into the darkness is, in reality, Mary Poppins. That, like all shooting stars, she was there, fleetingly and magically, but is now gone.

Travers's publisher, who still had hopes for further volumes in the series, protested that *Goodbye, Mary Poppins* was far too final a title. So, the third book became *Mary Poppins Opens the Door*. "Later," Pamela recalled, "I was glad that I hadn't said, 'Goodbye, Mary Poppins,' because after a while I wrote *Mary Poppins in the Park*."

When she wrote that book eight years later, she tossed aside, in a preliminary note (that like all such additions to books are really best left *unread*), a "word of warning," explaining that the adventures described within its pages "should be understood to have happened during any of the three visits of Mary Poppins to the Banks Family."

The result, contrary to the author's intention, was to give the reassuring illusion that Mary Poppins is permanently present. As, of course, in a way, she is.

For although the author told her readers that Mary Poppins "cannot forever arrive and depart," she was mistaken, because that is precisely what she does.

Every time someone picks up a copy of *Mary Poppins* and reads its opening words ("If you want to find Cherry Tree Lane, all you have to do is ask the Policeman at the crossroads . . ."), Mary Poppins is waiting to arrive: waiting for the east wind to throw her against the door of Number 17.

Every time the opening titles of the film version of *Mary Poppins* roll and we see the River Thames and the landmarks of London laid out, she is there—waiting on a cloud, with her carpetbag and parrot-headed umbrella, ready to float into view.

Every time the theater orchestra begins to play the overture to the stage musical of *Mary Poppins* and the houselights go down and the curtain goes up, she is waiting to arrive, waiting to make her entrance in a flutter of cherry blossoms, waiting to step into the lives of those in the Banks family, and also into the imaginations and memories of everyone watching the story unfold.

True, the moment of departure *will* eventually come, and she *will* go away, leaving as mysteriously as she did back when she arrived. But through the magic of literature, motion pictures, and theater—and in a way that even the author never expected when she had Mary Poppins leave a note for the children with the words *"Au revoir"*—the practically perfect nanny will return again and again: performance after performance, as days transform themselves into weeks, months, and perhaps years, for as long as audiences are ready to welcome her and the special enchantment she brings.

Like Alice, Peter Pan, Mr. Toad, and Long John Silver, Mary Poppins now exists in the common imagination without requiring the support of an author—alas a final confirmation, perhaps, of this Pamela Travers's oft-quoted comment: "I don't feel for a moment that I *invented* her. I feel *visited* by her."

Brian Sibley

is the author of more than a hundred hours of radio drama and has written and presented hundreds of radio documentaries, features, and weekly programs. He is widely known as the author of many movie 'making of' books, including those for the Harry Potter series and The Lord of the Rings *and* The Hobbit *trilogies;* The Disney Studio Story *and* Snow White and the Seven Dwarfs: The Making of the Movie Classic *(with Richard Holliss); and* Mary Poppins: Anything Can Happen if You Let It *(with Michael Lassell).*

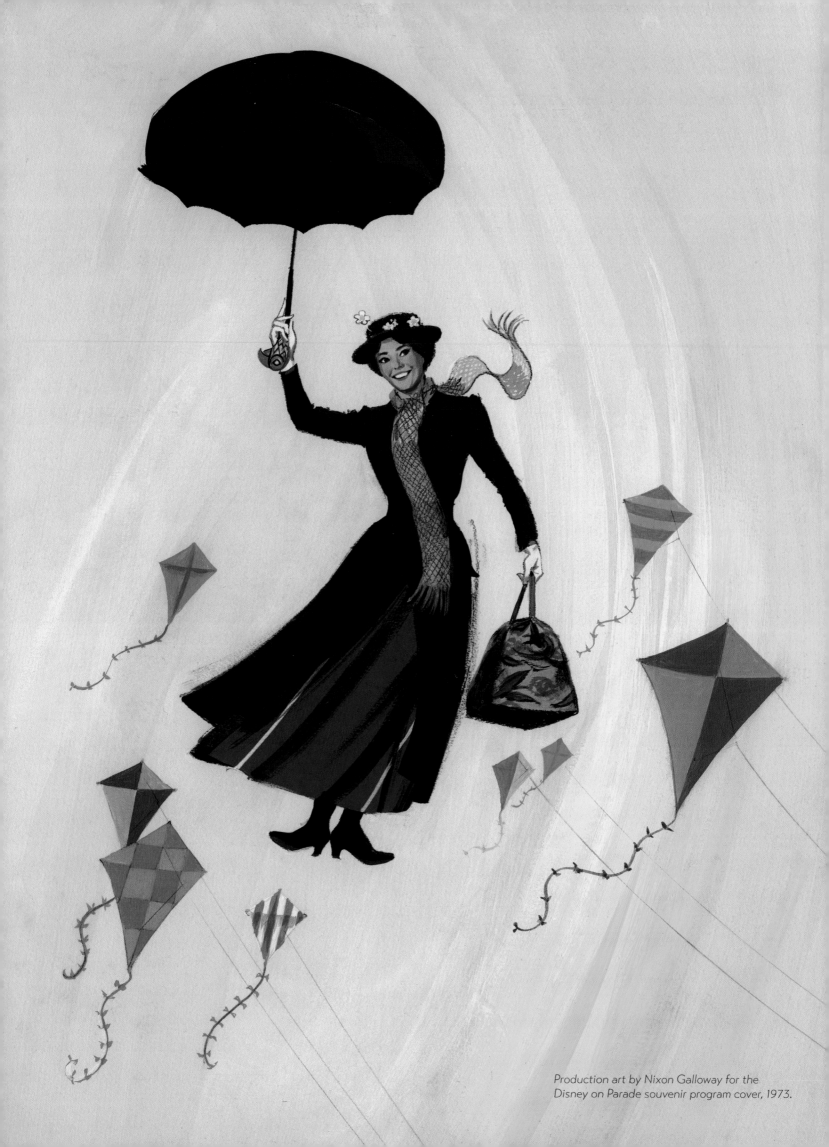

Production art by Nixon Galloway for the Disney on Parade souvenir program cover, 1973.

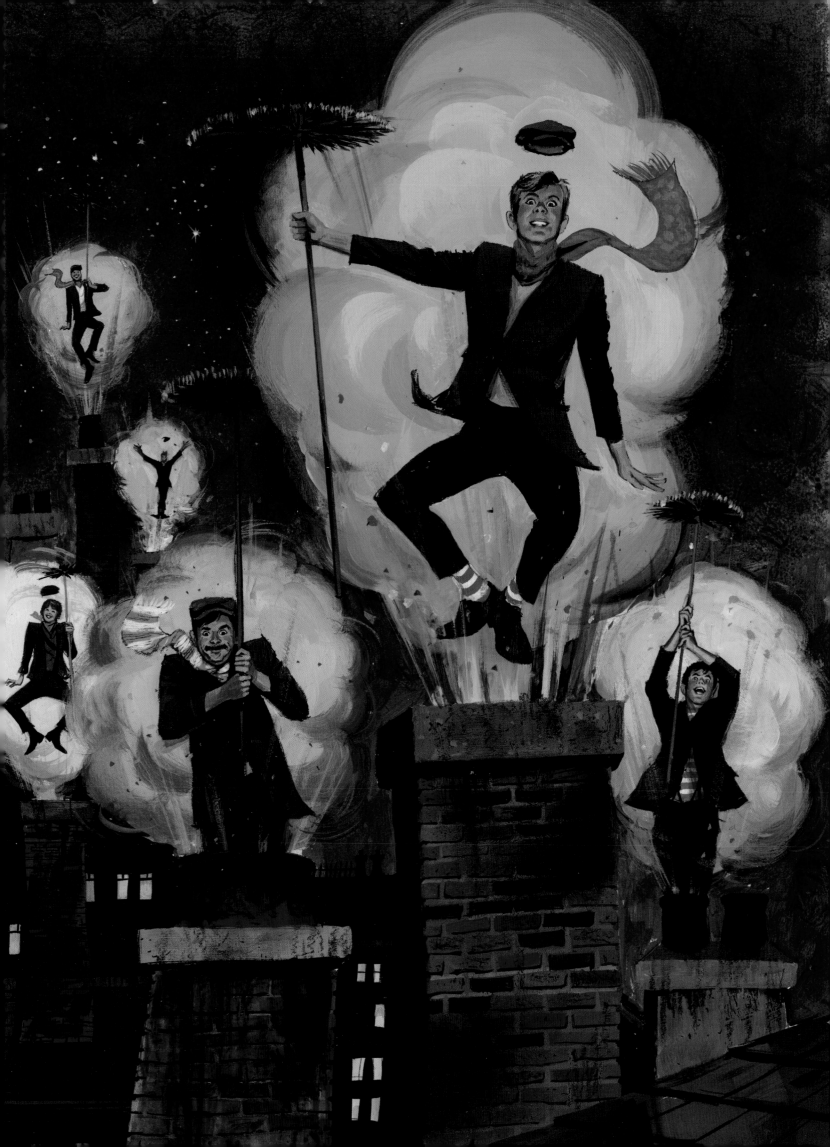

Andrews, Julie. *Home—A Memoir of My Early Years*. New York: Hyperion, 2008. Print.

Biedenharn, Isabella. "*Mary Poppins Returns*: Emily Blunt on Julie Andrews' Reaction to Casting." *EW.com*. Time Inc., August 27, 2016. Web.

D'Alessandro, Anthony. "'Into the Woods' Director Rob Marshall on Making Movie Musical Magic." *Deadline.com*. Penske Business Media, LLC. December 16, 2014. Web.

Farley, Adam. "What Are You Like? Jim Norton." *Irishamerica.com*. Irish American LLC, June/July 2014. Web.

Finch, Christopher. *The Art of Walt Disney: From Mickey Mouse to the Magic Kingdoms* (First Edition). New York: Abrams, 1973. Print.

Flanagan, Caitlin. "Becoming Mary Poppins: P. L. Travers, Walt Disney, and the Making of a Myth." *The New Yorker*, December 19, 2005, pp. 40–46. Print.

Giltz, Michael. "Exclusive: Tony Winner Jim Norton Kicks Up His Heels In 'Finian's Rainbow.'" *Huffingtonpost.com*. Oath Inc., March 18, 2010. Web.

"Glumpuddle" [pseudonym]. "David Magee Interview Transcript." *Talking Beasts: The Narnia Podcast. Narniaweb.com*. Narnia Fan Site. August 12, 2017. Web.

Lassell, Michael. "The Hunt for P. L. Travers." *Playbill.com*. Playbill, Inc. November 10, 2006.

Lawson, Valerie. *Mary Poppins, She Wrote: The Life of P. L. Travers*. New York: Simon & Schuster, 1999. Print.

Oresen. "David Magee, Screenwriter for *The Silver Chair*, on Writing a Screenplay." The Lion's Call. Narnia Fan Site, April 13, 2014. Web.

Radish, Christina. "Emma Thompson and Tom Hanks Talk *Saving Mr. Banks*, Bringing the Essence of Their Characters to the Screen, and How P. L. Travers Would Have Reacted." *Collider.com*. Complex Media, Inc., December 9, 2013. Web.

Rochlin, Margy. "Not Quite All Spoonfuls of Sugar." *NYTimes.com*. (*The New York Times*). January 3, 2014. Web.

Seacrest, Meryle. *Stephen Sondheim: A Life*. New York: Knopf, 1998. Print

Sells, Mark. "In Like Flint: Adapting Yann Martel's *Life of Pi*." *Scriptmag.com*. A division of Writer's Digest. November 22, 2012. Web.

Sherman, Richard M. and Robert B. *Mary Poppins* Original Cast Sound Track Recording, STER-4026, 1964, vinyl LP.

---. *Walt's Time: From Before to Beyond* (First Edition). Santa Clarita, CA: Camphor Tree Publishers, 1998. Print.

Sibley, Brian and Lassell, Michael. *Mary Poppins: Anything Can Happen if You Let It* (A Disney Theatrical Souvenir Book). New York: Disney Editions, 2007. Print.

Sloane, Leonard. "Advertising: Mary Poppins Fad Designed." *The New York Times*, July 24, 1964. Print.

Smith, Dave. *Disney A to Z: The Official Encyclopedia* (Fifth Edition). New York: Disney Editions, 2016. Print.

Snetiker, Marc. "*Mary Poppins Returns*: Inside the Magical Sequel 50 Years in the Making." *EW.com*. Time Inc, June 07, 2017. Web.

---. "Here's what the Banks family Is Up to in *Mary Poppins Returns*." *EW.com*. Time Inc, June 08, 2017. Web.

---. "Inside Rob Marshall's Vision for *Mary Poppins Returns*." *EW.com*. Time Inc, June 09, 2017. Web.

Travers, P. L. *Mary Poppins*. New York: Reynal & Hitchcock, 1934. Print.

---. *Mary Poppins Comes Back*. New York: Reynal & Hitchcock, 1935. Print.

---. *Mary Poppins Opens the Door*. New York: Reynal & Hitchcock, 1943. Print.

---. *Mary Poppins in the Park*. New York: Harcourt, Brace & World, 1952. Print.

---. *Mary Poppins and the House Next Door*. New York: Collins, 1988. Print.

Sondheim, Stephen. "The World of the Play: Stephen Sondheim," Roundabout Theatre Company *UPSTAGE* (Spring 2010), p. 10. Print.

Sondheim, Stephen. *Finishing the Hat: Collected Lyrics (1954–1981) with Attendant Comments, Principles, Heresies, Grudges, Whines and Anecdotes*. New York: Knopf, 2010. Print.

Thomas, Bob. *Walt Disney: An American Original*. New York: Disney Editions, 1994. Print.

Thomas, Frank and Johnston, Ollie. *Disney Animation: The Illusion of Life* (First Edition). New York: Abbeville Press, 1981. Print

Van Dyke, Dick. *My Lucky Life in and Out of Show Business: A Memoir* (First Edition). New York: Crown Archetype, 2011. Print.

Walt Disney Studios
Endpapers, Pages 2–3, 4–5, 13, 20–21, 23, 26-27, 29, 32, 33, 35, 37, 38–39, 40, 41, 43, 44-45, 46, 47, 48, 49, 50, 51, 52, 53, 54, 55, 56, 57, 58, 59, 61, 63, 65, 68-69, 70, 71, 72-73, 74-75, 213, 219.
Disney Theatrical Group
8, 10, 132, 136, 139, 201, 203, 206, 207, 209, 210-211.
Walt Disney Animation Research Library
15, 108–109, 112–113, 114, 116, 117, 118-119, 120–121, 124-125, 127, 166-167.
Walt Disney Archives
106, 107, 128, 130 (bottom), 133, 151, 152, 153, 154-155, 156-157, 174-175, 178, 186, 187 (top), 201.
Walt Disney Archives Photo Library
16, 18, 77, 92 (top), 99, 100, 101, 102-103, 105, 118, 119, 122, 126, 127 (bottom), 134, 140, 141, 142, 143, 144, 145, 149, 159, 162, 165, 167, 170, 173, 185, 186 (bottom), 188, 189, 190, 191, 192, 193, 196, 197, 215, 216.
Alamy Stock Photo
82, 95, 129, 130, 131 (top).
Pages 1, 91, 224
Illustrations by Mary Shepard, from *Mary Poppins* by P. L. Travers. Copyright 1934 and renewed 1962 by P. L. Travers. Reprinted by permission of Houghton Mifflin Harcourt Publishing Company. All rights reserved.

Page 79
Dan Lloyd / Alamy Stock Photo
Page 86
Emma Frater / Alamy Stock Photo
Page 89
Photo by Evelyn Frederick
Page 92 (bottom)
Courtesy of the Walt Disney Family Foundation Collection
Page 195
PA Images / Alamy Stock Photo
Pages 198-199
PA Images / Alamy Stock Photo
Page 200
Iconsinternational.Com / Alamy Stock Photo
Page 200 (inset)
Mim Friday / Alamy Stock Photo
220-211
Nixon Galloway art courtesy of Kevin Kidney

My dear friend Wendy Lefkon at Disney Editions and I have been waiting twenty-plus years to do a Mary Poppins book together. Maybe we just had to wait for the phenomenal Jennifer Eastwood and Winnie Ho to be here to work on it with us.

The filmmakers of Mary Poppins Returns were gracious, generous, and enthusiastic in supporting this project. Special thanks go to John Myhre, for a lifetime of friendship and encouragement.

Many thanks to Dominique Flynn, Dale Kennedy, Jessica Bardwill, and Caitlin Dodson at the Walt Disney Studios for their tireless support of this project.

At the Walt Disney Archives, thanks to Michael Vargo, Rebecca Cline, Ed Ovalle, and Kevin Kern; and to Michael Buckhoff and Holly Brobst at the Walt Disney Archives Photo Library.

At the Walt Disney Animation Research Library thanks to Fox Carney for his unparalleled eye for artwork and his thoughtful text contributions to this book.

At Walt Disney Imagineering, gratitude to Vanessa Hunt, Aileen Kutaka, and Evelyn Frederick.

Max Garvin, Hunter Chancellor, Dennis Crowley, Steven Downing, and Caitlin Baird at Disney Theatrical Productions offered generous assistance.

At Disney Editions, thanks to Monica Vasquez, Greta Miller, Warren Meislin, and Kate Milford.

Kevin Kidney is a phenomenal artist and a generous friend.

To my hosts in London, Sean McEnaney and Antony Hopkins, much love and appreciation.

And my heartfelt gratitude to Paul Wolski, Jefferson Marquis, Travis Tyler Black, Jordan Beeks, Chad Woodruff, Joseph Titizian, Tim Barnes, Jeffrey Sherman, Wendy Leibman, and Chris Tassin.

And as always everything I do is for Ken, Brendan, Joey, and Mitchell.

IMAGE CREDITS AND ACKNOWLEDGEMENTS

But they knew, both of them, that something strange

and wonderful had happened at Number Seventeen,

Cherry-Tree Lane.

—P. L. Travers, Mary Poppins